Multiplicity, Embodiment and the Contemporary Dancer

Multiplicity, Embodiment and the Contemporary Dancer

Moving Identities

Jennifer Roche
Queensland University of Technology, Australia

First published 2015 by
PALGRAVE MACMILLAN

Palgrave Macmillan in the UK is an imprint of Macmillan Publishers Limited, registered in England, company number 785998, of Houndmills, Basingstoke, Hampshire, RG21 6XS.

Palgrave Macmillan in the US is a division of St Martin's Press LLC, 175 Fifth Avenue, New York, NY10010.

Palgrave is the global academic imprint of the above companies and has companies and representatives throughout the world.

Palgrave® and Macmillan® are registered trademarks in the United States, the United Kingdom, Europe and other countries.

ISBN 978–1–137–42984–1

This book is printed on paper suitable for recycling and made from fully managed and sustained forest sources. Logging, pulping and manufacturing processes are expected to conform to the environmental regulations of the country of origin.

A catalogue record for this book is available from the British Library.

A catalog record for this book is available from the Library of Congress.

Typeset by MPS Limited, Chennai, India.

Contents

List of Figures vi

Preface vii

Acknowledgements xi

1 Introduction: Dancing Multiplicities 1
2 Descending into Stillness: Rosemary Butcher 25
3 Veils within Veils: John Jasperse 43
4 The Shape Remains: Jodi Melnick 60
5 From Singular to Multiple: Liz Roche 79
6 Corporeal Traces and Moving Identities 99
7 Further Iterations and Final Reflections 119

Notes 138

Select Bibliography 152

Index 162

List of Figures

2.1 Video still of Liz and Jennifer Roche in Rosemary Butcher's *Six Frames: Memories of Two Women* (2005). Courtesy of the choreographer, Rex Levitates Dance Company and Why Not? Associates, London. 32

3.1 Video still of Jennifer Roche with the choreographer concealed under her skirt in John Jasperse's *Solo for Jenny: Dance of (an undisclosed number of) Veils* (2008) #1. Videographer Enda O'Looney. 45

3.2 Video still of Jennifer Roche in John Jasperse's *Solo for Jenny: Dance of (an undisclosed number of) Veils* (2008) #2. Videographer Enda O'Looney. 47

4.1 Video still of Jennifer Roche in Jodi Melnick's *Business of the Bloom* (2008) #1. Videographer Enda O'Looney. 62

4.2 Video still of Jennifer Roche in Jodi Melnick's *Business of the Bloom* (2008) #2. Videographer Enda O'Looney. 75

5.1 Jennifer Roche in publicity image for *Shared Material on Dying* (2008) by Liz Roche. Image by Enda O'Looney. Courtesy of Liz Roche Company. 81

5.2 Video still of Jennifer Roche in Liz Roche's *Shared Material on Dying* (2008). Videographer Enda O'Looney. 89

5.3 Liz Roche and Katherine O'Malley in *12 Minute Dances* (2009) by Liz Roche. Photograph by Maurice Gunning. 92

7.1 John Jasperse in *Truth, Revised Histories, Wishful Thinking and Flat Out Lies*. Photographer Cameron Wittig. Courtesy of the Walker Arts Centre. 126

7.2 Jodi Melnick in *Suedehead* 2009. Photograph by Julieta Cervantes. 130

Preface

This book has emerged out of my practice as a contemporary dancer during a career in dance that has spanned almost twenty-five years. It began as a study of my creative process as a freelance/independent contemporary dancer while working with various different choreographers. As well as interrogating the creative processes of dancers from a theoretical perspective, it draws on practical research, which was undertaken with four contemporary choreographers to produce four texts that are written from the dancer's viewpoint. The choreographers are Rosemary Butcher from Britain, John Jasperse and Jodi Melnick from the United States and Liz Roche from Ireland. The central proposition that underscores the book is the notion that the dancer has a *moving identity*, which is both an individual way of moving and a process of incorporating different movement experiences in training and in professional practice. Over the course of their careers, independent contemporary dancers work in many creatively distinct choreographic processes, led by various choreographers, who each utilise an individual approach to movement. I propose that these processes alter the dancer's *moving identity* through the accumulation of new patterns of embodiment that remain incorporated as choreographic traces.

This practical research took place mainly in Ireland, my base at the time, but the book reflects the international nature of contemporary dance practice by including a wider field of choreographers and dancers working in Britain, North America and Australia through studio praxis, interviews and available literature. It is situated within a contemporary dance field that has become increasingly transatlantic over the past number of years, in a specific historical 'econo-political' juncture where contemporary dance production is becoming more commercialised (Kolb 2013). As Kolb (2013: 31) outlines, recent years have seen the role of dance artist shift from bohemian outsider to entrepreneur at the centre of a post-Fordist[1] producer and consumer culture.

Throughout this study, I have used my embodied self as the research tool, as the one who participates, discovers and records. The individual viewpoint is reinforced by extracts from substantial interviews with three dancers who each speak on the topic of moving identity and their engagement with choreographers and choreographic practices: Sara Rudner, Rebecca Hilton and Catherine Bennett. These

perspectives are further supported through contributions from workshop participants and input from the four choreographers through studio documentation and discussions.[2] Thus, the personal perspective engages with broader discourse in the field.

The book is structured around my singular perspective, constituting a phenomenological mapping of the territory, which I hope will point to further research possibilities into this novel area. In researching for this book, I have utilised my skills as a dancer to explore through a number of modalities, adopting a post-positivist research position that reflects the shifting and multiple nature of the socially constructed self. I have not endeavoured to establish a singular truth about the dance-making process, as this would detract from the agency of all dancers, but rather to reveal a number of new perspectives on dance as a dynamic and creative endeavour for dancers.

The proliferation of signature choreographers in recent years has required that dancers adopt sophisticated creative strategies that can differ between dance projects and this radically shifts the more traditional concepts of the choreographer as the embodied mind of the work and the dancer as the canvass or choreographic tool. However, revealing the dancer's co-creative perspective presents a challenge to authorship, agency and distribution of labour in dance. Although I explore these themes throughout the book, I am not seeking to destabilise the dance-making process but rather to offer avenues for deepening knowledge of these processes, by offering dancers a point of reference for examining their practice. As I endeavour to expose the meta-narratives of dancers, to reveal instances of agency that are uncovered through a detailed exploration of practice, I have positioned this work within studio praxis and speak outwards from first-person experience. Although this is a fine line to walk within an academic publication, it has enabled me to present an informed analysis of what transpired in the making of these solo pieces. In the understanding that this is only one of many potential and legitimate viewpoints, it is revealing of a side to dance creation that is rarely represented in academic writing and offers another voice beyond that of the choreographer, dance critic or academic and points to a new means of knowledge production in dance.

The research that underscores this book took place between 2003 and 2008, with a focus on constructing a frame through which to understand my dancing practice. Revisiting this text in order to bring this to publication, I have tried to broaden the context of my initial discoveries, while protecting the embodied experience at the centre of my writing. Throughout the time frame of writing this book, I have

encountered dancers who are unravelling the conventional limitations inherent in their role, to examine what it means to be a dancer-inter-preter through performance. Two such artists, Juliette Mapp and Levi Gonzales, both based in New York, have individually explored their dancing genealogies in dance performances. Gonzales (2008) presented individual excerpts of movement phrases by a range of New York-based choreographers at Dancespace Project at the Association of Performing Arts Presenters conference stating that he intended to be a human map of these different choreographies. Mapp, in *Anna, Ikea and I* (2008) cre-ated a piece that included on stage many of the choreographers, teach-ers and dancers who had influenced her throughout her career. In this way, she presented her dancing body as a composite of these multiple experiences.[3] Similarly, some choreographers, most recently, Jérôme Bel and Siobhan Davies, have created pieces that prioritise the dancer's per-spective within choreographic works. These viewpoints have emerged in conjunction with the infiltration of postmodern, post-structuralist and post-Cartesian thought into dance-making processes and reflect some of the prevalent philosophical trends of this current historical moment.

Traditionally, choreographies are usually discussed as representational of the choreographer, with little attention focused on the dancers who also bring the work into being. The elision of the dancer's perspective from mainstream discourse deprives the art form of a rich source of insight into the incorporating practices of dance. Choreographers are generally considered to be the embodied minds of the dance work, holding the template of the unfolding dance piece to act upon the neu-tral dancer. By the same token, dancers can be reduced to passive recep-tacles of the movement, puppets in the process, whose bodies are given over to the demands of the choreography. In this way dancers often cease to be considered as self-representational and are viewed from the outside as purely embodying the creative concepts of the choreographer in performance.

As dancers are live agents in dance-making and performance, this viewpoint overlooks the nuances that are specific to dance and the complexities of the relationship between the dancer and choreogra-pher, the dancer and the choreographic score, and the dancer within the performance terrain. These subtleties are brought to the forefront if attention is given to individual dancers' experiences of embodying choreography. Thus, this publication identifies a burgeoning area in the field of dance studies, by positioning dancers as a source of knowl-edge and as capable of self-representation. Dancing practices take place

across a broad spectrum, even within contemporary dance and so this book does not intend to account for every instance of dancing. Some aspects will resonate with dancers, choreographers and academics more than others. My hope is that it will challenge some existing ideas and open new possibilities for reframing practice, particularly in light of dancers valuing the contribution they make to contemporary culture.

Acknowledgements

This book marks the completion of a project that began in 2003 as practice-led doctoral research at Roehampton University, London. Working as a dancer at that time and living in Ireland, I juggled the complexities of academic research alongside the instability of a dancing life in projects, which took me from Dublin to Beijing, Vienna, New York, Paris and London (alongside less glamorous locations). Many of the choreographers, dancers and teachers whom I encountered over those years have helped me to hone my ideas through conversations and creative exchanges and I hope I have reflected these informal contributions adequately in my perspective.

My transition into academia was guided by my wonderful PhD supervisors, Carol Brown and Stephanie Jordan, and I will always be grateful for their patience as I learned to translate my dancing experiences into an academic frame. The book charts my journey through creative projects with four choreographers who each gave generously of their time, energy and talent to support my practical research. I would like to sincerely thank these choreographers, John Jasperse, Jodi Melnick, Rosemary Butcher and my sister, Liz Roche who have continued to support this project up to the final stages, including granting permissions for photographs and helping me follow up rights holders. I am extremely grateful to Sara Rudner, Catherine Bennett and Rebecca Hilton whose interviews so significantly underscore my ideas in this book. Their embodied knowledge added flesh to my theories and allowed me to move beyond the constraints of a singular perspective.

At different stages when undertaking this research, I interacted with other dancers in workshops and discussion groups. Philip Connaughton, Ríonach Ní Néill and Katherine O'Malley are mentioned in the text, but additionally, Jane Magan, Lisa McLoughlin, Deirdre O'Neill and Lenka Vorkurkova all contributed to the development of my ideas and contributed their perspectives on dancing practices.

I thank Marina Rafter and Catherine Nunes from the International Dance Festival Ireland/Dublin Dance Festival for financially supporting the initial stages of the practical research and Laurie Uprichard for seeing the co-production of the performance of the works in *Solo³* through to completion for the festival in 2008. I would also like to acknowledge funding support from the Arts Council of Ireland/An Chomhairle

Ealaíon throughout my doctoral studies, which facilitated my travel to work with the choreographers and to bring them to Ireland to work with me.

In 2013 I moved from the University of Limerick to take up a position as lecturer at Queensland University of Technology. It has been through the Creative Industries Faculty here that I have received the support needed to bring this book to completion. For this, I am extremely grateful to Alan McKee, who encouraged me to develop the proposal and gave me invaluable advice about the publishing process. Also, sincere thanks to Cheryl Stock and Gene Moyle for their input and advice over this period and the support they have given me to move forward with these ideas. Carol Brown and Sally Gardner very kindly read through a first rough draft of the book and offered invaluable advice and encouragement in helping me to shape it. Also, my thanks to the two anonymous readers who gave feedback on the proposal and first draft of the manuscript and whose recommendations on how to translate the doctoral thesis into an academic book were very helpful. Thanks to my students at the UL and QUT for helping me to understand the many stages of a dancer's life from training through to professional practice and to my colleagues at UL and QUT who were valuable sounding-boards over the years and months leading up to this publication. I must acknowledge the wonderful support of my family who have taught me continually to question and to remain open to other perspectives and possibilities: Freda, Declan, Liz, Denis and Maura and the partners and little ones. I would like to thank my husband Grant, who has been ever supportive throughout this project.

I am very grateful to Palgrave Macmillan for publishing this book, particularly Paula Kennedy and Peter Cary for their support throughout the review and production stages. I have made all efforts to secure the appropriate rights for any material used in this book. My thanks goes to photographers Maurice Gunning, Julieta Cervantes and Cameron Wittig for allowing their images to be used and to Liz Roche Company and Walker Arts Centre for the use of certain images and video stills. My article, 'Embodying Multiplicity: The Independent Contemporary Dancer's Moving Identity' (*Research in Dance Education* 12(2) (2011): 105–18) summarised the themes from my doctoral research and extracts from this article are reproduced throughout the book. If any material is not credited appropriately, please contact me through my publishers.

1
Introduction: Dancing Multiplicities

What are we seeing when we watch a dancer dance? Is it the accurate unfolding of the choreographer's oeuvre or is it the dancer's *interpretation* of the idea? From where does the movement form emerge, the choreographer's body or the dancer's body or both? What gives the movement its specific identity or brings about the differences that we see between one dancer and the next?

When describing the dancer in abstraction, we imagine a moving body encapsulating a high level of physical virtuosity, discipline and control; a body shaped through strict training ideologies, displaying movement versatility and physical prowess. However, in this current historical moment, the role of dancer is embodied in many different ways throughout the broad vista of professional contemporary dance practice.[1] The wide range of activities that is encapsulated by the term *dancer* in the twenty-first century is mirrored in the myriad creative methodologies utilised by choreographers to generate movement. Depending on the choreographic process they engage in, dancers could be considered to be choreographic instruments or the choreographer's canvas; or on the other end of the scale, as French choreographer Boris Charmatz describes, the 'substance of the process itself' (Ploebst 2001: 178). Dance writer, André Lepecki (2006: 54) explains that within the framework of Jacques Derrida's[2] concept of the 'theological stage', dancers' expressivity is muted. In this context, he presents an extreme view of a dancer as 'nothing more than a faithful executor of the designs of the absent, remote, perhaps dead, yet haunting power of the master's will' (Lepecki 2006: 54).

The entrance of dance into academia together with demands from the globalised performing arts marketplace creates the conditions for categorising dance-making into styles and genres. In academia,

categorisation allows scholars to analyse and discuss choreographic trends and in the marketplace it allows dance programmers and artists to promote and sell dance works. This leads to the promotion of choreographers as signature[3] artists, coupled with the tendency to ignore the significance of dancers in the creation process. Ramsay Burt (2004: 30), in recognising dancers' omission from writings on dance, explains how dance analysis 'too often [...] means the analysis of a disembodied ideal essence conventionally called "choreography" – rather than an analysis of the performance of that choreography by sometimes troubling and disturbingly material dancing bodies'.

Indeed, the subjective experience of dancers as they engage with the choreographic process is rarely expressed within current dance discourses. Generally, the choreography in abstraction is prioritised as the site of meaning above the materiality of dancers who embody and realise the work. Therefore, choreographic works possess an aura of engaging with dance history and the formation of a dance legacy which contemporary dancers and their singular interpretations seldom do. For example, Alexandra Carter (1998: 53) commented on the difficulty of accessing any writings by dancers 'especially on their experiences of performance', when compiling *The Routledge Dance Studies Reader*. From another perspective, American dance critic, Marcia Siegel (1981: xiv) justified the exclusion of dancers' contributions to the legacy of twentieth-century dance in her publication *Shapes of Change* because, 'choreography must be able to outlast dancers in order for us to have a history'.

The categorisation of dance-making, performing and the growing body of dance discourse within academia foregrounds a fundamentally inherent problem in dance and its relationship to archival knowledge. Diana Taylor (2003: 20) explains that 'archival memory succeeds in separating the source of "knowledge" from the knower – in time and/or space', which contrasts with how 'people participate in the production and reproduction' of the repertoire, by 'being part of the transmission'. Siegel acknowledges this in her prioritisation of tangible, archival facts over the more elusive, *enfleshed* knowing of the repertoire. Dance suffers due to its ephemeral nature; it does not leave a written document behind, but can only enter the archive through video documentation or dance notation. This has a political consequence, according to Taylor (2003: 25), as 'language and writing has come to stand for *meaning itself*'. This means that artists, whose practice is embedded in knowledge outside of linguistic or literary codes, are easily excluded from the discursive arenas that determine broader developments in their field.

Dancers embody a living repertoire of movement but the archive, as text, video or photograph, exists independently of their bodies and is

shaped by and connects with other signifying forces. They are no longer called upon to represent the dance piece once it enters the archive, rendering their material presence insignificant in comparison to the more important artistic or political statements proposed by the choreographer through the choreography. Through Taylor's (2003: 25) definition above, the embodied insights of dancers do not have any 'claims on meaning'. As outlined above, there are few sources to draw from when researching dancers' perspectives on the choreographic process. The limited range of literature indicates that, traditionally, the role has been perceived as creatively passive within the dance-making process. In spite of increasing creative involvement by dancers in the production of choreography and the increasing acknowledgement of this by the field of dance studies, first-person accounts of the creative practice of dancers remains a peripheral area within dance research.

In order to provide some context for the emergence of the independent contemporary dancer of today, the following passages outline how the roles of choreographer and dancer have shifted throughout the twentieth and into the twenty-first century. Although the peripheral positioning of dancers' voices may seem congruent with the status of choreographers as creative minds of the dance work, the primacy of choreographers in dance production is a relatively recent phenomenon. By the early twentieth century in ballet, Lynn Garafola (1989: 195) explains, the choreographer was little more than a ballet master attached to an opera house who 'performed a host of other functions as well – dancing, teaching, coaching, rehearsing and administration'. Dancers performing around the turn of the twentieth century, such as the Russian stars Tamara Karsavina, Vaslav Nijinsky and Anna Pavlova, had enormous fame and box office power. Garafola (1989: 196) situates the emergence of choreographers as artists within Diaghilev's Ballet Russes (1909–29) wherein Mikhail Fokine developed as a freelance choreographer in his own right, considered equal to other independent artists such as composers, painters and poets. Subsequently, other Diaghilev choreographers followed Fokine, leading to the commodification of choreographers and choreographic works. Diaghilev shaped choreographers from his ranks of established star dancers and thus, he integrated the marketable worth of the performer's persona and talent into the creative identity of the dance-maker (Garafola 1989: 198). Garafola (1989: 198) explains that, prior to this development in the role of choreographer, style in ballet was associated with particular methods formed within a training system or school; representing an institutional stamp rather than individual expression. This was altered radically by Nijinsky's *L'Après-midi d'un Faun* and *Le Sacre du Printemps*, whereby the

imagination of the choreographer produced 'the total vision of these works, a vision that determined not only their theme, structure and floor pattern, but also elements such as technique, body posture, and presentation traditionally belonging to a school' (Garafola 1989: 198).

In modern dance, which emerged during the same time period in North America, primarily through Isadora Duncan, Loie Fuller, Ruth St. Denis and Ted Shawn, and in Europe through artists such as Rudolf Laban and Mary Wigman, *dancer-choreographers* were prevalent. Pioneering artists such as Martha Graham and Doris Humphrey formed dance companies through which they performed their choreographies. They developed movement techniques that supported the choreographic works and which reflected the concerns of their own epoch (Brown, Mindlin and Woodford 1997: 44). The subsequent generation produced dancer/choreographers such as Merce Cunningham, Erik Hawkins and Paul Taylor, who also developed idiosyncratic choreographic styles. Many of the training systems aligned to these styles entered the canon of modern dance and still circulate in dance training institutions today. It should be noted that these modern dance companies did not originate through institutional thinking but usually grew around a signature choreographer at the helm. Sally Gardner (2007a) writes of the artisanal nature of early modern dance, which often involved a group of artists who were personally invested in the creation of a new movement style. As companies developed and expanded in size, an inevitable hierarchy was established that in many cases set the choreographer at the apex of a large performing and training institution.

Sally Banes (1993: 10), writing about the Judson era in 1960s New York, explains how one of the significant dance artists of this time, Steve Paxton (1939–), believed that 'the history of modern dance had been tainted by cults of personality, and he searched for ways of stripping any trace of the artist's hand from his own work'.[4] This position follows from Merce Cunningham's destabilisation of authorial intention in his choreography through his use of chance operations in creative decision-making.[5] At the *White Space* Conference at the University of Limerick in 2000, I attended an interview with Paxton on his work as a postmodern dancer/choreographer. He corrected the interviewer by saying that rather than being postmodern, he thought of himself as 'post-Cunningham', attesting to the latter's influence on the Judson artists (and perhaps his discomfort with the postmodern label).

Cunningham was indeed seminal in his influence on dance worldwide, through challenging many of the embedded conventions within modern dance and proposing innovative methods of constructing

choreography. He presented the dance, music, set and lighting as distinct elements that coexisted (at times randomly) within the performance space. Foster (1986: 169) explains that Cunningham freed choreography from the relationship to musical accompaniment and 'expressive subject', which allowed him to explore a range of choreographic possibilities. This included using chance structures to make choreographic choices, thereby subverting his position as author of the work. Dancers in this work cultivate a relationship to embodiment focused on enhancing movement options and embracing changeability rather than developing overt expressive qualities (Huschka 2011: 180). Cunningham's creative experiments significantly influenced future generations of choreographers and were expanded upon through the experimentation of choreographers of the Judson era (Foster 1986) who further *unhooked* the dancing body from canonical dance vocabularies, representation and expressionism, to present 'the body as a thing that senses, moves and responds' (Albright 1997: 20). Banes (1987: 49) describes this as a proposition for dance to move beyond the perfection of technique and expression to become 'the presentation of objects in themselves'.

Experiments in dance in the 1960s in North America influenced and continue to influence many developments worldwide. As a dance curator working in Montréal, Canada in the 1990s, Dena Davida (1992)[6] explained the international reach of these developments:

> Sparked also by intensified intercontinental exchange with American choreographers, a wave of European *new* free dance choreographers challenged the predominance of the classical danse d'école and the weighty tradition of opera house ballet. A 'new dance' movement was soon manifest in France, Britain, and Holland during the seventies; permeated Canada, Belgium, Switzerland, Austria, Spain and Italy and much of Western Europe in the eighties; and currently claims disciples in India, Australia, Scandinavia, Portugal and parts of Central and South America and Eastern Europe; and in the nineties has been carried into parts of Africa and Indonesia.

Also writing from first-hand experience, British choreographer and academic Emilyn Claid (2006) describes the emergence of New Dance in Britain in the 1970s. A collective of dance artists known as X6, named after the warehouse that was their base, emerged at this time. Their work reflected many of the prevalent issues uncovered through the feminist movement and radicalism of the 1970s. X6 contradicted notions

of the pleasing, disciplined female body as exemplified by classical ballet, through a project which involved 're-claiming the realities of mortality and reproduction from the transcendent desires of patriarchal spectatorship' (Claid 2006: 71). During this period, British dance artists re-evaluated codified dance styles and incorporated into dance the perspectives of somatic techniques, such as Body-Mind Centring and the Alexander Technique as well as martial arts forms such as Aikido and Tai Chi. Throughout this time, Release Technique, which was introduced to the UK by North American dancers, in particular Mary Fulkerson, became widely used as an approach that prepared the body for a greater number of movement possibilities.

Through Release Technique, Fulkerson combined her knowledge of anatomy gained through study with Barbara Clark, a student of Mabel Todd (1880–1956) who developed Ideokinesis[7] (Jordan 1992: 52). Jordan explains Fulkerson's use of imagery as a fundamental aspect of Release Technique: 'in release work's anatomical aspect, images are used to structure the manner in which bones balance or articulate in movement: images of lines, bridges and bowl shapes in the body, of paths of action-flow, all designed to release the body into easy efficient alignment and action' (Jordan 1992: 52). Release Technique is still widely used by dancers and dance students today and does not employ a specific movement vocabulary, but rather requires the dancer to employ an attitude of introspection and sensitivity towards the body's physiological structures. It has become an umbrella term, which encapsulates the idiosyncratic training methods that many dancers use to develop their skills and prepare their bodies for dancing.

Diana Theodores (1996: 1–3) describes the mid-1960s to the mid-1980s as a golden age in New York dance, outlining the prolific range of approaches in a widening field, which included 'the chaste and virtuoso metaphysics of Cunningham' and 'the heroic pedestrianism of the Judson Movement' alongside George Balanchine, Paul Taylor, Martha Graham and Twyla Tharp. However, in the 1990s the landscape transformed dramatically, according to New York-based dancer Veronica Dittman (2008), as the modern dance economy broke down due to significant changes in dance funding.[8] Dittman (2008: 23) explains that this impacted on the working practices of choreographers, even those who were very well established, and furthermore altered considerably the employment opportunities for dancers:

> There are barely ten modern dance companies in the city of New York that offer their dancers forty-eight weeks of work with a salary

you can live on and health insurance [...] below that very narrow top tier, dancers are all working for more than one choreographer and/or holding down outside jobs to fill in the gaps financially.

This shift in employment practices underscores the shape of the current climate, in which choreographers continue to develop idiosyncratic ways of moving outside institutional structures. Thus the freelance independent choreographer has become a staple of the dance milieu. Not attached to an institution or school, many choreographers now operate outside a fixed company structure to produce discrete projects for which new casts of performers are assembled and this is a global phenomenon. Contemporary dance projects are often instigated through commissions from companies, performance venues or festivals as well as through funding from public bodies. Choreographers working outside a company system may develop stable working relationships with specific dancers for a number of years. However, as Dittman (2008) charted above, it continues to be necessary for many dancers to seek employment on various projects with different choreographers throughout any given year. As choreographers may only employ dancers for discrete projects for short periods of months or weeks, dancers may work with several choreographers, often simultaneously, throughout their career. Aided by the growth of an infrastructure for dance in Western economies, which took place within schools, festivals, dance spaces/venues, producers and resource agencies, employment as a freelance or 'independent' dancer is now a viable career. This type of dancer nomadically traverses between different creative environments to work with different choreographers. In the UK, for example, major advocacy work has been carried out by organisations such as Dance UK and Independent Dance[9] on behalf of independent dance artists.

A significant development in recent years is the 'dance house', which is often situated in a capital city or major economic centre and provides a central hub of activity for contemporary dance. Due to the support offered through these organisations, dancers and choreographers are likely to situate themselves in proximity to these centres in order to avail of these infrastructures in developing their careers.[10] For example, the European Dance House Network (EDN) draws together twenty-two European dance houses from fifteen countries in projects such as Modul-Dance, which supports the work of emerging dance artists to develop and perform their choreography throughout Europe through residencies and co-productions. Funded through the European Union, this project endeavours to address the challenges that independent

dance artists face outside of institutional environments in creating and producing new work and in developing new audiences for this work (Yamashita 2011). EDN (2013) defines a 'dance house' as publicly mandated, that is, not promoting the work of a specific artist or artists. Rather, these resource organisations are focused on presenting contemporary dance through ongoing programmes, engaging in advocacy for dance, providing rehearsal and performance spaces for professional dance artists, as well as operating outreach and community-based projects. The support for artists through 'dance houses', or similar commissioning bodies, such as funding agencies or festivals, has cemented the project-by-project approach to dance creation, and so increasing numbers of choreographers and dancers outside the major funded companies work on a freelance basis.[11]

Bales and Nettl-Fiol (2008: viii) identify the 'entrepreneurial dancer' as 'a counterpart to the independent choreographer' and explain that this is often a career choice, rather than a necessity, as not all dancers aspire to work with only one or a few choreographers throughout their career. Being established as a freelance dancer means that there are opportunities to work within small cooperative ensembles and across a range of different contexts (Menger 1999: 565). Bales and Nettl-Fiol (2008: viii) describe these smaller ensembles as pick-up companies that 'mobilize around talent'. Larger, more established, companies with a single choreographer at the helm continue to cohabit within the unstable arts environment alongside the smaller groups and often compete for similar funding opportunities and performance slots. Company-based dancers in between longer-term contracts can easily traverse the fluid boundaries of these different professional settings.

Throughout this book I refer to 'contemporary dancers' in a broad sense, which acknowledges contemporary dance as an umbrella description, encapsulating a wide field of operation. When I began researching in this area, I focused on the field of independent dance because dancers within this milieu encounter many different choreographers and processes on an ongoing basis. The purpose was to create a distinction between company-based dancers who may work within a more stable creative environment under one particular choreographer. However, in recent years, these distinctions have become blurred as many choreographers utilise different methodologies for each creative work, so that a successful career in contemporary dance generally denotes mobility and versatility. Indeed, increasingly, mainstream choreographers cast for the lifetime of a production rather than maintaining a full-time company over a number of years, so dancers must embrace a peripatetic

lifestyle and follow where the work opportunities lead. Although each dancer will have an idiosyncratic career trajectory and will redefine the activities of the contemporary dancer according to the experiences they encounter, many of the questions this book raises apply across this broad range of contexts. In spite of the wide range of choreographic approaches and the cultural diversity of contemporary dance, the international nature of networks in this genre makes it feasible to examine the contemporary dancer's career as a particular type of arts practice.

In the endeavour to establish new descriptions of dancing practices that can incorporate the complexity of the current landscape for contemporary dancers, I now trace how some key writers in dance studies theorised the dissolution of canonical modern dance practices in the 1990s, in the understanding that these developments underpin the more diversified and democratic topography of twenty-first century contemporary dance. The impact of the shift in working practices in the 1990s is revealed through various writings of that time. Terms, such as the 'body eclectic' (Davida 1992), 'hybrid bodies' (Louppe 1996) and the 'hired body' (Foster 1992) appear during that period as descriptors of dancers that operate outside of specific codified styles. These texts are located at a point in time when independent or freelance dancers were beginning to be noticed by dance studies, marking the emergence of a type of dancer who is not aligned to one particular choreographer but must embrace versatility as a career path. Davida (1992) explains that these 'new dancers' (a term that she uses to encapsulate the role of both choreographer and dancer) have become 'arts researchers' through developing idiosyncratic movement vocabularies inspired by a range of ideas, emotions, theoretical concepts, images and sensations. Davida (1992) stresses the democratic nature of dance production as a positive development, renewing the autonomy of the spectator, dancer, choreographer and individual art forms. She explains, '[the] pluralism, present at every level of new dance activity, is creating dialogue between previously separate ideas, styles, media and milieu. Boundaries are being crossed and hybrid forms emerging' (Davida 1992).

In contrast, writers such as Laurence Louppe and Susan Foster interrogated what was being lost through the hybridisation of dancing forms at that time. Louppe (1996) explains that more than just a style, a choreographic vocabulary encodes a philosophy that results in a particular postural approach that impacts on body tonus[12] and this takes many years for dancers to incorporate fully. According to Louppe (1996) the superficial mixing of stylistic references, as exemplified in postmodern allusions to a previous style or work within a work, still maintains

distinctions in which the dancer's body is not deeply affected. In contrast, mixing references on a more profound level can be problematic as each movement vocabulary needs attention given to the way it individually shapes the 'dancer's relation to the world' (Louppe 1996: 63). If mixing approaches occurs as a result of circumstances rather than design, for example because of the requirements of earning a living in the case of the freelance dancer, she proposes that this creates a worrying outcome in which the movement can remain superficial and 'mimetic'. She adds that it can be equally problematic if there is an attempt to explore and embody at a deep level the core tenets of numerous codified movement styles, in which case, 'the subject's consciousness becomes fragmented and the references structuring the practice of the body become dispersed' (Louppe 1996: 64).

From a dancer's perspective Rebecca Hilton[13] explains the experiential edges she has encountered within various choreographer's distinctive styles and her enjoyment of these differences: 'I liked diving into this really clear aesthetic, like a boundary. If I do this [movement] I'm in a Stephen Petronio piece and if I do another movement, I'm not.' Claid (2006) wrote about this issue from the perspective of her time as artistic director of the London-based repertory company Extemporary Dance Theatre beginning in 1981,[14] outlining that choreographic styles are distinctive and the boundaries should not be traversed lightly. Her writing describes the complexity of incorporating the work of many different choreographers, each with an idiosyncratic choreographic style, into the company's repertoire. Claid (2006: 137) shares with Louppe a concern for the loss of distinctiveness of choreographic vocabularies as they are merged together in dancing bodies; she writes, 'I had underestimated the *time* it took for bodies to re-learn through somatic attention, despite their willingness to do so [...] embodying a different style for each piece proved exhausting and unfeasible. There was no time to let go, un-do, re-think and allow the body-mind knowledge to do its work.' Claid (2006: 140) describes the resulting general movement style in the company as predictable and lacking in precision, naming it 'middle mush'.

In her article *Dancing Bodies*, Foster (1992) is equally circumspect about the emergence of dancers and dance practices that are not aligned to one specific movement style such as was developed by choreographers of the 'grande modernité' (Louppe 2008: 24). However, Foster's argument differs from that of Louppe and Claid in that it is deeply rooted in training practices and how these shape different 'dancing bodies' rather than the formation of the dancer through working with

specific choreographers.[15] By describing the individual aesthetic and ideas behind each training system and indicating how each produces a particular kind of dancer, Foster demonstrates how dance styles embed cultural values in a similar vein to Louppe's definition of how movement vocabularies define dancers' relationships to the world.

It is clear, as Foster (1992: 482) posits, that because modern dance styles such as Graham, Duncan and Cunningham emerged out of a specific moment in history, which shaped the aesthetic goal of each technique, 'the daily practical participation of a body in any of these disciplines makes of it a body-of-ideas'. Indeed, Ann Cooper Albright (1997: 54) identifies the 'cultural ideologies that are literally incorporated into contemporary dance' and more profoundly, 'the meanings sewn into the neuromusculature of the body'. Equally, Geraldine Morris (2003: 21) explains that when training in classical ballet, dancers become unconsciously inculcated into its specific culture, which affects not only their movements but also shapes their thought processes, so that they become 'balletically constructed individuals'. These views attest to the deep impact of practices incorporated within human subjects and the way in which dancers are constructed as individuals, physiologically and psychologically, through the movement systems with which they engage.[16]

Dancing bodies are formed by the systems they practise. The ballet student becomes *balletic* and the Graham technique student becomes *Graham-like*. Both Louppe and Foster extend this shaping beyond physiology to incorporate the structuring of dancing subjectivities through corporeal practices, although there is a subtle difference in how each presents her case. There is a somewhat reductionist tone in Foster's definition of the dancing body as emerging through engagement with a technique, which assumes a pre-existing body to be shaped in different ways according to each training or choreographic ideology. Louppe (1996: 64), on the other hand, describes the development of a coherent practice by individual dancers in line with the 'aesthetic and philosophical orientations of the great creators' of modern dance, foregrounding this as a dancing practice rather than an abstracted training regime. Therefore, Foster places technical training as removed from creative choreographic practices, while Louppe is highlighting the dancer's exclusive work with a choreographer to develop a choreographic signature.

Foster (1992) discusses dance techniques syncronistically and in abstraction as disciplining forces to train particular types of dancing bodies rather than acknowledging the full range of influences that

shape dancers in training and professional practice – that includes working with one specific choreographer over an extended period of time.[17] Arguably, the separation of the idea of 'technique' from dancing practices as something disconnected from creative choreographic work has led to the appropriation of training regimes by institutions that may utilise modern dance techniques as amalgamated training styles even though they may have different (if not conflicting) aesthetic goals, ideal bodies and political values.[18] Claid (2006) identifies the problems that emerge from the use of multiple movement techniques as a means of training the body rather than embedding the deeper philosophies of the styles they reference. She expresses apprehension that without the clarity of an in-depth understanding of the body, which the acquisition of advanced skill in a specific dance technique imparts, homogeneity ensues. She writes, 'there are so many performance and body-mind techniques available that the dilemma facing contemporary dance is not the elitism of a particular system, but the mixture and merging of many' (Claid 2006: 140).

The immersion in a specific training approach can cultivate in-depth skills that give dancers the opportunity to differentiate between different choreographic languages. Claid (2006: 140–3) affirms that 'letting go into the experience of something new requires the lived knowledge and constant re-embodying of the thing we wish to release [...] that is why Pina Bausch's dancers return to the ballet barre day after day' and she bemoans the loss of depth in favour of breadth in the use of various dance styles within institutional British contemporary dance training, seeing this as the 'negative flipside of the [X6] legacy' which sought to neutralise the more extreme elements within codified dance techniques. However, recent publications such as *The Body Eclectic* by Bales and Nettl-Fiol (2008) have addressed how the requirement for dancers to be versatile has spawned increasingly eclectic approaches to training. Bales and Nettl-Fiol (2008) name this eclecticism *bricolage*, a term drawn from Elizabeth Dempster (1995) which she used to describe the development of the postmodern dancing body. *Bricolage* describes how training has become increasingly diversified and autonomous for the trainee dancer in response to changes in dancing practices. This diversification avoids the restriction caused by an overemphasis on one movement aesthetic to the exclusion of others, while arguably allowing dancers to develop skills in line with idiosyncratic movement preferences – to develop individual ways of moving.

Although training is an important factor in the development of dancers' identities it is not the primary focus of this book. I am drawing

on Foster, in spite of the slippage between technical training and choreographic practice in her article, in order to outline the less easily classifiable nature of independent dance and to signal the deeper issue of identity formation for independent dancers. Foster (1992: 494) identified this unclassifiable dancer as a 'hired body', whose origins she locates in the experimentation of the Judson Dance Theatre in the 1960s in New York. This 'new cadre' emerged following the Judson period of artistic exploration because, rather than developing individual dance techniques to sustain their choreographic work, choreographers encouraged their dancers to diversify in training through utilising existing techniques without incorporating one specific aesthetic vision (Foster 1992: 493). She states, 'I know the body only through its response to the methods and techniques used to cultivate it' (Foster 1992: 480). As pointed out by Bales (2008), Foster is somewhat dismissive in her definitions of dancers who are not aligned to a specific dance style with a codified vocabulary. Bales (2008: 34) writes, 'I do get the distinct message that Foster is uncomfortable with or not particularly interested in dance that is not *either* fully codified in its technical training *or* fully spontaneous, improvised movement.'

The loss of choreographic distinctiveness is a legitimate concern and it is echoed by Emily Coates (2010: 4) as she describes how the recent deaths of choreographic giants Merce Cunningham and Pina Bausch, 'signal the beginning of the end of two of the last great single-choreographer companies' and thus, the opportunity for developing dancers as true proponents of a specific style over many years. As these prominent choreographers of the 'grande modernité' are no more, distinctive movement signatures that have been developed and refined over many years are less and less prevalent (Louppe 2008). Foster's (1992: 494–5) hired body merges the individuality of different dance approaches, and she describes it as 'a purely physical object, [which] can be made over into whatever look one desires'. She posits that it 'does not display its skills as a collage of discrete styles but, rather, homogenizes all styles and vocabularies beneath a sleek impenetrable surface', forming dancers who lack the aesthetic principles to develop a distinctive performative self (Foster 1992: 494–5); in this view, the dancer's body is written upon over and over by different choreographic styles, unravelling the deep self under this strain. As the dancer's previous function, which was to perfect and perform a specific choreographic style and become expressive in that form, changes to incorporate multiple inscriptions, she claims that this new dancing body 'threatens to obscure the opportunity, opened to us over this century, to apprehend

the body as multiple, protean and capable, literally, of being made into many different expressive bodies' (Foster 1992: 495).

So, in the understanding that certain dancing practices construct particular dancing bodies, how is the contemporary dancer constructed when she/he embodies many different movement vocabularies and not only one? Although it could be assumed that these dancers adopt no philosophical stance because they are not aligned exclusively to any particular movement vocabulary, on the contrary, the divergence from canonical techniques emerged from the will to explore and express *originary* ways of moving (Foster 2005). Foster (2005: 113) uses this term 'originary' in a more recent article on Rosemary Butcher's work to describe how Judson choreographer Elaine Summers (US), who was trained in Graham, Limon and Cunningham technique, questioned 'the process of training through which one's own body becomes imprinted with others' aesthetic visions', resulting in a sense of living with an alien body image and energy pattern. Foster (2005: 114) outlines Summers' influence on Butcher's development explaining that Summers 'focused attention on body's weight and economy of emotion rather than its shape' and through developing awareness of these elements, Butcher slowly discarded movement habits that she had acquired through training in Graham technique and ballet.

In spite of the implications of the term 'originary' I am not proposing that there is a truer, more natural body that exists before the acquisition of dance training in any particular style. Indeed, as Marcel Mauss (1992: 461) explains, there is no '"natural way" [of moving] for the adult'. Throughout a lifetime, motor patterns, which are influenced by social, physical and psychological strata, are appropriated and embedded by the individual through social processes. The cultural traits that produce particular walks, for example, or the recognition of a gender-specific hand position as indicated in Mauss' essay, indicate that, prior to any appropriation of a new dance form, bodies are already shaped or marked by an embodied history. Grosz (1994: 142) affirms that movement patterns shape embodiment, stating that a body is 'marked by its disciplinary history, by its habitual patterns of movement, by the corporeal commitments it has undertaken in day-to-day life', thus she reiterates the impossibility of a pre-cultural, a-historical body. There may be useful explorations that allow dancers to reclaim an individualised sense of embodiment from the colonising forces of dance training, as outlined in the description of Butcher's experience, but this could be characterised less as an originary state of movement than the development of an autonomous movement approach.

The dancer in the twenty-first century is *unhooked* from the canon of dance techniques to follow idiosyncratic choreographic movement and can take on a multitude of shapes and forms. According to Louppe (1996: 64), 'the hybrid is nowhere, is nothing' and it is easy to see how dancers operating outside a clear disciplinary history are regarded as lacking the proper markings of a movement signature. Moving freely between forms in a somewhat promiscuous manner, thus not 'belonging' to a particular movement style or choreographer, means that points of reference are no longer evident. The argument that we are unable to know the dancing body when it does not display a clear disciplinary history runs parallel to Claid's (2006: 120) description of how female dancers became 'unmarked' when they presented alternative expressions of female subjectivity through New Dance by jettisoning virtuosity and seduction – the conventional markings of dance performance. She explains that in the development of New Dance, as female performers abandoned the fetishised, muscular, linearly codified movement languages that displayed virtuosity and the essence of the female as a projection rather than the reality of the female body, they simultaneously became invisible to the audience's gaze (Claid 2006).[19]

If a dancing subject is constructed through a choreographic aesthetic and philosophy of the body, how might the independent dancer of today reflect the post-structural approach to self-hood as multiple and contextually driven? As we discuss contemporary dancers who are not aligned to one particular recognisable canonical technique, there are fewer external markers to define them. Do dancers transform their movement from piece to piece, or do they display a recognisable homogeneity in approach which Claid (2006) suggests and is concerned about? The transformation from student dancer to competent Graham dancer is traceable, the shift from student to professional dancer who may engage in a different choreographic style in each project may be less so; they may just look like themselves. Yet, in this space there are new possibilities for defining how dancing subjects might be produced through choreographic practices and shape subtle movement distinctions beyond the codified signification of established dance styles.

This book proposes that independent dancers embody multiplicity and manifest this through embodied action. Thus, they indicate in an extreme sense the potential to display 'many different expressive bodies' (Foster 1992: 495). Locating dancers as individual sites of knowledge and experience dramatically challenges the notion that they must be either aligned clearly to one choreographic approach or be unknowable, unmarked and thus, nowhere. Descriptions of dancing bodies are

fundamentally problematic when they separate a dancer in time and space from the choreography through which she/he becomes this body. If the self is understood to be contextually triggered, then how can we discuss a dancer outside the actual movement context with which he/ she is engaged? Equally, as Burt (2004) suggests, there are implications for describing choreographies without acknowledging the particular dancers who embody them. For this reason, the explorations in this book are located in real-life creative processes to reflect the 'instantiated' and contextual nature of human embodiment (Hayles 1999). At the centre of this book is a fluid, dancing embodiment, a body-in-flux (or as-flux), that is subject to change through encounter with the other, rather than an abstracted object-body. The first-person perspective of embodiment experiences the body non-dualistically as pure process with no distinction between physiology and psychology. Dance writers, such as Glenna Batson (2008: 138) have explored how this perspective challenges the Cartesian body, which she describes as 'a concrete substance with sharply distinguished boundaries between mind and body, inner and outer reality, that is mechanical, predictable, reducible' – to present instead a dancing body-as-process.

In order to address the issues outlined in this book I had to construct a *ground* from which to speak. This is because there is limited analysis of the choreographic process by practising contemporary dancers written from the first-person position. As outlined in this chapter, contemporary dancers are defined, not through a specific style of movement, but rather through the engagement with many different choreographic approaches. I have settled upon the term 'moving identity', a metaphorical concept, to identify the dancing self and as a way of tracking consistencies when dancing across movement styles. This describes the dancer in action rather than the pedestrian everyday experience of embodiment, although even pedestrian characteristics might be called into play in certain dancing events. In order to unpack the moving identity, I adopt a range of philosophical theories of embodiment throughout the book. As the dancer's field of operation involves various experiential layers – from the deep-rooted feedback provided by the central nervous system, to the outer stratum where the dancing body's intersection with culture and society produces a social identity – it spans a range of disciplines. Rather than being drawn from one cohesive philosophy, the insights that emerge from the dancer's embodied viewpoint land on different branches of theoretical and philosophical epistemologies. Weaving these insights together into a cohesive framework, I amalgamate fragments from different perspectives in order to

reflect back the dancing body-in-flux. This post-positivist viewpoint acknowledges the possibility of multiple perspectives producing *many* rather than *one singular* truth, prioritising the first-person perception of embodiment to reveal how dancing practices intersect with other fields such as somatics, phenomenology, philosophy and gender studies. Thus, my dancing practice in action becomes the *shifting* ground from which to speak.

The book charts a dancing subject moving through distinct creative processes, who is simultaneously being produced as a subject by these environments. The four choreographic processes at the centre of this book are each examined through the lens of dancing and connected to key themes that emerge from praxis. At the core of this enquiry is the sense that the contemporary dancer embodies multiplicity through an almost (but not quite) schizophrenic ability to be inhabited by multiple selves, concepts, movement signatures and creative strategies, and to be open and willing to employ these or jettison them in the next, new creative environment; thus letting go of the stability of a 'molar'[20] identity and becoming a self-in-flux. Through an engagement with theorists such as Gilles Deleuze and Félix Guattari, particularly in how they intersect with feminist philosophers such as Rosi Braidotti and Elizabeth Grosz who draw on materialist views of embodiment, I use a concept of multiplicity that describes entities that stabilise for a period of time in certain configurations or relationships, but are always in flux. Qualitative multiplicities are poetic and virtual (Massumi 1987) and in relation to the contemporary dancer, could describe the disparate practices that are embodied (often simultaneously) and are called into effect through specific choreographic environments. The construction of self-hood is of prime importance when outlining the impact that dancing across various contexts may have on dancers and the Deleuzean model of multiplicity creates a foundation from which to discourse with other dancers' experience of self-hood as dialogical, porous and multiple.

My writing is framed through non-dualistic accounts of subjectivity that are grounded in phenomenological precepts as articulated through Maurice Merleau-Ponty's (2002: 106) placement of the body as 'the horizon latent in all our experience and itself ever-present and anterior to every determining thought'. Grosz and Braidotti have introduced new perspectives on human subjectivity that account for its material embodiment. For example, writing from a position that could be described as *the materialist school of the flesh*, Braidotti (in Dolphijn and Van der Tuin 2011: 33) presents ways in which subjectivity can be interrogated through corporeal rather than conscious frameworks

and locates embodied knowledge through a feminist interpretation of philosophy and non-dualistic accounts of subjectivity defining this as 'corporeal materiality'.

In the next section, there is a brief contextualisation of the four choreographers and my working relationship with each followed by an in-depth articulation of these processes carried through from Chapters 2–5. Each of these chapters draws outwards from a studio process with one of the choreographers to engage with broader themes that are of relevance to dancing practices, such as moments when dancers exercise creative agency in the choreographic process or how to uncover dancers' labour in dance-making. Issues such as authorship of the choreographic work are addressed in relation to the emergence of the signature choreographer in recent years, a phenomenon which has arisen through the influence of capitalist modes of production on choreographic practices. Dancers' psychophysical engagement with choreography is examined through focusing on body–mind synergies in creative work and through identifying the ways in which dancers can build or break habitual movement patterns. The status of dancers within the social stratum is interrogated also, through measuring the implications of their responsive, facilitative role, which can be undervalued within current contemporary arts practice. Following the explications of the solo processes, Chapter 6 synthesises the insights from these experiences to address the notion of a moving identity and how it is shaped throughout a dancing life. Chapter 7 addresses the aftermath of the performances by exploring how dancing traces linger and can be carried forward by choreographers and dancers into subsequent creative processes. This examination of ensuing performances and adaptations of the ideas from the solos by the four choreographers frames how dancers leave traces in a work or body of works. I end this concluding chapter by drawing together the many strands explored in the book. This conclusion encompasses the multiple and complex nature of moving identities and outlines the potential for creativity, agency and autonomy available to dancers in this current epoch.

Background to *Solo³*

> I have nothing to offer except to be acted upon. My speaking destroys the world. It takes up more space, creates more waste. Yet, how can I be expected to absorb without giving something back to the silence?
>
> (Process note book)

The following chapters explore dancing from a dancer's point of view in four choreographic processes. The three completed solos by Jasperse, Melnick and Liz Roche that resulted from this exchange were co-produced by the Dublin Dance Festival (DDF) 2008 and performed together over two nights as a full evening of work.[21] Although Butcher and I did not bring our solo work to completion, the encounter with her underscored much of my thinking when engaged in the development and analysis of the other works. The texts present a snapshot of the working practices I engaged with and the different approaches that each choreographer used to develop ideas within the context of these particular solos. I chose to commission these artists because of my interest in revealing what I felt was distinctive about each choreographer's approach to contemporary dance-making and the subsequent relationship to dancers. I had danced with each of these choreographers prior to this project in various settings and the seeds for undertaking the exploration were planted in these initial experiences.

I met Rosemary Butcher during a workshop that she facilitated at the University of Limerick in 2001 while I was completing my Master's degree. At that time she asked me to dance in a project with her but the opportunity to work together did not arise until she was engaged by the International Dance Festival, Ireland in 2004 to mentor a piece by Liz Roche, in which I danced. From that contact, the company that Roche and I co-directed, Rex Levitates, commissioned Butcher to make *Six Frames: Memories of Two Women* in 2005. In spite of the broad span of her career, Butcher continues to create radical contemporary dance works which reference dance and visual arts lineages to highlight the complexity of the body in motion. She has been a seminal figure in the development of New Dance in Britain and continues to influence generations of dancers and choreographers but more than this, according to Sayers (2011: 88), 'her work has contributed more generally to the expansion of our ways of siting and seeing dance'. Butcher was deeply influenced by her time in New York in the early 1970s, during which period she encountered the work of the Judson group and a range of artists including Merce Cunningham, Lucinda Childs, Trisha Brown, Meredith Monk and Robert Wilson (Butcher 2005). Less interested in the formal aesthetics of dance, she introduced ideas from the New York postmodern dance scene to British audiences throughout the New Dance era and continues to maintain this rigorous enquiry in her 'hypnotic minimalist pieces, striking cross art-form collaborations and haunting film works' (Bramley 2005: 11).[22] Butcher (Butcher and

Melrose 2005: 198) outlined the impact of postmodern dance on her development as a choreographer:

> I'd realised that dance could be absolutely *anything* [...] most of the work that interested me wasn't something that I could re-do in dance. What it was about was the experience of a moment, or seeing someone experiencing a moment, enabled by someone else [...] what kept drawing me back wasn't knowledge or technique, it was philosophical.

Butcher's work can be sparse for the viewer. Sayers (2011: 88) describes it as 'conceptualism and use of deliberate monotony', which nonetheless continues to find enthusiastically responsive audiences. The work can be incredibly rich for dancers as she inspires the development of deeply reflective performance states.

I first danced for Jasperse when he was commissioned to make a full-length ensemble work entitled *Missed Fit* by Irish Modern Dance Theatre in 2002 prior to beginning this project and I had been excited by the clarity of his movement language and the quirky nature of his stage design ideas. In his early years as a dancer, alongside performing with Lisa Kraus and Dancers, Jennifer Monson and Anne Teresa de Keersmaeker's company, Rosas, Jasperse began choreographing group pieces, subsequently forming John Jasperse Company in 2009 (Morgenroth 2004). His award-winning choreographic work[23] has been performed in festivals and venues in the US, Brazil, Israel and Japan and throughout Europe. Morgenroth (2004: 187) explains, 'Jasperse's work is often spoken of in oppositional pairs: violent and tender, awkward and precise, classical and vulgar', while Claudio La Rocco (2011)[24] refers to Jasperse as having 'a keen eye for detail and composition; the subtle internal logic of his choreography tends to drive both sense and sensibility in his dances'. He explains how he works through both a conceptual and intuitive process in the studio with the dancers present responding to a degree of serendipity as the work unfolds.

> I don't usually go into the studio alone and make dance phrases and then teach them. I make the material mostly when the dancers are there. Often the material is created from some preconceived structure that guides the physical choices [...] at other times making phrases is more intuitive, where I feel like trying a certain movement and I trust the feeling without knowing why [...] often I find that a coherence

emerges that is not guided solely by intellect, and I am increasingly interested in this.

My first working experience with Jodi Melnick was also on the MA in Dance Performance at the University of Limerick. Melnick created an ensemble piece as part of a larger work by Yoshiko Chuma entitled *Ten Thousand Steps* (2001) in association with Daghdha Dance Company, Limerick. At that time, I was inspired by her complex and fluid movement style and her engaging technique classes, which never failed to direct the body into a visceral dancing sensibility. After this encounter, I made three new works with Melnick, *Fish and Map* (2003), *Wanderlust Kentucky* (2004) and *Suedehead* (2008).[25] Melnick is an award-winning performer[26] who was a featured dancer with Twyla Tharp in the early 1990s. She has danced with a range of freelance choreographers, most notably, Susan Rethorst, Sara Rudner, Vicky Schick and Jonathon Kinzel, and in 2005 worked with Donna Uchizono on a trio in which she performed with Mikhail Baryshnikov. In 2002, she began working with Trisha Brown as assistant director on the creation and staging of two operas and in 2012, Brown created a solo on Melnick, entitled *One of Sixty-Five Thousand Gestures*. Boynton (2013) describes Melnick's dancing as having 'a Trisha Brown-like quality detectable in the freedom and nimbleness of her explorations of the space around her', and Kourlas, in the *New York Times*[27] writes, 'somewhere deep in the bones of this choreographer and dancer lies a laudable power to take ordinary gestures and give them opulence'. Melnick's choreographic work has been presented in various venues in New York and further afield.[28] She explains, 'my choreography is grounded in an ongoing interest in the body. My investigation is of nuance and gesture, and the emotion and drama inherent in the physical form [...] the dance emerges out of this process, not from a pre-determined notion [...] the experience of performing is crucial to the work'.[29]

As sisters, Roche and I had performed together at different stages of our professional careers. Our relationship as choreographer and dancer began when we started Rex Levitates Dance Company together in 1999. The company was founded to produce Roche's choreographic works in which I performed, while we shared the production, programming and artistic direction. Working together intensively over eight years, we produced a number of pieces and toured internationally.[30] Despite our shared origins, Roche had a different career trajectory to mine. Having trained at London Contemporary Dance School, she subsequently worked on a number of projects with Christina Gaigg in Vienna

and was a dancer and associate choreographer with Cois Céim Dance Theatre in Dublin. In her early years as a dancer, she performed in the reconstruction of French choreographer Dominique Bagouet's *Déserts d'Amour* and *Jours Etranges* by Les Carnets Bagouet for Dance Theatre of Ireland. Continuing a connection made with ex-Bagouet dancers Fabrice Ramalingum and Hélène Cathala (Compagnie La Camionetta, Montpellier) into further projects, Roche's choreographic language seems to have incorporated the Bagouet lineage and further influences from Ramalingum and Cathala's experiences dancing with Trisha Brown.[31] Roche began choreographing from her early twenties alongside her work as a dancer and her choreographies have been performed by her own company and through commissions in the UK, mainland Europe, the US and China.[32] Her works are non-narrative but are imbued with a theatricality that infers the human condition through her distinctive choreographic language. This references and embellishes a recognisably 'human' range of movement rather than a codified style. Donald Hutera in *The Times* (8 August 2012) described Roche's choreography as 'delicately woven but its threads possess an elusive tensile strength' and Michael Seaver[33] explains that '[the] work communicates at a very private level'. Diana Theodores (2003: 214) describes Roche's work as possessing 'an extraordinary sense of flow' with 'very delicate and very complex relationships between bodies [...] like a constant travelling ecosystem'. Roche explained her interest in making personal connections through her work, 'I would always hope that I could find something that was real for people and that they would maybe see a movement or see an expression or a texture [...] that wouldn't be so far away from them.'[34]

In *Solo³*, positioning his or her work within a wider context instigated by the performer appeared to be a new experience for each choreographer. They each acknowledged the impact of this role-reversal in different ways. For example, Melnick explained, 'there were more restrictions, as we were all here at the same time, sharing her and had to fit into her world and her timing and her availability'.[35] Whereas Liz Roche spoke about how the particular circumstances of the *Solo³* project offered the possibility to approach the process differently to her normal practice as a choreographer, 'to have to engage in something without having to make the whole piece, just to deal with one part of it'.[36] Jasperse was less concerned about this aspect of the creative process, but stated that he found making a solo piece 'tricky [...] I haven't made a solo in a really long time for anybody and the only time that I actually made a solo was for myself.'[37] For each choreographer, there was a

sense of being brought into a working experience through which they had less control of the outcome than usual. Although this gave me a more empowered position as commissioner/project manager/performer, I maintained a dancer's creative role in the work. I achieved this by not imposing any creative imperatives on the outcome of each solo. Within the existing limitations of resources, I gave the choreographers as much creative freedom as possible. My reliance on the choreographers to bring these works to completion over the time span of the research project revealed the complexity of the relationship between dancers and choreographers, which is inherently interdependent. This was clearly demonstrated through the dissolving of the project with Butcher whereby it was not possible to complete the solo work within the commission's time frame due to insufficient resources and scheduling issues.

Gardner (2007a) writes of the involvement between dancer and choreographer within modern dance and the intimacy of this relationship that affects both parties, as it requires the establishment of a physical rapport between specific individuals. Although Rudner[38] highlights the power of the dancer in manifesting choreographic work, she states, 'you have no idea of the power you hold as the dancer, there is no dance without you – you are the dance'; the dance-making process usually carries the dancer along, with the responsibility for the realisation of the work lying with the choreographer. Even more so, in the independent dance milieu, choreographers must operate as entrepreneurial producers who bring together all the different collaborators to create a new piece (Louppe 2010). Rudner[39] offered this as one of the reasons that she left her long-time collaborative relationship with choreographer Twyla Tharp, 'all we had to do was go into the studio and dance. She [Tharp] took on everything else. She raised the money, she took the bookings [...] I had a very strong independent streak. I needed to feel myself a little bit more.'

My role as commissioner, performer and researcher placed me in unusual circumstances and challenged my tendency towards passivity within the choreographic process. One difficult aspect of this particular experience was managing this role outside of a company structure and thus being responsible for overseeing each aspect of the entire project. This position of responsibility conflicted with my tendency to relinquish creative responsibility in rehearsals. For example, I became aware that I do not deem it appropriate to comment on the choreographic work from inside the process unless asked to do so by the choreographer. I became aware of underlying beliefs that I hold, such as, the choreographic space *belongs* to the choreographer because

the choreographer is usually employing the dancer to take part in the process. By reversing these roles, I became aware of my somewhat conventional views about being an obedient dancer rather than a creative collaborator, in spite of the creative contributions I made in each case. As a dancer in this particular situation I realised I did not have a clear sense of how to position myself as a collaborator, how to value and acknowledge my contribution and how to navigate the complexities of the studio encounters in tandem with our personal exchanges.

The projects which took place alongside the development of this book have also fed many of the ideas embedded in the text drawing together an understanding of choreography through the lens of a dancer. Conversations and exchanges between the choreographers and me took place over the research time frame, as I met with each of them in different contexts. I also viewed performances by these four choreographers with other performers, allowing me to experience their choreography from the outside.[40] Indeed, beyond the confines of the *Solo³* experience, deeper shifts in my moving identity may have been taking place throughout the course of the research project. Therefore, while the performance was a significant punctuation mark for the creative process with the choreographers, it was more importantly an opportunity to reveal some of the ongoing experiences I have had while working with each of them. While creating an opportunity to research the creative process with each choreographer, the structure of the DDF performance allowed me to embody each of the three choreographers' style within one evening of work. This highlighted the experience of moving from one choreographic approach to another in a more immediate and heightened setting. During the *Solo³* creative period, I was aware of transformations occurring in my moving identity. This was most acutely felt over the two days preceding the performances when the three solos were almost completed and I had integrated most of the movement information. While observing the rehearsal footage, I could see that my dancing body appeared to be more articulate and capable of displaying detail than in previous documentary footage. I had begun to execute the movements with fluency and there was a definition to my muscularity that showed the shaping by these different works. The choreographic schema of each solo had been digested and was already showing its markings as I became constructed as a dancer for *Solo³*.

2
Descending into Stillness: Rosemary Butcher

> I seem to be unable to feel at the moment, as if it is all
> too overwhelming. I see myself careering through the
> air, in this tight position; the body in extreme tension
> but free falling.
>
> Rehearsals with Butcher, June 2005, London

This chapter draws on my exchange with Rosemary Butcher and gives an account of the creative process for the duet *Six Frames: Memories of Two Women* (*SF*) in 2005, while covering studio research undertaken with Butcher between 2006 and 2008. This chapter has a different structure to the three following chapters. It draws on a fragmented series of interactions with Butcher rather than a contained solo creative process to look more broadly at many of the themes that emerge from an analysis of Butcher's choreographic methodologies and the way that these can be seen to reflect on contemporary dancing practices.

Butcher's work is deeply collaborative with dancers. Rather than prescribing the movement vocabulary from the outset, she will ask dancers to respond to her instruction, improvise on particular themes and lay down choreographic material over time from these research origins. Perhaps this degree of engagement has led Susan Melrose (2005) to question the role of the dancer in Butcher's work specifically regarding Butcher's long-time collaboration with dancer Elena Giannotti. She asks, 'what's in a name? And what remains, when the dancer's name goes under-represented, because it is the choreographer's name which seems to own the work?' (Melrose 2005: 175). Melrose addresses the erasure of dancers in her writing on Giannotti's contribution to the piece *Hidden Voices* (2004). She proposes that Giannotti is not engaged in performing a movement vocabulary, but rather mediating

a series of 'fragile breakings, of unbearable continuity' (Melrose 2005: 175). Despite the minimalist nature of the movement, Giannotti's contribution is mediated by her professional expertise, which Melrose (2005: 176) adds, 'is consistently informed and modulated by her judgement – the most difficult quality to separate out from its effects'. The issue of technical virtuosity does not enter into this description, yet Melrose identifies that other kinds of virtuosity are implied which relate more to the manifestation of Giannotti's skills and professional judgement in performance. Furthermore, through examining Giannotti's presence within the work, Melrose (2005: 176) finds herself 'unable, on this sort of basis to represent Giannotti's own (signature) work by the reductive and objectifying term "the body" – so widely used in recent years in dance writing and in visual arts writing'.

Melrose's identification of Giannotti's signature work contained within the signature of Butcher's choreography is an unusual proposition within the capitalist system of production, which Gardner (2007a: 40) explains 'suggests a subsuming of several arts within a totality controlled and directed from a position outside those arts'. The position of choreographer often is identified with writing, conceptualising, theorising and owning the work, from a position of singularity that can register within theoretical discourses as distinct from the group of dancers who instantiate the work. For example, Gardner (2007a) argues, in modern dance choreographers often danced alongside the group and thus did not easily assert their work as *high art*. Paradoxically, Louppe (2008) explains, just as dance creation became more democratised in the 1980s, the choreographer as a signature auteur emerged in line with the auteur film and theatre director. Choreographers such as Jérôme Bel and Xavier Le Roy have challenged this positioning. For example, in 1999, Bel was commissioned to make a new work and decided that although he would make no content for the piece, he would give the work his signature. His asked Le Roy to construct the work, which Bel subsequently entitled *Xavier Le Roy*. Ploebst (2001: 57) explains the outcome of this exchange,

> Jérôme Bel had already taken up the problem of authorship in works like *Nom donné par l'auteur* or *Jérôme Bel*. The audience now visited a new piece by Bel with the title *Xavier Le Roy*, which in truth is a work of Le Roy's about Bel [...] Le Roy waived his power in the system: as auratic creator and material beneficiary.

This interrogation by Bel[1] and Le Roy of the role of author in dance production highlights the predicament of the dancer within the

construction of choreographic work. The dancer is not authoring the work but may be extremely significant in its construction and yet, as is written above, relinquishes power and benefits within the system of production.[2]

Melrose's examination of Giannotti's expertise cuts through the objectifying description of her as merely 'the body', and the skill Giannotti displays in her ability to exercise a seemingly spontaneous yet well-mediated judgement in performance starts to bring her out of the role of *body under-erasure* into the discursive arena of the work. Or perhaps through the act of noticing and recording Giannotti's contribution, Melrose writes her into existence and makes her body visible to established discourses. Giannotti, who is not trying to represent a character, emotion or theme, is bringing her lived presence to the performance. However, does the acknowledgement of the centrality of dancers both in the creative process and in performance upset the delicate balance of choreographic authorship, forcing us to question the appropriateness of a choreographer's signature writing over the totality of the performance?[3]

Graham McFee (2011: 183) explores choreographic authorship making clear the line between the author/choreographer and the craftsmanship of dancers, saying, 'in typical dances the dancers instantiate the dancework. Thus I have defended the centrality of the *dancer as person* – and hence the dancer's *subjectivity*, in that sense – without seeking to overrate the dancer's role' [emphasis in original]. He states that a dancer cannot be considered to be the artist in choreographic terms because the choreographer can only occupy this position. This is because, even when incorporating a range of creative inputs from dancers, it is the choreographer who has the final say in how the work is presented and performed. McFee (2011: 160) does concede that at times dancers improvise in performance and thus, could be seen to author the work, but he makes the distinction that these events are 'happenings' and once off in nature rather than being re-performable dance works. In the case of improvisatory decision-making by dancers in performance, McFee (2011: 160) categorises this type of performance in the following way: 'any version which takes the improvisation as constrained by reference to the *context* of that improvisation, and which draws on that *context* to resolve the relevant identity questions for the artwork, might readily be thought a case where *more* than just improvisation is required' [emphasis in original]. So, in this instance, Giannotti's work does not challenge the position of choreographer as sole author of the work. Although McFee's argument presents a clear

definition of the choreographer's role, it brings us no closer to accounting for the myriad contributions dancers make in manifesting the choreography. The result is that it is difficult to quantify their labour in the production of the work, simply because it is often unclear what dancers are responsible for.

McFee's (2011) categorisation gives due weight to how the choreographer moulds the dance material into the final dance work, while also creating and modifying the context through which it appears. Although McFee (2011) acknowledges the centrality of dancers and the 'craftsmanship' they bring to the dance work, the lack of knowledge about the way in which this craft unfolds means that the creative process is not fully represented. Thus dancers' labour is not easily counted and their contributions are often reduced to their physical or interpretive attributes. Louppe (2008: 23) writes that in contemporary dance the 'notion of "work" (oeuvre) as confused too readily with spectacle' is overlooked within the culture of consumption of dance productions. She writes that in modern dance, the development of 'a body, a technique and an aesthetic' was central to the choreographer's signature and an ongoing project in which dancers were principally engaged (Louppe 2008: 24). This ongoing work formed a dancer equally as she/he 'constructed the choreographic signature out of her/his own body' (Louppe 2008: 24). McFee's (2011) definition does not recognise the more subtle challenges in assigning labour between choreographer and dancer, particularly in the current epoch, as Louppe notes, where choreographic authorship now has a number of different meanings and modes of operation.

In McFee's (2011) model of choreographic authorship, it is a given that there is a singular author. However, as in the case of Bel and Le Roy, in order to create choreographies outside a hierarchical system, contemporary choreographers have subverted the traditional position of the choreographer as sole originator of the choreographic material and singular author of the work. In Chapter 1, I outlined how influential Cunningham has been in developing choreographic methodologies that displace authorial intent. Similarly Barthes' (1977: 146) concept of the *death of the author* relates to an anti-humanist idea that questions the singularity of the subject (in the classical model) and specifically the author as privileged subject whose work is given meaning through her/his signature upon it; he writes, 'we know now that a text is not a line of words releasing a single "theological" meaning (the "message" of the Author-God) but a multi-dimensional space in which a variety of writings, none of them original, blend and clash'. Many contemporary choreographers continue to be influenced by philosophers such as Barthes

alongside Derrida, Deleuze and Foucault, who each deconstructed the classical notion of a unitary self that is limited by the body to a specific location in time and space.

Jo Butterworth (2004: 54–62) describes the spectrum of choreographic processes as ranging from didactic to democratic and outlines them in the following manner; 'choreographer as expert – dancer as instrument [...] choreographer as author – dancer as interpreter [...] choreographer as pilot – dancer as contributor [...] choreographer as facilitator – dancer as creator [...] choreographer as collaborator – dancer as co-owner'. As Butterworth (2004) explains, in the course of any choreographic process, a number of approaches from across this spectrum may be in use. Thus it can be counterproductive to seek an absolute definition of the choreographic process and the relationship between choreographer and dancer within this shifting terrain. Many choreographers utilise methodological tools such as task-based composition, choreographic scores and dancers' improvisation in performance to challenge the unitary author position. These methodologies vary considerably within a choreographer's body of work or even within a singular work.[4] Davida (1992) describes dancers' bodies as 'the site for mediation between creative idea and gestural response' as she explains how the more 'directive' role of the choreographer has been replaced by 'an interchange of ideas' between choreographer and dancer. In each of the four creative processes in this book, the choreographers used a range of choreographic tools to generate the material for the pieces; the only common thread being that the methodology was designed to fit the intended outcome. A variety of choreographic methodologies arise in response to the intention the choreographer has for the dance, whether this is an image, theme, process exploration or vision of the final outcome as stimulus (Lavender 2009). This flexibility allows choreographers to respond to the unpredictable results of studio explorations and the creative input of dancers rather than pursuing tightly preconfigured plans.

Although these fluid and democratic choreographic processes are currently prevalent, Amanda Card (2006: 10) notes that this may change in time, as she writes, 'choreography, like any field of production, has its historically dominant processes and, for the moment, it is the overtly democratized that has the floor'. Choreographers use various models of attribution to acknowledge the input of the dancers, such as, *with the dancers, devised by the dancers* or *directed by the choreographer in collaboration* with the dancers. In spite of this, Card (2006: 6) acknowledges that 'the cult of the choreographer' prevails. She explains,

Audiences [...] do not always recognise this more democratic model. In defiance of the choreographer's assertions, they often continue to identify a dancer's movement vocabulary with the company or choreographer under which the work is made. Even open claims to a democratic practice are difficult to defend in a society that has never really come to terms with the 'death of the author'. And this despite a more-than-passing acquaintance with the tenets and application of deconstruction, cultural specificity, and a post-structuralist, post-modern sensibility. (Card 2006: 6)

Although an eclectic mix of methodological tools are not new to the dance-making process, some contemporary choreographers utilise them specifically as a means to question representation, subjectivity and authorship and the political implications of these issues. More specifically, the *political ontology* of choreography has been scrutinised by choreographers such as Bel, Le Roy and Charmatz, to name a few (Lepecki 2006).[5] As new waves of choreographers examine performative states and engage in experimental choreographic processes with dancers, systems of control are challenged and there is more scope for the presence of dancers' contributions within the body of the work. Using chance operations, scores and task-led enquiries to subvert the position of choreographer as author, the sense of *transmission* of choreographic style from choreographer to dancer may be less evident, yet I argue that a dancer in this case is still engaging with a schema instigated by and co-located in the composite body of the choreographer. In fact, stylistic continuities are still evident in the work of choreographers who may not demonstrate specific movements but still create a particular style, which is generally considered to be consistent throughout their work.

Rather than externally manipulating the bodies of the dancers who engage with the work, or seeking to represent overarching concepts through his dancers, Charmatz (Ploebst 2001: 178) states, 'the dancers are not part of the project, they are the project itself'. This viewpoint represents a paradigm shift from the role of dancers in the modern dance era in which they were in service to 'a body, a technique and an aesthetic' (Louppe 2008: 24). Indeed, as dancers manifest differently in each choreographic work, in producing different corporeal configurations, choreographic works could be understood as the material traces of the inter-corporeal encounter between the choreographer and dancers.[6] When working with Butcher in the studio, I wrote: 'I don't feel that I am getting a style or a way of moving through a conscious attempt

to fulfil Rosemary's aesthetic. Rather, I feel that I am building a structure on which to hang the form that is already there between us in the room.' This passage alludes to my experience of being part of a working process that seemed to be unfolding in a specific way without the absolute didactic control of the choreographer. New Zealand based choreographer Carol Brown (2014), describes a similar experience of being led by the unfolding parameters of a work. She writes, 'at some point in the process, as a choreographer working with dancers I have to stop talking and speculating and pay attention to the emergent sensations and developing somatic language in the room' (Brown 2014: 19). Anna Pakes (2009) describes the choreographic knowledge which underlies this responsiveness to the emerging shape of the work as intersubjective and personal rather than objectively detached and universal.[7] She explains, 'the kind of knowledge needed in this domain is not a technical understanding of how to manipulate processes, so much as a creative sensitivity to circumstances as they present themselves' (Pakes 2009: 18). Indeed, while Butcher's deep-seated knowledge and skill was apparent throughout the process, in her ability to respond and direct when necessary, the process itself seemed *emergent* from the interaction with circumstances both inside and outside the studio which impacted greatly on the creative process.

As an example of dancers making choices within a choreographic structure, through stimuli laid down in the choreographic score, Butcher describes the performance of *SF*: 'it was clear that these dancers weren't just being filmed, performing a pre-established choreographic script. It was the performers' actual composition, unfolding in time, before the onlooker' (Butcher 2005: 202). As one of the dancers in *SF*, I will outline how her process in creating the work gives an example of unfolding life narratives within a defined spatial-temporal framework. The piece presents two dancers, Liz Roche and I (Figure 2.1), reliving memories from our lives in real time in performance. Butcher was interested in exploring how two people with a shared history might remember the same event differently. The piece dealt with memory and so we engaged in a live sense with our memories, within a structure that Butcher created as the process developed and became solidified into *triggers* written into a score. In performance, with so much information to deal with, we were able to make new choices, while circulating within familiar territory, as both free and restricted agents.

This work was inspired by a photograph which had appeared in *The Independent* (UK) newspaper of two women from Beslan in Ossetia, Russia in 2004 who appeared to be sisters, looking out grief-stricken

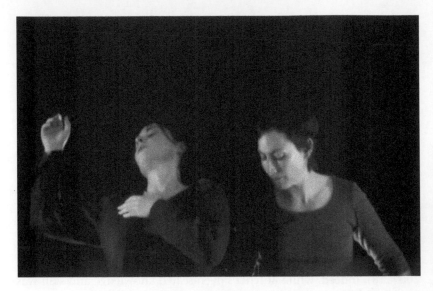

Figure 2.1 Video still of Liz and Jennifer Roche in Rosemary Butcher's *Six Frames: Memories of Two Women* (2005). Courtesy of the choreographer, Rex Levitates Dance Company and Why Not? Associates, London.

from the window of a bus. This was during the tragic hostage taking and murder of 380 people, including 186 children. On the first day in the studio, we watched a video of a memorial concert for the victims of the massacre. Butcher was struck by the look of prolonged stress on the women's faces in the photograph, but once we began the working process, we didn't refer back to this image or the details of the events in Beslan.

Through initial studio explorations, Butcher identified the movement parameters of the piece. She had started the process with a clear sense that we would be standing beside each other and this became limited to standing together in one place, without moving our feet through-out forty-two minutes. During the course of the creative process, we constructed movement scores from responses to tasks she set for us. This started by each choosing three performative states that we moved between to produce three movement outcomes. These movements were slow and formed the foundation for other movement variations. In order to give a broader structure to the piece, some choreographic tasks were stimulated by a series of thirteen paintings by American artist Jasper Johns, which we viewed at an exhibition at the Irish Museum of

Modern Art in Dublin. Each painting was a variation on the same theme and we used the differences between the paintings as stimuli from which to build more detail into the score. The following is an example of my response to one of the paintings:

> The ultimate union of all aspects, not as beautiful as the sub-divisions – yet all is in order and all details are present. Is it falling in or emerging out of? The pale blue of the mother's dress, the flesh has more contours and the clothes are softer – not so inhuman.

The piece was divided into six sections, or frames, of seven minutes each. We formed the individual content for the frame by writing about aspects of Johns' paintings. Butcher instructed us to write down twelve of our own memories, which were evoked by each painting, one example is, 'the photo of me under the sunflowers, now lost', which describes a photo of me as a three year-old under a towering sunflower in a family friend's garden. Butcher then asked us to look at the negative (as in photo-negative) of this memory, that is, to foreground the part that is not initially seen. In this case, the house behind me in the photograph came into prominence. Thus I wrote 'the house', as a trigger for that rich layering of memory and embedded emotion. Butcher treated each of the frames differently, for example, in another frame we looked at the rhythmical structure of the image and created from that perspective. Each different perspective produced twelve triggers. The twelve triggers for the photo-negative frame were:

1. The sea below
2. I see her in her bed
3. The house
4. My own wilderness
5. No one would come towards me
6. My beauty
7. The tragedy
8. The set-up
9. Significance
10. Womanhood
11. The melting
12. My fragments

These words were emotionally charged and triggered associated responses that directed the texture of the movement in a particular way. Thus, we co-constructed a score with Butcher through incorporating meaningful personal experiences within her overall structure, hence the sense of alive-ness and presence that Butcher describes above. The score was kept private and never revealed to the audience or to Butcher in any detail. It gave us a structure to refer to, while also allowing us to respond in the moment of performance to the impulses that arose from

the triggers. Interestingly, Roche and I created contrasting scores as we had interpreted many of Butcher's instructions differently.

In performance, the live work was placed alongside an edited film version of the two of us moving through the entire score, which was synchronised with the live event. The scores were written out on A3 pages and placed on the stage in front of us. Rather than being committed to memory, which may have caused us to amalgamate the different stimuli, we read through the instructions during the piece. Butcher used a recording of 1960s American poet Robert Lax reading his poetry aloud for the soundtrack. This linked the film temporally with our live performance of the written score and we had moments when we had to be in unison with the activity in the film and/or the words as Lax spoke them. The lighting design by Charles Balfour also highlighted each of us in different ways, at different times throughout the piece. The movement was very slow and steady and therefore it was possible to connect to these different structures without breaking the sense of constant slow motion. The result was a very complex structure and series of stimuli, which directed our movement, under a deceptively slow and calm choreographic vocabulary. Butcher (2005: 202) explained, 'they had to read what they had written as notation, not as a memory [...] it had to be as though they were seeing, through the notation, something with which they connected in their childhood'.

This *autopoetic*[8] working process is an example of ways of incorporating the life experiences of the dancers within choreography, while being shaped by the specific circumstances through which the work emerges. The piece seemed to be integrated with the environmental aspects and to be informed by the circumstances around us until it became its own entity. As we created the work, the themes we explored were reflected in life events and equally, external circumstances that occurred over that time shaped the outcome. Butcher seemed to create strategies that were sufficiently loosely configured so that the piece emerged organically in its own right. As a performer, I felt there was no position to take outside the work, as it was utterly absorbing until the performances were completed. However, the clarity and intensity of Butcher's process ensured that the identity of the work was clearly defined. For example, although we did not have a specified movement vocabulary set, it would have been unthinkable to move our legs or engage in more dynamic movements. The content of the piece was formed through the life-experiences of the dancers, but the structure and form was defined and shaped by Butcher.

Another important characteristic of Butcher's approach was her interest in developing movement that would not register as a dance vocabulary. Indeed, Butcher endeavours to reduce the display of the skills of the professional dancers she works with, while using these skills in order to find new expressive movement forms that do not reference more generic and recognisable movement vocabularies (Butcher and Melrose 2005: 153). In her description of *SF*, she says, 'I keep it choreographic, without using a dance vocabulary of any sort', explaining 'it is still quite clear that these are highly trained dancers – from the ability to focus and to intensify minute detail' (Butcher 2005: 202). In the choreographic process, focus is often centred on finding new movement forms to materialise the specific concept of the piece. This requires dancers to become researchers in order to allow creative responses and instinctive choices to emerge in the creation of the choreography in a move away from the familiar, the prescribed and the already known. Deleuze's (2003) description of the creative process in which he tackles the underlying forces that can obstruct the emergence of a new artistic idea illustrates why Butcher might seek to circumvent known and familiar movement within her movement developments. Deleuze explores this specifically in the creative field of painting, yet this has clear parallels with the formation of dances. He writes:

> It is a mistake to think that the painter works on a white surface [...] the painter has many things in his head, or around him or in his studio [...] they are all present in the canvas as so many images, actual or virtual, so that the painter does not have to cover a blank surface but rather would have to empty it out, clear it, clean it. (Deleuze 2003: 7)

Perhaps even more so than painting, choreographers and dancers' bodies are full of potential cliché, habitual movement and generic dance vocabulary. For example, in one studio session, Butcher asked me to work with a different relationship to the floor than would normally be instilled through dance training: '[she] talked about not wanting a dance form to emerge – how this is something other than dance. That dance training prepares the body for a kind of response to the floor – a "pushing into" it to rise up from it'.[9] As Deleuze (2003: 71) argues, 'what we have to define are all these "givens" [*données*] that are on the canvas before the painter's work begins, and determine, among these givens, which are obstacles, which are helps, or even the effects of a preparatory work' [insertion in original].

In as much as choreographers may seek to bypass familiar choreographic methodologies in order to create original movement responses, there are also creative pitfalls that emerge as the work becomes more defined. As choreography habituates towards freezing moments in time, by crystallising inherently fluid moments into formed movements that then take on a static texture, it can be in danger of stilling the fluidity of the movement. When dancers research movement ideas in rehearsals that must then be edited and restructured to form the choreographic schema, these movements can become representational of an original state rather than actually emergent out of this state in the moment that it is finally performed. Claid (2006: 154) describes this as 'full body becoming empty body', explaining that performers can lose the connection to the process which created the material and collapse it into a 'product' that holds the shape but not the meaning of the movement. The structure of *SF* did not allow this to occur. In spite of the clear structure of the score, there was nothing repeatable to rehearse, so in preparation we performed individual sections in the studio after which Butcher gave feedback. There was no difference between our intensity of engagement in these rehearsals and the performance of the work in front of an audience other than the mental focus needed to move through all of the six frames in succession.

This particular approach used by Butcher created fluidity in performance keeping us engaged as performers through interacting with the changeability of the performance environment. In order to achieve this, the choreography had to contain a structure to engage with that did not entrap subjectivity but produced a process of *becoming* each time. The example of Butcher's working process above illustrates how the structure allowed us to engage and re-engage with the work anew and therefore find that aliveness and agency. In this work, the choreography could be seen as 'the fixed terms through which that which becomes passes' and the dancer as ideally, perpetually in a process of *becoming* (Deleuze and Guattari 1987).

The potentiality in performing choreography within an emerging present is described by Erin Manning (2009: 19) as the 'preacceleration' of the movement – 'it is the expression of movement's capacity for invention'. This is the moment when the many possible materialisations of the gesture collapse and stabilise into a specific form. This resonates with Francisco Varela's (1992) outlining of the interactivity of the subject with the world in an unfolding present that is also shaped by the subject. In light of the plethora of possibilities that are available through the many 'subprocesses in every cognitive act', Varela (1992: 325)

questions 'how are we to understand the very moment of being there, when something concrete and specific appears?' This emergent property is when one of numerous processes, for example those that operate in human cognition, takes prominence and shapes an outcome in the concrete world.

Through his theory of enaction, Varela (1992: 331) proposes, 'perception is not simply embedded in, and constrained by, the surrounding world; it also contributes to the *enactment* of this surrounding world'. Thus he describes how events are emergent out of the interrelationship between subjects and the world. Thus, reality is not formed in a pre-given sense, but is dependent on how it is perceived. Rather than being constructed by the perceiver, it is 'perceiver dependent, not because the perceiver "constructs" it at whim, but because what counts as a relevant world is inseparable from the structure of the perceiver' (Varela 1992: 330). The influence of the perceiver is manifested through action in her/his immediate environment and thus the changes that result from this action shape the environment.

Varela (1992: 330–2) concludes that it is the way in which 'the perceiver is *embodied*' that shapes experience and this speaks to the depth of impact somatic sensibility can have on the perceiver's relationship to shaping their experience of 'the fine structure of the present'. He explains, 'the reference point for understanding perception is no longer a pregiven, perceiver-independent world, but rather the sensorimotor structure of the cognitive agent, the way in which the nervous system links sensory and motor surfaces' (1992: 330–2). This awareness of the possibility to cognitively co-create the present seems to be fundamental to enabling dancers to maintain fluidity of subject-hood in performance. It is how one engages with the present moment that can allow a freshness of experience and sense of agency to be brought forth. Although it is easier to imagine how a score like the one composed by Butcher could create this interactive space, rather than more structured choreographic dance movement, it is clear that certain choreographers and dancers specifically focus on maintaining this experience of inter-activity with the present moment in performance.

The dancer's subjective presence in choreography is brought to attention by Kirsi Monni (2008: 41), when she highlights the shift in the role of the dancer, in parallel with the breakdown of 'Cartesian meta-physics'. She states that once choreography moves away from representation, the presence of the dancer's lived body has the potential to reveal underlying processes of 'being-in-the-world' (2008: 41). The dancer's body begins to be perceived as more than just an objectified

tool or 'as material for representation of supra-sensible themes or ideas' within the choreographic process, 'but it is also understood that an individual's perceptive action and conscious movement in itself is a unique way of thinking and therefore possesses a power for disclosure of reality' (2008: 41).

In the following discussion, I outline a further choreographic process undertaken with Butcher as part of this research. This piece was not completed as part of this series of works in *Solo³* but, nonetheless, the process produced many insights that contributed to the themes in this book. The material from this research is still somewhat fragmented, yet it holds many rich insights despite remaining in a space of exploration and discovery without having become solidified into a finished work. When working towards creating a solo piece for DDF, we adopted a similar working method to *SF* of building an improvisational score that developed into a well-defined movement vocabulary. Butcher intended to create a work that could be filmed and then projected onto a horizontal screen at the same time as my live performance of the material, thus simultaneously presenting a recording and a live version of the same movement score. The conceptual starting point for this work was the idea of freefall through the air. Butcher wanted to create some of the movement from the activity of managing a parachute, though not in a literal way, but rather for the movement to be somewhat functional and to have the same kind of intention as the enactment of a martial art. Before entering the studio, Butcher had set up the physical parameters for the exploration which involved my movement taking place on the floor. On the first day she discussed this decision saying that she was entering the process 'with the sense of the idea rather than knowing about the shape of the movement', stating 'I just, in a way, deal with the present'.[10]

As discussed earlier, Butcher wanted to avoid using a way of moving on the floor instilled through dance training. In this initial research phase, we found a number of body positions on the ground that evoked a sense of freefalling. Butcher introduced various words from which I was to create a movement code and my task was to be highly physically coherent in the enactment of this code. The words or phrases were: *moving out; eliminating; burning; throwing away; breaking; taking down; unfastening; un-nailing; unplugging; dismantling; folding up; cutting off.* Once I had worked with these words and identified corresponding movements, she asked me to pick five of the movements and put them together into a sequence that ran for fifteen movements. I noted that the movement had to 'maintain its neutrality and sense of operation'.

Butcher and I worked together again for one week in November 2006, during which time we explored expanding these initial positions, through infusing them with layers of instructions and information. I created a written score for each shape by notating my responses to a series of photographs she showed me from a book she was working with. These photographs were situated on opposite pages to each other and I wrote lists of words in two columns, with each column representing my responses to the photograph on a page.

Directed	Hard
Detailed	Blurred
Advanced	Distorted
Calm	Overwhelming
Solid	Elusive

Following this, I created a movement response to each pair of words. For example, I began with the image of *directed* and then changed energy to embody the image of *hard*. I tried to embody both instructions at virtually the same time. This created a sense of internal duality through splitting my movement intention. Butcher's method created minimalist and detailed movements, with imperceptible shifts happening at times. We created a movement score that was not just written in my notebook, but was physically materialised through its relationship to the series of meaningful associations. As the performer, I created my own internal code and language that linked these different movements together, I noted: 'It was a process of memory and recall; connecting meaning with movement.'

Having written out the score, my task was to run the sequence together so that the movements became physically incorporated. As I learned and subsequently embodied the score, my absorption in remembering the sequence, sensations and words anchored my physical activity and my preoccupation with this task was an important element in the performative quality of the emerging work. It was not problematic if I momentarily forgot the order of the movements. I had learned in *SF* that consciously trying to achieve the layers of tasks that Butcher set was more important than achieving these tasks. As long as I remained engaged with the task, this seemed to create the embodied state that Butcher was seeking.

Following this stage of the working process, Butcher and I both applied to separate funding bodies for the finances to create the film. With the added costs of making a film, this solo idea required a higher

budget than I had already secured for the solo performances from DDF. Unfortunately, we were both unsuccessful in our applications and subsequently, the future of the work became uncertain. Butcher agreed to continue the working process in the lead up to the DDF performances but with reservations, as by the time that we began working together again in January 2008, eighteen months had passed and her original idea had changed considerably. At this stage, she wanted to move on from the flying idea to explore a type of evolutionary process. She was interested in exploring the way in which form changes and develops through evolution by losing some attributes while gaining others. In order to pick up the traces of the original process, we started from the falling shapes outlined above. Butcher used images such as *folding* and *cutting* to evoke responses and again, I wrote my responses to diagrams in a book, which she showed me, this time by evolutionary theorist and scientist, Richard Dawkins (2004). These diagrams showed species' forms shifting through different stages of evolution. I transferred these into movements as before.

Butcher created a working atmosphere that seemed to overwhelm me, through giving many movement tasks on top of each other. She also played recordings of music throughout the rehearsal as a soundtrack that often seemed conflicting with the task at hand and which had the effect of splitting my attention. Her choreographic instructions were abstract and image-based, so it was often difficult to follow these rationally. My conscious mind became overloaded and at times, the rehearsal process itself seemed like an improvisation. I understood Butcher's instructions at various levels, both consciously and unconsciously. Sometimes these instructions did not make sense to me, but still inspired creative responses without much conscious intervention on my part. Butcher gave feedback on the movement that I produced, identifying moments that resonated with her concept for the piece. She spoke a lot within the sessions, overlaying instruction with image-based stimuli. When reading my journal passages on her work, my language seems stilted and I write about 'feeling empty' and 'numb'. I also write at times of being very inspired and excited about being able to access deep insights through the work, 'I find that I am thinking about my own life, as if this process is pushing me into a deeper connection with myself.'

Butcher's methodology seemed to be aimed at bypassing conscious configuring in order to tap into creative undercurrents connected to the themes of the work. As mentioned earlier, I wrote in my journal that I felt as if I was building a choreographic score on which to hang the

form that was already unconsciously present between us in the studio, thus revealing my perception of the emergent nature of the process from the inside. This process of emergence also evokes what Gardner (2007a: 37) describes as the 'intercorporeal/intersubjective relationships' in the dance-making process, as we were both forming the piece but were also the *material* that shaped the work. This process made me aware of how the dancer and choreographer form a matrix of connections, both physical and conceptual, out of which the structure of the piece emerges. Through building layers of meaning and association, we created a particular universe that had a specific logic. I experienced this very acutely in *SF*, where it would have been unimaginable to move outside of a defined range of movement. Butcher created a movement form through overlaying a set of rules that I subsequently internalised. As the dancer in this process, I felt that my life script was intrinsically linked to the movement research. However, this did not mean that I felt 'centred' in the work. In fact, the experience was of being *acted upon* as if I was being constructed through Butcher's language. Yet, this language resonated deeply with embodied layers of memory, emotion and psychological phenomena.

Butcher's continuous layering of one task on another triggered unconscious states from which many deep associations emerged. One particular sequence resulted from the task of transcribing an earlier movement section from facing downwards to facing upwards. In this position, I had to remember the original impetus for each movement and its place in sequence while also converting this onto a completely different body position and with a different range of movement available to me. The movement had a functional quality in this section, as I was balancing. Even small movements were significant because subtle shifts altered the shape and weight placement of my whole body. The head was dropped back and lost its hierarchical verticality. The position required me to surrender control and subsequently, person-hood. The upwards-facing movement evoked the evolutionary theme of the beginning of animal life on dry land. The strain embedded in the movement seemed to reference the trajectory from the containment of the sea into encountering gravity to support the weight of a body. It seemed that without seeking to represent these ideas, the movement began to take on the characteristics that Butcher intended.

Ultimately, we decided that it was not possible to complete the solo within the given time frame and budget for the DDF performance. Although this was challenging at the time it became clearer gradually how the extended period of studio work with Butcher had influenced

my understanding of my creative strategies as a dancer. The work with Butcher made me aware of the process of connecting meaning into movement in a way that became lodged in my cells. At one point in the studio, Butcher said that the piece was about coming to terms with oneself. I resonated with this personally and noticed a sense of coming into my body and accepting the materiality and its potential for decay as the creative process became interwoven with my everyday life.

Butcher was capable of weaving many threads of meaning into her creative process in a way that deeply affected me as a dancer and uncovered many layers of personal experience and insight. In this shared, intimate space there were possibilities to explore deep associations and to imbue movement material with significance. I noted, 'we talk about duality – how my movements are so small in response to these words that can trigger huge sensations. Because we limit the reaction in the body, perhaps the states of being remain to be felt by the spectator. In this rehearsal, the spectator is Butcher. She says that it is very touching to watch these "micro-movements".' The most significant impact of this work on me has been a sense of dropping down into the deep stillness underlying embodiment. I noted, 'the form is not pre-cast or set; words are not written first. We engage in and acknowledge our process of interpretation from the outset. Although it is Butcher's vision, something is being shaped by both of us and I am anchoring it through my embodied self in movement.'

3
Veils within Veils: John Jasperse

> We're rehearsing in the studios at the Brooklyn
> Academy of Music. We do a lot of back and forth
> improvisation. Some of the improvisations are very
> comical and playful. We also experiment with me
> moving through the wall sequence and trying to exter-
> nalise my inner monologue as I move. John says that
> this makes me sound very neurotic.
>
> Rehearsals with Jasperse, January 2008, New York

In this chapter, I focus on the work undertaken from studio to perfor-
mance with John Jasperse on developing the piece *Solo for Jenny: Dance
of (an undisclosed number of) Veils (DOV)*. For this piece, the lights come
up on a black box space, with a wall hanging of a brightly coloured
flower pattern. This hanging material starts from halfway up the back
wall of the theatre and flows directly forward downstage, almost to the
front edge of the dance floor. At the beginning of the solo, I appear in
a video projection on a screen on the back wall of the theatre. I explain
to the audience that although Jasperse and I had been interested in
working together, we never found the time to connect up physically
and so we did not create a solo piece. I assure the audience that I will be
thinking of them at 8 p.m. when the performance starts and that I am
with them in spirit, although I will not be physically present. Towards
the end of this announcement, I enter the space (the real me), moving
slowly and privately along the backcloth dressed in a costume made
from the same fabric as the backcloth. I merge with the pattern – more
background than foreground – moving through a sequence on the wall
which is then transcribed to the floor. The movement is all angles and
edges. This sequence brings me downstage to where the wall hanging

43

meets the edge of the stage. The idea that inspired the last part of this movement is levitation and different parts of my body rise – hips, hands and legs – upwards at different moments.

Next, I take off the costume and am wearing black tights and top. I move to centre stage, where there is a microphone and I execute a single pirouette a number of times. After each turn I critique my performance of this codified movement, 'my weight is too far back', or 'I didn't lift the leg quickly enough'. The audience start to giggle. I have broken the silence and illusion of calm and externalised my inner critic. After momentarily leaving the stage and removing the microphone, I re-enter, hidden behind a chair that I move from place to place and then settle downstage centre. There is vaudeville music playing and I produce three balls with which I perform a number of badly executed magic tricks. The first one, I make disappear through hiding it under my armpit, the audience can see this fakery but the soundtrack plays canned applause and I bow. I repeat this act in different ways until I merge into another sequence which is slow and pompous, full of self-importance. I move slowly upstage while transforming into this performance presence. I have been tracing the first few movements of the coming phrase, which I then begin to dance to Bach's Pachelbel's Canon. It is a complicated phrase that twists and turns, constantly changing direction. The movement displays technical complexity and I indulge in its fine details. My hands and feet circle, as filigree to my winding torso and limbs. This movement fades out and I leave the stage, to return dragging a heavy sack. I slip the sack over my legs like a skirt and two longer legs emerge out of the other side – they are the choreographer's. With this extended dancer/choreographer body, we move through a phrase on the floor. As I turn on my front, he turns with me and as I draw my knees in, his body amplifies my hips, making them look enormous. We move through the final parts of the floor phrase until the lights fade finally on my circling hand (Figure 3.1).

When I encountered Jasperse's working process in 2002, I was struck by his ability to follow a concept through the body into unique movement vocabularies that contain the essence of the concept. This seemed to require me to recall the sensations alongside the form of the movement, which was unusual, in that much of my dancing experience prior to that project was focused on external shape rather than sensation. Formerly I remembered phrases through connecting to the shape and mapping these pictures in my head, whereas Jasperse required me to identify specific sensations and to re-find them each time. His interaction with the environment was also noteworthy, in how he drew

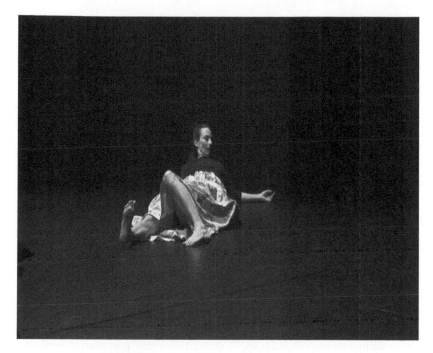

Figure 3.1 Video still of Jennifer Roche with the choreographer concealed under her skirt in John Jasperse's *Solo for Jenny: Dance of (an undisclosed number of) Veils* (2008) #1. Videographer Enda O'Looney.

elements into the piece that surrounded us in the studio. He describes how this occurred when developing *Missed Fit*[1] in Joyce Morgenroth's (2004: 198) exploration of his working practices:

> We were dealing with round objects. I felt like there needed to be something with angles. I looked around the room and saw chairs [...] they were objects that were symbolic of rest, designed to conform to the body, to support it in an alert but rested position, and yet we used them in a way in which they were totally unfriendly to the body. (Jasperse in Morgenroth 2004: 191)

Jasperse spoke at the beginning of rehearsals about wanting to explore authenticity and truth in performance as identified from the subjective positions of both the observer and performer. The piece is made up of a series of sections which each explored a different aspect of this theme. Jasperse asked me to improvise with the concepts that he

was researching before forming his ideas into a movement phrase, so there was an accumulative process of building the idea together before he set it into choreography. Jasperse told me that he was interested in exploring authenticity because of the growth of Authentic Movement[2] as a tool in dance practice and the subsequent questions and judgements that it provokes. His sense was that the appropriation of the word 'authentic' was problematic as it created a binary between truth and falsehood and thus a judgement about the genuineness of different movement practices; as Goldhahn (2009: 53) identifies, 'a claim to authenticity may imply a hierarchy between those who can move authentically and those who cannot'. In the process of making the solo, we began by taking turns at improvising being 'authentic' or 'inauthentic' and moving between these states in structured improvisation. After each improvisation, the mover spoke within a given time frame and without stopping the flow of speech about which moments felt authentic and which did not. This produced a somewhat neurotic assessment of our own feelings of truthfulness and led to the idea of externalising the inner critical monologue.

Jasperse used this idea of inner critic for the pirouette section in which I perform a series of single pirouettes and then assess my performance by making comments such as, 'I don't think my preparation was correct' or 'I did not use enough force'. These were technical assessments of my execution of the step by the inner voice that may be very familiar to a trained dancer but might seem somewhat overly self-critical when brought into the public arena. I spoke into the microphone after each attempt at a pirouette and the words were delivered as a kind of confessional. According to Jasperse, in this case, the pirouette represented 'not ballet as ballet, but as empirical truth'.[3] As such, I was confessing my inability to fully embody the perfect pirouette and thus my failure in authentically realising this movement truth; the point being that one could never execute the perfect pirouette. Coming from a different age and level of experience it was challenging to return to this approach, which evoked memories of my ballet training through words such as *efficiency*, *performance* and *technique*. Yet this codified movement was still available to me to re-embody after a number of years. Although I was less invested in performing a high quality pirouette after many years of letting that movement approach go, the inner critic easily snapped back into old habits of self-correction accumulated through ballet training (Figure 3.2).

Another section towards the end of the solo was formed from the intention to show purposeful complexity in movement. Jasperse told

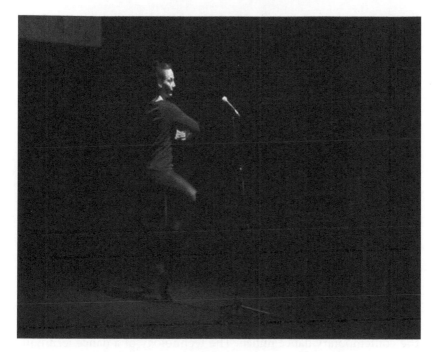

Figure 3.2 Video still of Jennifer Roche in John Jasperse's *Solo for Jenny: Dance of (an undisclosed number of) Veils* (2008) #2. Videographer Enda O'Looney.

me that this movement was inspired by an aesthetic that has emerged through the work of choreographer William Forsythe of hyper-articulation of the different body joints, which displays a kind of virtu-osity predicated on complexity and articulation. Jasperse was exploring this balance between the dancer's display of her/his competence and the communication of the theme or state of being of a choreographic work. He used these counterpoints to explore authenticity, embellish-ment and artifice, producing a detailed and decorative phrase that displayed the limbs and torso twisting and untwisting around each other. There were many weight transitions and complicated changes in direction overlaid with decorative gestures including circling the ankles, wrists and head.

Lepecki (2006) proposes that the performance of choreography is primarily focused on the display of a disciplined and controlled body in performance. Referencing Baroque dance as performed by Louis XIV and his court, he states that choreography produces a body 'performing

the spectacle of its own capacity to be set into motion'[4] (2006: 7). Presenting non-virtuosic movement in dance has challenged the definition of choreography as a seductive display of technique and skill. The relationship between choreography and spectacle had been somewhat reconfigured through the work of early modern dancers, particularly Isadora Duncan who reduced the distance between the audience and performer by 're-ordering [...] the visual priorities of dance' and circumventing the objectification of the dancer's body through establishing 'an exchange based on a strong kinaesthetic experience' (Albright 1997: 18).

The display of technique and discipline was further challenged by artists of the Judson Dance Theatre era, for example Yvonne Rainer, who embodied a task-like and non-performative approach to movement in her seminal work *Trio A* (1966). As outlined in the previous chapter, Butcher seeks to decrease the display of the professional dancer's skills while utilising them in her choreography (Butcher and Melrose 2005). However, in dance training, the acquisition of 'technique' is often given primary importance. For example, Jaana Parviainen (2003: 162) describes technique as a kind of weapon that dancers seek as armament in order to survive the volatile and unstable working environment of the contemporary dance milieu. The technology of a dance technique can become its own expression rather than serving the creative theme of a dance piece and this was the issue that Jasperse alluded to in this section. Gardner (2011: 164) identifies the potential limitations that overemphasis on technical formation can produce, as it creates an objectified body with 'a juridical relationship to the self' and this judgemental position was brought to light when the inner critic was externalised in the solo.

After our initial period of work in January 2008, Jasperse developed many of these ideas with two other dancers, Erin Cornell and Kayvon Pourazar, in New York. When we began to work together again in April 2008, some of the sections of material were close to completion. It is not unusual for Jasperse to share material among a range of dancers as part of his choreographic process. I worked with Jasperse on the beginning of many of the movement ideas in the solo, which I learned in their finished form after Cornell and Pourazar had contributed to them. When working with Jasperse in 2002 on *Missed Fit*, he had already developed many of the movement ideas for the piece with other dancers prior to beginning the project. Jasperse[5] explained why he uses this approach in making work: 'I have a really long trajectory of thinking about an idea and I try to find ways of exploring that.' In relation to the solo

process, he explained, 'this is actually the beginning for me of look-
ing at these ideas of lies and truth, presence and absence, fakery and
creativity and how we construct belief'.[6] Thus, unlike Butcher, although
they may have influenced the development of the movement mate-
rial, the individual performers were not central to the work. Although
Jasperse arrived to complete the solo with many of these ideas in place,
he incorporated serendipity into his process and was influenced by the
working environment. He explains how 'the detritus of stuff around
[him], whether it be ideas or objects or something that rubs against
what [he is] thinking at the moment' influences the direction the work
takes (Morgenroth 2004: 199).

Jasperse spoke about his approach to me as a dancer in his work,
stating, 'it seemed interesting in terms of this proposal to ask her to
return to some kind of physical investigation that she had basically
lost all interest in. For herself, engaging in it for herself, but asking
her to somehow examine something about that, seemed appealing in
relation to this process.'[7] This was in reference to the fact that I worked
through more organic approaches to movement, such as Release
Technique, but had trained primarily in ballet. In this way, Jasperse
connected my life experience into the structure of the work by using
his knowledge about my previous dance experiences as another stimu-
lus for exploring authenticity. The investigations in this solo required
me to embody a traditional dancer role at times that was not inclusive
of my movement predilections but in service to the broader ideas of
the piece. Although I had been actively involved in the initial research
of the movement ideas, Jasperse formalised them in a way that made
them seem new to me again. Therefore, I had to relearn them from
outside the experience. Some of the movement ideas we explored were
not used in the final work but they were drawn from modern dance
positions that required me to employ strategies that I had utilised as
a younger dancer.

Jasperse's work focuses strongly on sensation and requires an under-
standing of how to transition weight between different body parts. The
outward appearance of the work is shaped through deeper connections
that are established through improvisational states, which may not feel
natural to embody. Rather than seeking to transcend the materiality of
embodiment through elaborate technical feats or fluid through-lines,
Jasperse confronts the limitations of the architectural structures of the
body. Dancing in his work, these places of struggle and effort were
important qualities to maintain so that the movement never became
second nature or fully integrated. This consistently drew my attention

back to the sensation required for each movement in order to embody it fully, as mentioned earlier. Confronting challenging new ways of working, whereby known strategies are not appropriate, is grist for the mill in the dancer's career trajectory. Indeed, when I first worked with Jasperse in 2002, I found it extremely demanding to balance the complexity of his work and anchor that in a sensorial task, so that weight or texture of the movement would inform the mechanics.

In the initial stages of the creative process for this solo, Jasperse asked me to improvise with a number of different stimuli simultaneously, thus pushing me beyond my habitual range of movement responses. I experienced this *unfixing* of movement as being coerced over a threshold into a new experiential terrain, which was almost beyond my control. For example, during rehearsals I noted:

> I feel like I have to find my body in his movement, to locate myself in relation to him. It starts with watching, trying. Then really it is a leap of faith into the unknown and it's uncomfortable. I feel self-conscious about not learning the movement quickly, but then it comes to me in a non-rational way. The understanding descends and I begin to have reference points.

When working within structures that are so clearly defined by the choreographer, how might the dancer have agency or more correctly, experience her/himself as an agent in the dance-making process and thus move from being out of control to gaining a sense of control within the creative environment? As we generally understand agency to mean being in control of one's actions by making deliberate decisions to perform an intentional action, it could be easily argued that dancers are not agents in that they are operating within an environment that is controlled by the choreographer. On the other hand, Gallagher and Zahavi (2008) offer a nuanced understanding of agency. They explain the distinction between the sense of ownership of an action, which involves knowing that my body is performing a particular action even if it takes me by surprise, such as when someone moves my limbs or pushes me across the room, and a sense of agency whereby I feel myself to be the cause or author of the action. In the latter case, this would mean that I am able to trace the intention behind the activity to a line of reasoning that is congruent with my overarching goal. Gallagher and Zahavi (2008: 161) describe this as the 'radical top-down account',[8] in which my sense of agency 'derives from the reflective attitude I take towards it', that is, it matches my understanding of my underlying intentional state of being and it is congruent with this.[9]

To dissect this further, if I intend to do the washing up, the washing up is the goal behind my action even though I will engage in a number of steps along the way such as getting out of the chair and walking to the kitchen and turning on the taps which will feature less prominently and feel less intentional on my journey to the intended outcome; in any of these steps 'I might act before I have a chance to decide to act' (Gallagher and Zahavi 2008: 159). Thus Gallagher and Zahavi (2008: 160) further distinguish between 'an experiential sense of agency' which describes the pre-reflective stages on the way to the sink, in which I am aware of but not consciously ordering the precise details of my movement, and 'attribution of agency' in which I would attribute doing the washing up (and all steps along the way) to myself. Although this attribution of the action is dependent on memory and occurs after the event, I would not attribute it to myself unless I had an experiential sense of agency while carrying out the activity.

Gallagher and Zahavi (2008: 167) do not propose an overarching definition but rather acknowledge how challenging it is 'to explicate how we are aware of our actions'. I am drawing certain aspects of the above notion of attribution and reflection into a discussion of how dancers might regard themselves as possessing creative agency at certain moments in dance-making. This also speaks to the levels of congruency the choreographic process might have alongside a dancer's personal goals and beliefs. The idea of ownership of an action, that is, recognising that I am engaged in an activity and experiencing myself as author and therefore agent of an action is an interesting one within dance creation. In many ways, the dancer's role is to become the agent of a movement in spite of its instigation by external directions. The concept or idea may not be instigated by me but nonetheless, part of my work is to locate myself at the centre of the activity and produce the action as if it were my own. Furthermore, if the work aligns with my interests, then I will have a stronger sense of agency and empowerment in this work.

As an example of this, Twyla Tharp dancers, Jenny Way and Tom Rawe, in an interview with Gardner (2007b: 37), explain how they engaged with Tharp's ideas in the studio, to develop her choreographic material. Tharp was less interested in phrases she constructed and more focused on what the dancers could make out of these initial sketches; they remember her ethos being, 'I don't want to see what *I* did, I want to see what *you* can make of this' (Gardner 2007b: 38). Therefore, the dancers exercised a certain power within the work, which, they explained, extended to '*reigning Twyla in*' during moments where they felt she

was not going in an interesting creative direction (Gardner 2007b: 42). They describe bringing Tharp's original movement sketches for duets in *Sinatra* to life, which were initially 'sappy and saccharin' and so they 'knuckled under' to bring more integrity into the movement (Gardner 2007b: 42). This was in alignment with Tharp's working practice and her interest in seeing what the dancers could extract and amplify from her initial ideas. In what might seem a relatively conventional working process, in that Tharp was positioned in an authorial role, the dancers acted as agents to achieve particular goals, which were not explicitly articulated by Tharp.

For dancers, the journey towards agency could involve a process of finding congruences and connections in spite of the initial sense of being impacted upon by external forces. Drawing from the descriptions of agency as a kind of congruence with personal understandings of self-theories and stories, I question how dancers operating within the contemporary dance milieu might experience themselves as agents while being subject to the instabilities of a career path that is built on, often, random connections with choreographers and is difficult to intentionally direct.

Dancers create continuities or transitions between movements, ideas, working processes and choreographic styles. In Jasperse's solo, I had to find a pathway through disconnected states, to create a through-line in the work. Dancer and long-time collaborator with William Forsythe, Dana Casperson (2011: 94) describes her view on this aspect of dancing within choreographic process: '[dancers] practice understanding that freedom is not the absence of external pressure, but an internal ability to remain fluid and engaged under demanding circumstances [...] so dancers become accustomed to riding multiple, sometimes apparently conflicting, energetic waves to find out where they might go'. Casperson's description evokes how dancers might move in the gaps between choreographic moments, finding solutions and possibilities, remaining responsive to the events that occur and following them into new movement territories. Furthermore, in the interstices between choreographer and dancer, moving collaboratively into the unknown, many new and often unexpected outcomes may arise. The experience of breaking into new creative spaces was evident in the explorative improvisations that Jasperse set when searching for movement material. By layering a number of tasks together that I had to address when moving, I was pushed beyond conscious configuring into novel movement choices that did not seem to relate to the previous movement patterns in that they broke with the steps that preceded them. Perhaps every artist seeks the

emergence of this new terrain, which does not arise purely as a result of the formula that precedes it within their work.

Melrose (2003) identifies the notion of 'qualitative transformations' within expert arts practices and I interpret this term as referring to moments of insight that cannot fully be planned for, yet appear as a supplement to all the ingredients of the performance; more than the sum of the separate parts. Identifying the process as 'chasing angels', Melrose states that these moments are elusive and intuited rather than consciously constructed, yet the choreographer creates the circumstances in which they may emerge in the moment of performance. These transformative moments are the new experiential states that the choreographic process opens up. In order to achieve this, choreographers must engage in a process that allows for the emergence of something new and perhaps indefinable. Similarly, Petra Sabisch (2011: 8) describes choreography as a relational process that is not reducible to its constitutive ingredients but acknowledges that each individual choreographic assembly produces more than the sum of its parts.

The choreographic endeavour to break habitual movement patterns in the creation period of a dance piece, in order to find new movement forms, entails coaxing the dancer through thresholds of conditioned movement. Perhaps, this is what Forsythe (2011: 90) is identifying when he writes that 'each epoch, each instance of choreography, is ideally at odds with its previous defining incarnations'. The endeavour to break with the traditions of the past and establish new movement paradigms for dance corresponds with Dee Reynolds' (2007: 1) term 'kinesthetic imagination', which describes how dance can overthrow cultural conditioning through finding new movement dynamics: 'kinesthetic imagination is an activity whose aim is given in movement itself, and is not fully transparent to the agent. It is both a response and an active resistance to constraining patterns of energy usage that are culturally dominant, and that shape the kinesthetic experiences and habits of individual subjects.' As the choreographer induces the dancer to open up new terrains, this is not a moment wherein the dancer enacts personal agency. It is rather, *how* dancers respond to this rupturing of the known that might engender a type of agency in their relationship to choreography. As Hilton writes, 'often it's having the option of not being a slave to the aesthetic somehow, where you're really clearly doing it, it's not doing you. I think it's a power thing in a way.'[10]

As outlined earlier, at the beginning of this solo I explain to the audience, through a projected recording at the back of the stage, that I will

not be present for the performance but that the solo will continue without me. Meanwhile, during this speech, I enter and begin to dance. The purpose of this was to create an obvious disjuncture between reality and artifice, so that the audience could experience this juxtaposition. A further interpretation related to this discussion of agency is that Jasperse absented me as a self-representational subject from the performance in order to allow me to embody the role of dancer, a role that could not be performed while my identity was fully intact. In the previous chapter, we explored how Giannotti's apparent agency moved her into the discursive arena of Butcher's work. Louppe (2010: 33) writes that a dancer appears on stage with 'no other support at her/his disposal than what shows and above all localises her/him as this subject in the world'. Perhaps the potential for me to appear as an agent of the work at a particular moment in time was balanced by the degree to which I could relinquish context of self.

It was challenging to move between the multiple states required throughout the solo as my role vacillated between subject and object. In a section on the wall, I faded into the background as a special effect. At other times, I was like a stage technician manipulating props or a showman performing tricks. There were moments when I was the subject of the solo, talking about my pirouette or dancing a complicated phrase. Jasperse intentionally made allusions to other dance pieces or aesthetics throughout the solo which highlighted a sense of irony in the work by placing a range of different references beside each other. Aside from the connection to Forsythe identified above, Jasperse consciously made reference to dance companies that created optical illusions in their work, such as Pilobolus,[11] who he spoke about when creating the section when he is under my skirt, pretending that his legs are mine. It was confronting to embody these different types of presences, especially as Jasperse undermined the more obvious appearances of each section through inserting ironic counterpoints. For example, when I performed the series of magic tricks, they were badly executed intentionally so that the trick in each case was revealed. Yet, I had to present them as if I were accomplishing an outstanding magical feat. This created an underlying sense of confusion as to what was intentional in the work, made more complicated by the challenge of embodying all of these ideas as a solo performer.

The beginning 'wall into floor section', which transposed floor material onto the wall, started with pressing my lower back into the wall and circling my hips. The movement had to appear weighted in places that had no real weight in them and so required the illusion of weight. This was even more demanding because this section occurred at my

point of entry into the work at the beginning of the solo, the first time I appeared on stage in the flesh. When Jasperse demonstrated this sequence to teach it to me, he clearly held the movement form from position to position, while being sufficiently soft to yield to moments of rest. He danced this section with a specific rhythm that looked natural but actually required me to fake moments of arrival and weight. In the rehearsal process, we explored how I might externalise my inner monologue throughout this section and this monologue revealed how actively I was trying to embody Jasperse's many choreographic instructions. In performance, I had to hold on to these tasks mentally through reciting, 'press lower back into wall, circle pelvis and turn knees and head'. Unless I reaffirmed these moments through sensation, image and remembered verbal instructions, I seemed to lose focus and be propelled out of the sensation and into the next moment.

The difficulty in reading dance performances is that one can never know from the outside how the final outcome was created, or indeed what the dancer is thinking. Is it wholly the choreographer's intention that the dancer moves in a particular way and to what degree is the dancer being self-representational? Claid (2002: 33) has written extensively on the interplay between audience and performer and the ways in which the dancer can be constructed through the 'specular' (or mirror-like) relationship in the performance moment. She writes:

> I watch the performer and observe a real body becoming a performed surface, an illusion [...] the more her real body plays in becoming surface illusion, the more intriguing her performance becomes to my imagination [...] the oscillating relations between her real body and performed surface create an ambiguity [...] the ambiguity triggers a seductive play regarding what is present and what is absent, between knowing identity and not knowing, between depth and surface.

The site of ambiguity in dance performance, this oscillation between real and imagined subjectivities (or what is imagined to be real), shows the potential for many layers of interplay within the dance. Claid (2006: 87–8) applies the term *'jouissance* dancing', drawn from 'psychoanalytic/French feminist/post-structural theory', to describe pleasurable states of dancing in which the 'performing/watching relationship [...] cannot be fixed' because the performer is attending to internal sensations rather than the seductive play of dancing. In Melnick and Roche's work, I was engaged internally in listening and responding to the impulses that emerged even while following prescribed choreographic

lines. This brought an authenticity to my presence, a state that I didn't need to question during performance. In contrast, in Jasperse's solo process I was somewhat decentred and decomposed because the ideas he had were defined so clearly from the beginning. In contrast to the processes with the other three choreographers, who each seemed to take my physicality very strongly into account in choreographing, Jasperse's concepts were constant and did not bend around me. I had to employ learned techniques rather than finding organic responses to his tasks. The sensation was as if the movement was *happening to*, rather than *emerging from* the body.

Jasperse's solo brought up questions of performative presence beyond the experience of 'jouissance' or indeed, the utilitarian quality of many postmodern dances as exemplified by Rainer's *Trio A* (1966), through which she choreographed the performer's gaze away from the audience, thus avoiding a seductive engagement with the spectator (Burt 2004: 36). Without requiring the formation of a specific character, Jasperse's solo required the display of differentiated dancing selves that were theatrical and humorous, in order to display the irony within the work. Rather than highlighting the integration of self and world, this work explored the awkward moments of disconnectedness, lack of cohesion and clumsiness in the relationship between self and environment. As the solo explored authenticity, it was interesting that I had to struggle internally with my sense of authentic connection to the work. Yet, this process also made me aware that the attempt to find an organic connection to movement can be too comfortable a state to allow me to adapt to new movement approaches. I noted, 'In Jasperse's work, I feel as if I'm driving myself outwards. I'm extroverted. I have to push through inner inhibitions and shyness to present myself to the world. There is also a lot to manage, with props and timing and costume changes. It feels messy but I have to weave all the elements into the performance somehow.'

As the solo was episodic, I moved through a variety of relationships to the audience. In the first section, as the wallpaper, I had a sense of drawing them into my movement. The pirouette section gave me an opportunity to connect outwardly to the audience and establish a sense of warmth and humour between us. The magic tricks also had this quality of humour and connection, although I was less comfortable in those moments as there were many details to address in executing the tricks. In the complicated twisting phrase towards the end, I was focused on projecting a kind of intensity following on from the instructions that Jasperse had given me, which were to display the movement. This was

more like presenting a character which caused me to feel disconnected from the previous rapport established through the magic tricks section. There were many breaks between sections, including a moment when I had to change costume on stage. These down-times were taxing, as I had to carry the audience with me through these obvious discontinuities. I tried to stay connected to the audience by being very aware of how I physically moved while interacting with the props and costumes. As there were so many elements to think of as well as the execution of the movement and changes in dynamic quality, I felt the weight of carrying the solo very acutely. When the choreography positioned me to connect with the audience through movement or humour, I was able to establish a sense of rapport but the in-between moments between sections were more pressurised.

I was required to adopt a series of strategies to bring the work to the audience in performance and this seems to be an integral part of a dancer's role. The strategies may not always be consciously enacted by a dancer nor specifically requested by the choreographer, but the act of bringing choreography to the stage will require dancers to find continuities in order to deliver the piece. Different performance strategies may often be required for different pieces. Although dancers work from a set of internalised instructions that have been given by the choreographer, the individualised strategising process is an important element in bringing out the identity of a choreographic work. In Jasperse's solo, I had to make a conscious effort to connect to embodied sensation, to understand his movement through my physicality. I found myself moving at a new pace. My tendency is towards seeking resolution and integration of movement material to present an accomplished presence on stage. Instead, I had to embody ambiguity on stage and cope with the lack of comfort that this evoked. The solo shifted from one state to another, requiring me to change performance presence and body texture in the work. My way of dealing with this was to project an underlying sense of centredness in my presence as the dancer – a kind of *show must go on* mentality – that belied the discontinuities I embodied. This projection seemed to be an unconscious defensive strategy to enable me to maintain power on the stage as the solo performer within the destabilised environment instigated by this choreography. I created continuity for myself, despite the sense of fragmentation that I felt in performance.

The use of these tacit strategies are evident in Hilton's (Hilton and Smyth 1998: 73) account of her work with Petronio: 'as a dancer in Stephen's company I make a lot of decisions. A lot of the work is made

through improvisation and through playing with manipulating phrase material that we've been running for a year and that we know inside out and back to front. I have a lot of artistic control and input into the work.' These dancing instances outline a creative dancing agency, occurring in the moments of composition and/or performance, when dancers contribute to choices or follow ideas into new experiential spaces. This agency is not limited to improvisation but also occurs in choreographic practices of making and performing. As I outlined earlier through the discussion on dancing agency, dancers often have the opportunity to exercise conscious and unconscious choices despite being in a responsive and receiving role within the creative framework of the choreographer.

The creative agency of dancers can ultimately change the power dynamic in the creative process, challenging the perception that dancers are passively regurgitating a preformed and tightly controlled choreographic script. Following the performances, Jasperse[12] commented that there was a light quality and humour in the solo that was 'not necessarily typical' of how he perceives his own work and that surprised him. It seems to me that this lightness came from my unconscious strategy to connect to the audience through humour in order to manage the fragmented nature of my experience as a performer. Perhaps I normalised the complexity of the experience through projecting a calm and humorous performative self as aspects of my moving identity drew the fragments together in a particular way.

As mentioned earlier, Jasperse found the process of making a solo 'tricky' and perhaps this was due to the strain of drawing all of these ideas into a solo performance. I was a temporary host for the choreographic ideas but this solo version of the work was not permanent or lasting. It was an assemblage for a particular performative event that was then reconstructed around the next set of creative circumstances as his development of these themes rolled forward.[13] The distribution of ideas among the group of dancers meant that I did not have a sense of ownership of the work and it was a more detached experience than that with Melnick and Roche, in spite of a strong personal connection with Jasperse. I noted:

Not wanting to be 'the subject' anymore, resisting my wish to resist the work, I have a feeling of pressure, while enjoying the movement. I become the subject in the solo and people read it as 'me'. Friends in the audience said they didn't realise that I had such a 'funny side',

but the magic tricks were copied from a recording of Erin Cornell who dances with Jasperse. She created them and I just learned them.

Working with Jasperse evoked questions of ownership and agency. He drew significantly from the circumstances of production and the dancers involved in developing his ideas. These ideas were manifested in solo form by me but then expanded into subsequent group versions by others[14] so that the experience was of plurality and distribution rather than a solo dancer with a singular identity. Our inputs were amalgamated into his creative process, becoming projections of him in the work. Indeed, he explored ways of being present as my legs under the skirt at the end. Not a didactic choreographer, nor fully democratic in his approach, he employed a sophisticated range of creative methodologies to explore his ideas. His physicality was at the centre of this as he consolidated improvised material into set choreography and explored various textures and performative states. This required me to shift modes often and be attentive to sensation and impulse – to manage conflicting ideas simultaneously – while maintaining the edges and angles.

4
The Shape Remains: Jodi Melnick

> We have been working on movement and the material
> is familiar. I'm overwhelmed – whether it's a combina-
> tion of the intensity of the summer and the city or just
> relevant to this process, I don't know – feel shaken.
> I feel static and blocked today. She was in the throes of
> a lot of movement when I came into the studio. It all
> came at me in a clump.
>
> Rehearsals with Melnick, August 2005, New York

The creative process on the solo *Business of the Bloom* (*BB*) with Jodi
Melnick is outlined in this chapter. In this solo, I enter the space at
the upstage right corner to a crackling soundscape and a yellow wash
of light. I am wearing yellow trousers and a light patterned top. Feet
in parallel position, my arms rise forward up to sternum height before
breaking apart into a jointed series of arm and leg gestures that come
to rest through my pointed finger scanning from left to right, taking
the audience into my gaze as I go. The piece is a collage of carefully
constructed sections that see multiple impulses expanding into move-
ment possibilities. My right hand travels forward passing through
the horizontal crook of my left elbow. It opens like a flower before
contracting and retreating – this is/was 'the bloom' from the title.
I embody a muscular, exaggerated *macho* walk downstage to confront
the audience to the soundtrack of the 1966 Western *The Good, the Bad
and the Ugly*. This character falls away as I return to movement that
scans from left to right across the space. There is a sense of restraint
throughout, a lifted quality in my movement. A strain of guitar music
accompanies a series of quick and detailed impulses that I trace but do
not fully extend into. The crackling sounds return as I stand on one

leg, a heron in repose, waiting until this picture dissolves into the next. Each new movement idea arises enough to be visible without being projected fully into space. This draws the eye into subtle complexity. The 'bloom' returns again, this time as my hand at hip height. I wear it as a corsage, until it dissolves again. Undulations from the feet cycle up through the torso and arms until I release through my legs, falling to my knees and turn into an expanded version of the earlier guitar phrase that is marked (not danced fully) and complex. I bob through the detailed movement, which is even more understated than the earlier version. My instructions for this movement were to signal the impulses without fully realising them, while moving quickly from one to the next. My body is multiple, complex and mutable. This section ends with me folding into my hips extending through my legs and retreating upstage as I turn into a gentle wave and turn and wave again with one more wave before the lights come down. I walk downstage in darkness to switch on a single standing lamp which is at the edge of the stage for a short coda. Facing the upstage diagonal, I lift my right knee. As the knee comes down my arms trace up the front and down the back of my torso, counterweighting each other as I repeat this numerous times. I turn to the front and circle my shoulders to the private and dreamy song, composed by Joel Mellin: 'I don't know why, I keep on dreaming of you'. Finally, turning upstage I cycle my arms forward and back towards my torso, one arm extended in a long circle and one smaller, brushing past the left hip. I maintain this action as I extend into a backbend, focusing upwards and outwards, as music and lights fade out (Figure 4.1).

Melnick embodies a sophisticated and articulate understanding of movement drawn from her dancing experiences with choreographers such as Twyla Tharp, Trisha Brown and Sara Rudner. Her choreography demonstrates her fascination with physicality, which she has cultivated from a young age:

> I loved the idea of being ferociously physical [...] and I had this crazy sense of momentum. Like I understood momentum in my body, and I remember it colliding with a fearlessness and with form [...] I would go to modern dance class, and it was running, putting your heels down, articulating the hip joint, the foot going into the ground, using your body weight, what the elbow did, how you moved through space, and there was something about that that moved me. I had a visceral connection to it. (Melnick in Kourlas 2013)

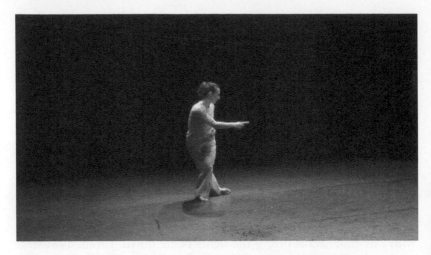

Figure 4.1 Video still of Jennifer Roche in Jodi Melnick's *Business of the Bloom* (2008) #1. Videographer Enda O'Looney.

Melnick[1] explained her approach to making this work in our post-performance discussion: 'I was really concerned [...] that Jenny had an experience, that I have had before as a performer, [that] every movement, every word, every step, even though it's formed and there's a structure and set material, is happening to the body for the first time.' Entering the creative process with many ideas, images and stimuli, rather than with a concept to be explored, these images seem be located within her physicality as movement impulses.

When I first started working with Melnick, I found her choreographic process unusual, as she configured the movement through dancing. This was notable because many choreographers verbally articulate the type of movement that they are looking for and there is an intellectualising process that precedes the creation of choreography. Jasperse, for example, sought out particular types of movement to elucidate the ideas he was presenting in his solo, while Melnick worked by moving and then editing in movement, rather than projecting choreography onto me. She demonstrated the whole movement in motion and this was usually too complex to embody initially. Through suspending the need to execute the material correctly but rather tracing and following her through space, eventually the movement phrases settled and finer details could be added.

The immediacy of this interaction and the lack of an objectively posited conceptual motivation were challenging. This is because

Melnick did not give verbal explanations to frame the movement experiences, which made it difficult at times to orientate myself in the process. Our interaction was intimate and involving. Indeed, the working atmosphere in the studio often felt hypnotic and it was difficult to mentally recall the material outside the studio process. I wrote in my notes, 'I trace the movement behind her; trance-like I mimic and respond.' In resonance with this experience, Parviainen (1998, 2003) writes that dancers and choreographers obtain knowledge of movement through the practice of dancing and making dances. A seemingly obvious statement, it is nonetheless centrally important in understanding how dance can be a form of knowledge production and how subjects could be considered to think in movement. This concept is espoused by Maxine Sheets-Johnstone (1999: xxxi) who proposes 'a kinetic bodily logos', by which she means to counteract 'the widespread assumption that there is no thinking outside of language – or outside of some kind of symbolic system'. Using improvisational practice as a model to demonstrate this, Parviainen (2003: 164) explains Sheets-Johnstone's theory:

> movement is not a result of a mental process which exists prior to the activity. I am not first mentally exploring a range of possibilities and then later taking some action in consequence of them. Thinking in movement is an experience in which the qualitative dynamics of movement combine to form an ongoing kinetic happening.

The following passage from my notes describes the working process with Melnick, outlining the process of choreographic creation unfolding as a movement practice that is transmitted from body to body:

> Melnick begins by tracing a physical idea, dynamic or direction. We always work in and through movement. She plays with a kinetic idea and then solidifies this through repetition while interspersing it with other options. Therefore, each repetition gives more information about what the form is, or could be. Throughout this process, I follow with my body, without trying to 'learn' the choreography, but rather to let its logic begin to settle. She focuses on certain moments to develop them further and to check other options for transitions or rhythm and dynamic. All of this interplay will ultimately impact on the quality and texture of the choreography. After we have 'played' with many choices, Melnick will clarify the parts of the body involved and the physical area that she is focusing on in

each movement. This helps to anchor the choreography for me, as I can relate her visceral experience to my own.

Dancing Melnick's solo in performance, I felt that my consciousness was floating on the surface. My body felt light and sensitive, prone to interference or distraction. I was in a fluid state of being, responding to minute details and shifts in my bodily sensations. I perceived each moment as it unfolded. This was the performance state that Melnick sought for the work, that although it was choreographically defined, had an emergent quality. The seeds of this performance quality were sown within the rehearsal process.

Melnick's approach engendered a dancing state that echoes Banes' (1993) writing on inspirational dance teacher and choreographer Anna Halprin (1920–), who influenced the work of many postmodern choreographers. Banes (1993: 11) describes Halprin's ability to induce a 'dance state, in which the body is focused and receptive to impulses that set off movement flow'. Indeed, dancer and choreographer Simone Forti claims that she coined the term 'dance state' to describe Halprin's work in the studio and she characterises this as a 'state of enchantment' where 'your creativity, your awareness and your knowing what to do are amazing you [...] suddenly the thoughts are moving, that's what I call having a dance state' (Ruhsam 2012). Although there is a sense of freedom attached to this state, Forti explains that it includes artistic discernment which she likens to jazz musician Miles Davies experimenting with different tonalities and timing in the flow of a session; she says, 'you are seeing possibilities but you are seeing them within the framework of something' (Ruhsam 2012). Although Forti is referring to this dance state unfolding through improvisation, it is clear that this state can be materialised in compositional processes and indeed, Forti's description aligns with my experience of the studio atmosphere with Melnick, where I followed her through these dance states as she traced movement possibilities. The looseness in this process allowed me to experiment and maintain the qualities of surprise and spontaneity that Melnick was seeking. Once the material was sketched, Melnick refined it further through making anatomical or image-based statements such as, 'think of your left little finger nail arching back towards your right eyebrow, or imagine in this section that you have swallowed a rock'.[2]

The example from this working process with Melnick shows how the dance material did not pass through a separate symbolic system outside of dance, as Sheets-Johnstone (1999) describes above, on its way from one body to another. As my experience of working with Melnick

illustrated the capacity to think in movement within a choreographic, rather than improvisatory process, I will now explore how this experience might offer alternative viewpoints to recent writing on dance trends which have emerged in the 1990s and are described as 'non-dance' or 'concept-dance'.[3] Lepecki's (2006: 1) inspirational writing on the still-act in the work of the new wave of European choreographers in the 1990s, such as Bel, Le Roy and Vera Mantero, interprets 'the eruption of kinaesthetic stuttering' in the work of these artists as a challenge to the ideals of dance 'as agitation and continuous mobility'. He explains that when they emerged, there was a refusal by dance writers to regard these new dance trends as anything other than 'a down-time' in dance – an art form which is otherwise considered to be movement-centred (Lepecki 2006: 2). Lepecki (2006: 15) describes how the 'still-act' in dance proposes the possibility of arresting the flow of history in order to interrogate 'the tensions in the subject' caused by historical forces and he outlines that performances of this kind by North American and European choreographers in the late 1990s arose in response to the filtering down of political uncertainties of the time. Through linking dance, dance studies and specifically postmodern and post-structuralist writings from Derrida, Foucault and Deleuze, he proposes 're-framing choreography outside artificially self-contained disciplinary boundaries' that link it solely with movement (Lepecki 2006: 5).

Lepecki draws attention to dance's *exhaustion* through its compulsion towards constant movement and articulates how this impetus to move could be viewed as the result of controlling and disciplining forces on the dancing subject. Thus, he links the unfolding of choreography as an 'art of codifying and displaying disciplined movement' to the development of modernity (Lepecki 2006: 7). Through adopting Peter Sloterdijk's notion that 'kinetics is the ethics of modernity', Lepecki (2006: 7) identifies a relationship between modernity's symbolic movement forward, as exemplified in the motion of progress through modernisation, and dance's association with mobility. Sloterdijk (2006: 38) proposes that 'the meaning of "being" in modernity is understood as "having to be" and "wanting to be" more mobile'. Therefore, Lepecki hypothesises that it is through arresting the flow of dance movement that choreography can examine and critique modernity's entrapment of a particular type of subjectivity. This infers that dance which engages bodies in movement cannot critique the destructive elements of modernity·.

Lepecki's (2006: 12) position proposes stillness as a means of protest, which he draws from Deleuze's notion of blocking movement as a form of political resistance. Although Lepecki's (2001: 3) exploration of the

value of stillness within dance performance reveals the ability to engender alternative dances, 'under which time expands immensely, awakening discarded memories to flood, allowing sedimented yet necessary gestures, thoughts, feeling, sights, to emerge once again in the social surface', it also produces an unfortunate binary between movement as subjective compliance and stillness as a means to engage politically. Thus, it could be regarded as re-enforcing a pervasive Cartesianism that assigns intellectualisation to the brain and action to the body, thereby easily reducing dancers in motion as passive subjects unthinkingly enacting systems of control.[4]

Indeed, Lepecki (2006: 9) says that choreography 'demands a yielding to commanding voices of masters (living and dead) [...] all for the perfect fulfillment of a transcendental and preordained set of steps [...] that nevertheless must appear spontaneous'.[5] Thus, choreography could be considered to corral dancing bodies into moving according to the will of the choreographer through the command of writing. The way in which Lepecki characterises the choreographic process and as a consequence, the role of dancers, produces a somewhat limited view of dance practice that can be expanded when viewed from a dancer's perspective. While offering vital considerations with which to interrogate dance's collusion in the political project of late modernity, Lepecki's text overlooks some of the subtle yet significant nuances of relational dancing practices.

Although the dancer's position is not the focus of Lepecki's argument, the case he presents regarding modes of choreographic production impacts on how dancers are perceived as compliant. Gardner (2007a: 37) highlights this frequently occurring slippage in dance scholarship that presents a generalised and symbolic binary relationship between choreographers and dancers when discussing the choreographic process. She says that this is carried across other genres despite its origins within and specific relevance to the classical ballet model. Gardner (2007a: 36) explains that in the majority of dance scholarship, the terms 'dancer' and 'choreographer',

> Refer to a specifically 'modern' conception of dancing and of dance production consonant with a division and complementarity between 'art' (choreography) and craft (dancing), mind and body. This conception of dance creation arises from within ballet culture whose own history traverses and is implicated in the modern period and is linked to the history of (industrial, capitalist) 'production' more broadly.

The binary distinctions made through these symbolic roles do not adequately represent the diversity of dancing relationships that produce choreographic works, which Gardner (2007a: 37) characterises as 'intercorporeal' and 'intersubjective'. These are important distinctions in relation to Lepecki's text, primarily because dances are often externally read as tightly controlled scripts that are fully representative of the choreographer's intentions, when indeed processes of making are often more collaborative and fluid than is evident from outside the experience. This collaboration extends beyond the democratisation of dance-making outlined earlier, to encompass a shared process of moving together to produce the choreography.

Gardner (2007a) writes that the hierarchical relationship between dancer and choreographer was challenged in modern dance and as a result, the fabric of the choreographer/dancer relationship is more complex and nuanced in current practices. She explains that modern dance styles emerged mainly as a solo form and thus, there was no division between the choreographer and dancer; they were the same person. It was only when solo modern dance artists made group pieces that idiosyncratic styles were transmitted from the body of the choreographer to the bodies of other dancers (Gardner 2007a). However, the process of choreographing on other bodies in modern dance did not intrinsically impose distance between the choreographer's role and the bodies of the other dancers; rather, many modern choreographers continued to perform within their group pieces, alongside their dancers (Gardner 2007a). Therefore the choreographer, in this dance genre, did not necessarily assume a hierarchical position, as is prevalent within the ballet tradition. Gardner (2007a) demonstrates how the relational space through which dance is made, and which is represented through the modern dancer and choreographer dancing together, is often rendered invisible in dance discourses.

When dance artists articulate practice, these mechanisms are brought to light, such as when Hilton[6] alongside Vicky Schick, articulate the interpersonal nature of the dance studio. Hilton explains that personal relationships are fundamental to knowledge exchange in dance. She says, 'You can't take it apart from the person. A set of information is in the person. So it has a lot to do with if you like the person, or if you can understand the person and I think that is particular to dance. You're really learning directly from someone's body'. Schick gives an example of her experience in the studio moving with Trisha Brown in the 1980s, explaining how 'the very rigorous work of learning movement from her body was a glorious experience. Once you got into the company,

Trisha was extremely trusting and generous. She would demonstrate something a thousand times. She was utterly patient in passing on the movement' (Roche 2013: 14). Schick explains, 'this exchange in the studio was crucial and the crux of everything that happened then' (Roche 2013: 14).

The accounts from Hilton and Schick highlight the articulacy of dance as a mode of thinking and describe how choreography can be constructed through intercorporeal exchange rather than written into being.[7] They serve as an antidote to discourses that conceptualise the material processes of dance production from outside the studio. Indeed, Kent De Spain (2007: 59–63) writes of the 'hegemonic nature of discourse itself' which necessarily imposes a linguistic framework on dance, thus privileging the verbal and inscriptive above the material and incorporative model of dance-making. He asserts that dance theory regularly writes over the bodies of practising dance artists, rendering lived experiences invisible by glossing over what is 'an inherently complex and downright messy somatic experience' (De Spain 2007: 59–63). By defining choreography as 'a technology that creates a body disciplined to move according to the commands of writing', Lepecki (2006: 6) elides the material processes of choreography and prioritises the *graphic* aspect of the act. This viewpoint does not account for the activity of dancers in the construction and performance of work or the intercorporeal exchange between choreographers and dancers that can happen within the dance studio (Gardner 2007a).

Although there are written descriptions of an approach to choreography that is pre-scripted – Annabel Farjeon (1998: 24) describes Ninette de Valois arriving at the first rehearsal of a new ballet with the details of the entire ballet 'marked out' in private (she explains that '[de Valois] inclined to use dancers as puppets to be manipulated and there was little elasticity to the system') – the process undertaken with Melnick is one example of a method that engendered a very different approach to the construction of movement material; that of working *in and through moving together*. These studio exchanges are rarely articulated because they are not visible in the final dance product. Roses-Thema (2008: xii) explains that this impacts on how dancers are perceived as creatively passive because, 'so often the perception of a dancer in action is constructed to match socio-cultural norms that are drawn from audience perceptions of the dancer onstage'.

Melnick required me to embody a fluid state of being, to be a body in constant motion, thus this process destabilised and deconstructed

my intrinsic sense of embodied organisation. It seemed that in order to learn the material, I had to surrender my dancing strategies of analysing movement and to trust my ability to make unconscious embodied connections. Brown (2014: 19) describes how dancers descend rapidly 'into a kinesthetic or somatic state which goes beyond rational thought to readily sense the inter-subjective cues between each other'. Our rehearsals were not all conducted in silence but finding the logic of the movement happened in non-verbal states. I noted, 'just following, shadowing her movements and not really speaking together, but I am thinking all the time in this rehearsal. My mind is constantly throwing thoughts at me. It's this strange feeling of being alone while being totally together.'

This working experience with Melnick highlighted how movement becomes unfixed through the dancing process and how this could be highly confronting to my sense of self. Moving alongside Melnick in the studio, I noticed the agitation that sometimes arose in an internal monologue, particularly when I was less sure of the focus of the movement or my ability to embody it. Hayles (1999: 211) proposes that the internal monologue re-enforces a sense of self-hood, enacting 'self-discipline as well as self-creation'. In Melnick's creative process, we often had long periods without talking in her rehearsals during which I was aware of the interruptive nature of this voice, which seemed to be a reaction to the destabilisation of my familiar ways of moving. As this was happening at an accelerated rate throughout the rehearsal process, there was no time to examine this and bring it to my conscious awareness. However, when I wrote up my notes afterwards, I could begin to unpick some of these thoughts and the poetic quality of these embodied states emerged. For example, I wrote, 'I feel as if I am just unravelling, not in an uncomfortable way, but dissolving away from life into something else – chaos, the unconscious – the other. I am destabilising into movement. I feel a bit "unhooked". Is this the experience of freeing myself from everyday cultural norms – the habitus – or whatever identity enactment stabilises my sense of self at the moment. I feel "ungrounded".'

I question whether the accelerated internal monologue I noticed throughout this process was my defence against the discomfort of crossing the borders of habitual movements that had previously anchored my moving identity. Although a continuous and whole 'self' may be illusory, it nonetheless presents a sense of continuity that is experienced as real. Corey (1995: 164) describes the ego as consisting of 'all modes of thought used by individuals to reach their goals and to defend their self-concepts'. The 'ego' or reassertion of an identity

could be described as a defence mechanism that is activated when these lines are crossed. When choreographic process begins to decompose habitual movement that may be linked to a continuum of self-hood, resistance may arise. This was outlined in the previous chapter as the inner monologue that Jasperse externalised in the piece and through which I critiqued my performance of a pirouette.[8] The dancers I interviewed resonated with these theme of resistance and/or the eruption of the ego-self in the working process. Phillip Connaughton[9] spoke about how the ego 'is an intricate part of the whole' and he questioned if 'the fact that you're not able to do it [...] means the ego steps forward, or does the ego step forward and block you doing it? It's probably not one or the other.' Catherine Bennett[10] described getting 'more stubborn' as she gets older; while sometimes physicalising the choreographer's requests 'naturally', she explained that she often has to acknowledge to herself, 'OK, I know that they want this, but this is how I'm going to make it make sense for myself and this is how my body will be able to do it.' In a humorous passage, Hilton[11] describes the working process with Jasperse and Melnick for the choreography *Becky, Jodi and John* (2006):

> I get quite hostile, which is my way of dealing with things and that upsets him [Jasperse], so there would be a kind of tension. But because we're such good friends, we can talk about it and Jodi [Melnick] would slow the process down and get into it and we'd stop and talk for a while. It was very functional, but all our peccadilloes would surface.

Traditionally, dancers have been conditioned in training not to express these personal feelings in the dance studio but rather to act in a professionally distant manner. Although I have argued for dancers being regarded as agents in the choreographic process, it must be acknowledged that dance training systems are adept at subjugating dancers' individual personality traits, making it challenging to engage as collaborative artists. In the extreme, industrialised dance training can create a *body-as-object* to be modified and cultivated in alignment with external power structures. Thus, dancers negotiate a fixed training system that projects an ideal body, never fully achievable through flesh and blood. In Barbour (2011: 53), New Zealand dancer Raewynh Thorburn described her dance training as a 'colonising' experience, describing the imposition of various dance techniques on the body: 'when I began training in modern dance, jazz and ballet, my dance

voice was reshuffled and at times torturously categorized to the norms of these codified techniques. My natural sense of weight and momentum in space was pruned, coerced or restricted into patriarchal criteria of how the body worked.' Thus, operating under the imposing force of dance techniques that maintain fixed positions as unachievable ideals, as the example above indicates, can mirror a colonising process. This is corroborated in Geraldine Morris' (2003) use of the theory of habitus[12] in her research into the training of ballet dancers. She explains that ballet dancers are 'constructed individuals' and that 'it is probable that most are controlled by their habitus' and thus, it is suggested, primed to be manipulated within the hierarchal structures of the ballet studio (Morris 2003: 21). Concurrently with appropriating dance techniques, as Morris explains, dancers construct and refine a dancing self that is aligned with the aesthetic values of the technique while incorporating some of the personality traits that such a relationship might infer.[13]

Gardner (2007a: 40) articulates how, through industrial models of production, 'artists/artisans lose control of [... their] practices – becoming alienated from their own labour, losing the power of self-regulation and artisanal self-definition'. As Fortin, Vieira and Tremblay (2009: 61) explain, 'in the dance training milieu, there is a certain amount of consenting to training or choreographic demands that are sometimes violent, and physically or psychologically abusive'. Over time, dance production processes, such as training systems and large institutionally based dance companies can subjugate individualistic traits. Drawing on Foucault, Fortin, Vieira and Tremblay (2009: 61) explain that the execution of power involves internalising certain norms that manifest as personal goals for the subject. The subject becomes self-regulating so that the authority no longer needs to exert control and the subject no longer needs to be constrained by an external system. Therefore dancers negotiate a variety of external and internal regulatory systems.

My activity in these choreographic processes often involved receiving, absorbing and responding rather than instigating action as discussed earlier in terms of agency. Carol Brown (2014: 19) describes dancers' 'propensity for becoming *willing subjects*' in the dance process. This responsiveness is somewhat problematic in relation to current Western socially normative behaviour, which encourages self-directed individuality. For example, in the Society of Dance History Scholars conference at Centre Nationale de la Danse in Paris in 2007, Ann Cooper Albright spoke of teaching dance to teenage girls. One of the significant

challenges she identified was teaching them to take a receptive role in Contact Improvisation work and to be guided by their partner.[14] She stated that they were culturally conditioned to instigate and control a situation – to act rather than to respond. In further writing on this subject, Albright (2013: 244) describes how 'these various positions of active and passive are pathologized into power dynamics, where the passive figure is seen as not having control, as being either infantile or lazy, rendering them an object of pity'. She explains how her experiences of total passivity through movement practices have revealed many layers of feelings that have created enjoyment and imparted a sense of agency. If yielding to the other is read as non-agency, dancers will be seen to relinquish subject-hood within the choreographic process. However, actively yielding is not passivity and, as explored in Chapter 3, there are a range of strategies that dancers must utilise as they follow particular currents within the creative process so that they can move in the choreographic interstices and uncover new movement possibilities.

Lepecki (2006: 10) implicates choreography in modernity's process of subjectification whereby it 'locks subjectivity within an experience of being severed from the world'. Dancers are symbols of compliance and passivity within dominant discourses because this activity is usually read as such from an external perspective. He identifies how the act of adhering to choreographic structures engenders a passive dancer's body, surrendering agency and autonomous subject-hood in order to dance to the command of the other.[15] There is no question that Lepecki's description of subjectification and control, through choreographic structures and the institutions that support them, depicts the experiences of many dancers. However, it is counterproductive to characterise the choreographic act as an intrinsically subjecting force as this neutralises the subtleties within specific processes and continually condemns dancers to this passive role in all cases, whether or not they enact creative decision-making and/or varying degrees of agency when dancing choreography.

As Gardner (2007a) has outlined, modern dance cultivated an 'artisanal' approach which is person-specific and built on intercorporeal exchange rather than the large institutional structures of classical ballet. She writes, 'thinking in terms of "the artisanal" allows the dancer and the choreographer to be perceived not as two autonomous roles, but to be able to move across and between these; to be in relations of mutual identification rather than of opposition or exclusion' (Gardner 2011: 160). Artisanal approaches nurture the craft of dancers by locating

the creative outcome more directly in their individual embodiment rather than requiring them to present a body that can be moulded into whatever shape the choreographer desires. Independent contemporary dance has inherited this artisanal approach to a degree while also being influenced by the depersonalisation of dancers through industrialised dance training. In many cases, the technique class has replaced bespoke, artisanal training.[16] As a young dancer, Melnick worked with Rudner in the dance studio over many years in an artisanal exchange. Melnick went on to dance some of the roles that Rudner originated in the choreographies of Tharp, which implies that there was a transfer of embodied knowledge over an extended period of time between the two dancers. Rudner[17] spoke about a similar process of moving in the studio with Tharp, explaining:

> I remember Twyla [Tharp] through those periods when she would improvise in front of a TV camera,[18] this was 1970, early cameras; reel to reel. She would say, OK learn this movement and Rose [Marie Wright] could do it and I could sort of do it, but it drove me crazy. As soon as she started dancing again and I could stand behind her and move with her, then I could get it, I would know what it was. So, Jodi [Melnick] is like that.

Taken from my notes while working with Melnick, the following passage describes exchanges that are not confined within the parameters of a particular dance project but ongoing dancing relationships: 'we are moving alongside each other in an artisanal sense. I have always been interested in her [Melnick's] dancing relationship with Rudner. It was an ongoing practice that was not focused on producing particular works. Over these years, I have had this experience with Melnick.' In her interview, Rudner framed the relationship with Melnick through Australian choreographer Russell Dumas'[19] ethos of how movement is traditionally passed from choreographer/teacher to dancer/student in artisanal practices:

> Dumas would talk about the way that dance is taught in other cultures, he always talked about the importance of the teacher being right there with you and moving with you, so that you were getting information from the body. You weren't being told 'go to the barre and do two pliés et cetera', the language might be somewhat codified, but you're in the physical presence of the practitioner – of the teacher. And he even talked about cultures where the teacher dances

the body, holds the child from behind and moves the body like in the Balinese culture. There's a certain kind of sympathy.

Indeed, Dumas adopts this fluid approach in choreographic creation with little distinction between preparing the body to move and choreographic process. Philipa Rothfield (2008: 13) explains how rather than constructing a tightly configured choreographic movement, Dumas 'will, over time, explore a range of possible physical approaches towards a particular choreographic activity', mapping possible lines of movement or feeling 'traces' that become associated with the choreographic movement and which can be reinstantiated in the moment of performance. Less focused on finding choreographic solutions, this process takes time to embody and understand. Rothfield (2008: 7) says, 'it is not a series of postures, positions or end-points, but a challenging series of choreographic demands/actions'.[20]

This account of Dumas' working process echoes Melnick's approach, whereby multiple repetitions and options are explored during the composition that then become part of the history or 'trace' of the movement when it is performed. This was apparent in a marking phrase towards the end of the solo, which came from our first rehearsal session together. Part of this section was taken from an improvisation that Melnick asked me to perform while she recorded it on camera. We then re-embodied this movement and incorporated it into a longer phrase. The idea was that the phrase would maintain a light quality as if marked (not performed fully) while keeping the sense of detail. The phrase focused on a quality of tracing movement ideas while moving as if preoccupied with other thoughts. Melnick changed this phrase many times and it never settled into a fully defined form, but remained impressionistic. In this section, I often felt that I was dancing on an edge. I experienced this as moving faster, and with more complexity, than I could consciously track with my awareness, by literally being ahead of myself. The material was very detailed but Melnick did not want me to achieve it in a polished way or to make it look too smooth. There were a number of tasks required for this section, which were to move quickly, maintain looseness in the legs and hold the image of being mentally distracted. Initially, it was difficult to find the correct quality, which engendered a balancing process between the mental configuring of the movement and letting the muscle memory unfold. If pushed too much in either direction, the movement lost clarity. This section was light and complex with further changes of direction and a gentle bounce inserted into the phrase when it was repeated. It required

Figure 4.2 Video still of Jennifer Roche in Jodi Melnick's *Business of the Bloom* (2008) #2. Videographer Enda O'Looney.

a balance between being directed and easily fluid – it was known yet not completely fixed. When performing this section, the material seemed to be an accumulation of these traces from rehearsals, an accumulation of multiple possibilities, some of which were referenced and some that did not always materialise (Figure 4.2).

Melnick's choreographic methods are embedded with her sophisticated dancing strategies and her highly developed practice as a dancer, which stems from a lineage incorporating Tharp, Rudner and Brown and displays the body of knowledge accumulated over her dancing life. Indeed, reflecting the knowledge that dancers accumulate and as an advocate of dancing practices, Rudner created a choreographic work in 1975 that spanned five hours and foregrounded the work of the dancers. I had the opportunity to see this piece, entitled *This Dancing Life*, when it was restaged in Ireland by Irish Modern Dance Theatre in 2007 by a group of sixteen Irish contemporary dancers and five US-based dancers.[21] Rudner explained, 'I want the dance to be about the dancers. Choreographers might think of wonderful ideas, but they are useless without a dancer to realise them.'[22] In her endeavour to present dancing as an ongoing practice she ensured that the performers could rehearse the choreography during the performance before presenting it. She said, 'I want the dancers to feel completely comfortable at all times. So I've told them we can rehearse the trickier bits and stop and repeat sections

that might go wrong.'[23] In this way, Rudner presented the activity of the dancer as an ongoing work in progress. In her role as choreographer she also performed a solo in the work and during the creation process often danced with the group in the studio. Indeed, Rudner has created a beginning section for the work that can never be seen by the audience, as it commences before they are permitted to enter the performance space. Thus, Rudner created a private space for the dancers, which prioritised their personal engagement with the movement above its presentation to the audience.

This work is intended to represent the reality of movement as a continuous part of a dancer's life. The movement sections presented are studies in themselves of ideas and treatments of particular themes which have movement as the origin and end, rather than as a tool for the representation of ideas. Audience members are not expected to stay for the duration of the performance but rather to come and go in the understanding that even when they are not witnessing the performance, the dancers are still dancing. Rudner described her idiosyncratic approach to the first iteration of this dance piece: 'I just want to keep on dancing, and I don't care how much the audience sees or if they see the whole thing, we're just going to do this.'[24]

In spite of the pressure to distinguish the work of the choreographer in the dance marketplace, Rudner's approach highlights the dancer dancing in a democratic creative process which also involved her dancing with the group. It is one example of realigning power relationships in dance production, while making the effort, skill and labour of the dancer explicit in the performance. This is further established because Rudner, as choreographer, is seen to dance alongside the dancers, rather than holding a position outside the work of art as a singular author.[25] In contrast, capitalist modes of production promote the author/genius figure and Rebecca Schneider (2005: 36) queries this, referencing Yvonne Rainer's frustration when singled out from the group of Judson artists less because of what she did and more because she lived in an environment that sought to distinguish a 'star' from a group of peers. When a collaborative dynamic is acknowledged, the division of labour between dancer and choreographer becomes unclear and this presents problems when marketing and publicising the work. As Card (2006: 7) explains, it is challenging when there is more than one artist credited with choreographing a work, as 'it is hard to interview a collective'.[26] Furthermore, the durational nature of *This Dancing Life*, alongside the large cast numbers, challenges the market-driven model of an hour-long choreographic structure that can be easily slotted into a festival programme.

In alignment with her creative practice, Rudner has developed a teaching ethos that embeds a sense of aliveness and autonomy even with dance students in training. This is focused on maintaining fluidity while building technical awareness, as she employs two fundamental premises: 'one is stay in motion, don't stop. The other is to creatively don't [sic] repeat forms you already know.' Rudner's rationale for this approach is to keep dance training focused on a dynamic type of engagement with a body-in-flux, rather than repeating habitual movement patterns that may ultimately limit the ability to incorporate new movement possibilities. This is achieved by maintaining a dynamic relationship to embodiment. Rudner's purpose is 'to make technical practice a creative act', which can ultimately be transferred to creative choreographic work and this ethos appears to have deeply influenced Melnick's approach.

My performance presence in Melnick's solo was less outwardly focused than within the other two. Engaging in the 'jouissance dancing' defined by Claid and mentioned in Chapter 2, I was drawn back into body sensations by performing a type of amplified interiority, which could also be lost at times under the pressures of the live performance. As when the chain falls off a bicycle, I could momentarily lose my connection into this unfolding movement process. These were the moments when I became distracted internally or externally. Even though I was acutely aware of internal sensations, I extended my attention towards the audience at times to connect to them and bring them with me through the choreography. With Melnick, I experienced the accumulation of layers of information that sedimented as movement patterns. However, these movement patterns remained dynamic and open to change rather than becoming fixed. This was achieved by building information about the movement through experiencing it, rather than creating a phrase of definite positions for the body to travel through. Movements were not individual and separate but part of a wider gestalt.

Many of Melnick's dynamics or rhythmical tendencies seem integrated in my movement approach now and I notice that I tend to draw finer lines in movement. I am also more conscious of how movement is orientated both spatially (in relation to my body and my body in space) and in direction (when travelling through space). Another valuable addition to my framing of the dancing process is the awareness of how to inhabit a 'dance state' that is responsive to inner impulses and creative through and in movement. These incorporated differences are very subtle but through seemingly unconscious processes, they occasionally emerge from my body-in-movement, 'fluid boundaries, unstable ground, nothing to anchor "self". Melnick has a catalysing effect on

my movement.' Though this choreographic process was not obviously collaborative, in that Melnick produced the majority of the material for the solo, my presence seemed central to the unfolding process as we dialogued in the studio. This creative process was not task-based; Melnick found movement, observed how it settled for me and adapted her ideas accordingly. Through maintaining fluidity in the construction of the choreography, she created a multi-dimensional movement portrait. It was a reciprocal and relational process of exchange that was informed by my presence while being drawn from her idiosyncratic movement palette.

5
From Singular to Multiple: Liz Roche

> I feel underlying panic; there is no time to get this
> movement. We talk throughout the rehearsal while
> moving, about anything and everything. Talking like
> this clears the blocks [...] our bodies have softened
> throughout the session. This rehearsal was about find-
> ing our common movement dynamic.
>
> Rehearsals with Roche, Dublin, April 2008

This chapter discusses the creation of *Shared Material on Dying* (*SM*) with Liz Roche and fellow dancer Katherine O'Malley. A solo, danced in unison by three people with only me – the centre dancer – fully lit, this piece explores the engagement with an intensive somatic sensibility in studio and performance. The first image in this solo materialises downstage left, with three bodies in an embrace but only my face looking outwards towards the front, just visible under the low lighting. The lights fade and I appear again at the rear of the stage in the centre, with my back to the audience, seemingly alone under a strong overhead light. I am wearing a black suit jacket – a hidden and secretive figure. There are glimpses of my fingers in the light as they move over my back and the side of my torso in silence. At one point, my hand forms a gun and I shoot myself in my left side. My upper body crumples temporarily before I take a few stumbling steps backwards and then travel diagonally to position myself to the right edge of a square of light that is at upstage centre in the space. I am facing the side. I step towards centre and swing my right arm down, snaking it upwards to stillness before retreating from this pose back to the beginning position. This phrase repeats and accumulates and becomes increasingly complex. Each time I move forward to the next part of the phrase, I repeat elements either as a variation or

deconstruction of the sequence. It is a series of stutters and stops, inter-spersed with long arcs of fluid movement. In the silence, the sounds of stepping and little murmurs are louder than they should be for one singular person. At one point someone (not me) says 'I don't remember' and someone else says 'Oh yeah', before I move on in the phrase. The lights either side of me gently brighten. There is something reflective in the darkness to my right side and then, as I move towards the front of the stage, the silhouette of another body is revealed to my left. There are two other dancers, each either side of me in the darkness. Although they are not fully lit, the three of us can now be seen by the audience moving as one, in separate channels running up and downstage that never intersect. The tension increases as the sense of this fragile unison becomes apparent. There is no music to draw us together, we are listen-ing intently to each other.

This deconstructed phrase ends towards the front of the stage. Our left hands again form a gun and we walk slowly upstage to shoot our-selves in the left side. We stumble through the next movement phrase, hand on the wound, sometimes checking it and once saying 'Oh my God, I'm bleeding' while still moving together (Figure 5.1). This dance has more momentum. It references the earlier phrase but lurches from one point to the next, almost out of control but still in unison, until we come to rest standing downstage. Resolutely, we turn and walk away from the audience. Stopping suddenly, we scratch our heads and drop to the floor. We remove our jackets, as the shapes become more earth-bound and sculptural, retreating further from the onlookers into the darkness at the back of the stage. We make one final trajectory forward, absent-mindedly checking through tiny gestures of touch – shoulder, elbow, wrist, forehead – what still remains. Ending sitting on the left hip, resting on the left hand, our heads scan around to see the audience. A final utterance of 'OK' and our three dropping heads mark the end.

Roche began working on this solo, which is embodied by three danc-ers, through creating a movement phrase that she then broke down into shorter sections. The phrase consisted of movements that she said 'had kinaesthetically made sense to her' and that during the process of teaching the material, she began to unconsciously assign meaning to the movement.[1] Roche explains how the ideas for her work emerge from the everyday:

> For me, it doesn't follow a creation process. Sometimes I'd be wash-ing my hair and get an image of [...] a strong choreographic pattern in my head. Or I might see something happen [...] then I start to

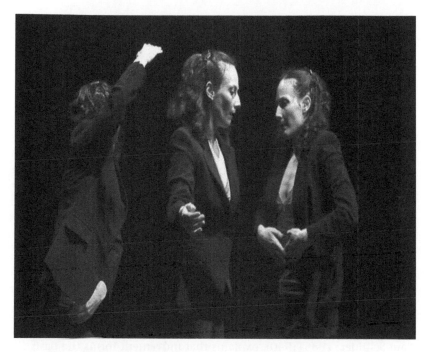

Figure 5.1 Jennifer Roche in publicity image for *Shared Material on Dying* (2008) by Liz Roche. Image by Enda O'Looney. Courtesy of Liz Roche Company.

think about what the pattern means, and ideas grow out of that [...] I would prefer to keep things more instinctive [...] I have a basic fascination with the grounding, and the expression of these concepts through the body. My work is through the body. (Liz Roche in Mulrooney 2006: 157)

As certain movements in *SM* began to look like responses to physical pain, Roche subsequently built in the story of a gunshot that we inflict on ourselves two-thirds into the piece. This had the effect of introducing a narrative through-line into what had been an abstract movement study. The gunshot retroactively made sense of the previous movements as they were repeated in a new way, to represent checking our hands for blood or holding the sides of our bodies in pain. Roche explained how the idea for the piece arose:

I was interested in having an experience, with Jenny [Roche] and Katherine [O'Malley], so that there was a sense that Jenny was doing

a solo but her timing relied on us and we were helping her, or getting in her way. I just liked the idea that we could be some support to her through it [...] it's a solo, there are just three of us doing it and I see it that way.[2]

Roche sometimes worked separately on developing the material with O'Malley, which she would then teach to me during our sessions. However, it seemed that the shape of the dance could only be approximated in these sessions and needed three of us present to fully define the material. I wrote in my studio notes that she wanted me to be 'an integral part of the unfolding work, rather than just a dancer learning the movement' and 'she seems to only feel which movements make sense when the three of us are dancing together'. The effect that Roche was seeking was that we were the same person divided into three, so that the other dancers looked like my shadows or mirror images to the audience. The demands of this piece were significant because although we attempted to dance together in exact unison, this task could never be perfectly achieved, adding humanity to the futility of the endeavour.

The task of dancing in silence, in unison, for twenty minutes demanded intense concentration and focus. Deane Juhan (1987), after Paul Schilder (1886–1940), explains that movement forms the basis for body perception. In a motionless position without stimuli, the body image loses its definition and orientation. Yet, as soon as the body moves again causing 'various degrees of friction, stretching, and impact [...] the sharp lines of [...the] body's physical boundaries [...] leap back into focus' (Juhan 1987: 187). The other dancers were in semi-darkness and it was difficult to see them. In general, I had sufficient cues to locate them in space but there were moments when I moved off-grid into a type of sensory blackout in which I had to approximate their positions until I could see or hear them again. In these blind moments, I had to visualise where an arm would be or when they were about to step, creating a heightened sensorial experience. This intensified my anxiety when I could no longer perceive them with my senses and increased my sense of confidence when I was able to track their movements, thus producing powerful emotional states, which were concealed under the calm and steady movement. As we did not come into physical contact during the piece, except for the very first tableau, I had to extend this mapping process further out into the space beyond my own body in order to locate the other two spatially.

Gail Weiss (1999) explains that it is through the body image that we locate our embodied selves in the world. Writing from a

phenomenological perspective, while expanding on this to include the importance of cultural, gendered, racial and social factors in the formation of body images, Weiss (1999: 17) defines the body image as a 'dynamic gestalt that is constantly being constructed, destructed and reconstructed in response to changes within one's own body, other people's bodies, and/or the situation as a whole'. The body image is formed through interconnection with the world and therefore no two body images develop in the same way but are the result of the specific conditions of an individual's life experience. Weiss (1999: 18) describes how the body image is open to modification throughout a subject's lifetime:

To be 'dependable', the body image must be flexible enough to incorporate changes occurring both within and outside of the body, while continuing to seek a certain 'equilibrium' which will provide the stability needed not only for effective bodily movement, but also for a relatively unified perceptual experience.

Although it is necessary to have a unified body image in order to experience perceptual equilibrium, there must also be sufficient plasticity to enable dancers to incorporate new bodily configurations. When learning choreographic movement, dancers must integrate new information into the body image in order to re-establish a bodily unity that incorporates the learned movement. According to Schilder (1950: 208), dance is 'a method of changing the body-image and loosening its rigid shape' – in as much as we seek stability, there is a desire to 'loosen' these boundaries. Schilder (1950: 209–10) explains how the body image transforms from stabilised contained entities that dissolve into a stream of experiences in movement to become less stabilised, only to recompose again into 'better form and changed entity'. As an example of a conscious reconfiguring of the body image, Bennett describes the process of incorporating movement by choreographer Wayne McGregor, with whom she danced from 1997 to 2002. This passage illustrates Bennett's use of imaging strategies in order to encompass new and complex movement possibilities; 'it was kind of an *outside-in* process, quite image based. And I would somehow manage to map some images in my head that he was making on his body and then by using those images, bring it back to myself.'[3]

Returning to *SM*, where there was a requirement to extend the body image across three dancers, this experience of embodiment aligns with the concept of subjectivity as a multiple and porous phenomenon.

Schilder (1950: 137–8) explains that the body image is socially constructed and not contained by the boundaries of the skin; from infancy 'the child takes parts of the bodies of others into its own body image [...] postural models of the body are closely connected with each other'. The challenge in this choreography was managing the spatial element of the shared body image, which was both singular – orientated around each of us in a separate part of the stage – and multiple – extended outwards to incorporate each other in the wider schema of the piece. The space around each of us had to be divided, reminiscent of the grid technique in figure drawing, where the object in space is placed within a subdivided frame. We accomplished this through discussing details such as the number of steps taken or angles of limb extensions into space. This was also similar to corps de ballet work, in which, as Foster (2009: 26) describes, 'the bodily shapings are rendered more geometric [...] the spatial orientations of dancers clearly presentational toward the viewer observing the contents of the proscenium'. However, the choreography did not originate through a geometrical sensibility but we had to analyse and define how we might classify it through a shared understanding of shape and direction. These measurements had to be reconstructed in each new rehearsal and performance space and the distance between us maintained throughout the dance. The material was strictly defined with no room for individual nuances or flourishes. I wrote, 'I am not able to move without the others. The movement is the information; I just have to embody it. Not singular, but multiple. Consciousness is spread around the room. A strange feeling of being separate and taking the movement on, and at the same time being part of a bigger whole.'

In as much as the body image is a subject's perceptual, conceptual and emotional attitude to her/his body, 'body schematic processes are responsible for motor control'; they are almost automatic and operate below conscious awareness (Gallagher and Zahavi 2008: 146). These sensorimotor operations function independently of conscious intention, organising bodily posture and movement in relation to the immediate environment and work most efficiently when the object in focus is not the subject's own body (Gallagher and Zahavi 2008; Gallagher 1995). Each time a dancer must incorporate a new movement pattern or coordination that does not come naturally, she/he must interrelate with existing body schemas and reorganise. This is evident in Bennett's description of mapping images from McGregor's body and transferring them in ways that correspond with her previously established movement sensibility.

It can be surmised that choreographic movement has a profound effect on the dancer's body image but equally it deeply influences the body schema – the way the body is organised in movement, as defined above. To explore this further, we must first look at how movement is registered by the nervous system. Montfils, Plautz and Kleim (2005: 471) explain that 'motor skills are encoded as enduring neurophysiological changes within motor areas of the central nervous system'. These skills are encoded through a motor map or engram (Montfils, Plautz and Kleim 2005). From a somatic perspective, Juhan (1987: 266) explains, 'the engram is the cortex's means of learning new skills and behavioural patterns, and of imposing them upon the primitive levels of our motor organization'. When a particular motor activity is required, a subject recalls and reproduces the appropriate engram. Juhan (1987: 273) explains how motor engrams 'encode a particular movement, but also a sense of "style" which can permeate all movements' saying that these can alter the style of 'nearly everything we do'. Bennett described how working with McGregor over a period of five years had a cumulative impact that shaped her moving identity:

> The vocabulary was such a seal, such a stamp on the way that I move that I felt very strongly about going through a process of shedding all of that. As much as I appreciated the speed and the articulation with which I had learnt to move in his work, I also felt that it was too much of a style in my body and my natural way of improvising and I wanted to shed some of that in order to be able to enter another way of moving.[4]

The moving identity could be conceptualised as the accumulation of past *choreographic* engrams that continue to circulate and influence the dancer's movement choices in the present. At the University of Southern Denmark, Susanne Ravn (2009: 262) interrogated the sensations of space, weight and memory in a phenomenological study with dancers, finding that her subjects experienced how previous choreographies and training experiences 'leave traces' and that these can 'suddenly reappear when moving' in improvisations. This haunting by past movements demonstrates how traces of choreographies circulate and continue to influence after the dancing event. Shusterman (2006: 4) explains that the 'preferred repertoire of neural pathways' forms 'the precise makeup of an individual's nervous system' and this demonstrates how dancers form a moving identity through the assemblage of a repertoire of movement experiences. Each dancer is

specifically located in a unique unfolding of embodied experience and therefore, each moving identity is unique. It is constructed through a specific life path and range of experiences that make it particular to that person.

When learning new motor skills, the new engram often overlays previous engrams as the new skills are developed (Juhan 1987). This can be challenging to achieve as habitual ways of moving must be interrupted and patterns reset. These were the modifications that we had to make within this piece, to override some of our individual habitual responses and redirect movement through other pathways. As a way of understanding how established movement patterns can be superseded by new ways of moving, a process with which dancers are continually engaging, I turn briefly to Thomas Hanna (1928–90) who was originally a philosopher and became a practitioner of the Feldenkrais method before developing his own system (Johnson 1995: 339). Hanna coined the term 'somatics'[5] and developed Hanna Somatic Education® which addresses the pathologies that arise from the habitual and involuntary contraction of muscles through stress responses and injury. Hanna Somatics specifically focuses on treating sensory motor amnesia, which Hanna (1988: xii–xiii) explains is the accumulation of stress and trauma responses, causing the activation of 'specific muscular reflexes [... which when] repeatedly triggered, create habitual muscular contractions, which we cannot – voluntarily – relax' [my insertion]. Similarly, developing habitual ways of moving, through codified dance techniques for example, can limit our ability to explore other options.

It can be counterproductive to force changes at the neuromuscular level as muscles contract further if pulled forcibly into position, due in some part to the protective function of the stretch reflex. However, Hanna found that the involuntary contraction of a muscle could be released by engaging directly with the brain's sensorimotor functions through voluntarily using the muscle or muscle group in question, thereby sensing the area more fully. The release and subsequent clear functioning of the muscle is achieved through biofeedback to the sensorimotor cortex, wherein this sensorimotor feedback loop allows 'the muscular system to adjust itself to more efficient functioning'; Hanna (1979: 159) states that this is not a question of '"mind over matter" but of sensory over motor'. By engaging the sensory motor cortex, voluntary, that is, *conscious* movement can affect changes to involuntary habitual movement patterns and this is a theory that is effectively utilised in other somatic practices such as the Alexander Technique and the Feldenkrais method.

To give an example of the subtlety of shifting movement patterns, when I made the transition from classical ballet training to working in contemporary dance, the only way I could achieve an intentional fall would be to close my eyes and lose control. These moments were hesitant and unconscious as I momentarily lost track of myself in space. I experienced this change from verticality to floor-bound contemporary work as a plunging into the unknown. After years of training that curbed instinctive physical reactions, I did not know how to allow my body to react to the fall instinctively and so I forced myself to fall through creating a kind of sensory blackout. Ballet had taught me to drive the changes in my body and this awareness took many years to cultivate to the point that it felt natural.

SM produced a feeling of *otherness*, of being disconnected from the material through being both the mover and the observer of the movement, waiting to move and then finding oneself in movement. The resulting discontinuity interrupted the clear intentionality of physical activity of the body schema, which, as Gallagher and Zahavi (2008) outlined, functions best when the body itself is not the focus of the action. The self-consciousness that was created through the need to continually observe the other two dancers interrupted the free flow of movement and highlighted the divisions between the intention to move, moving and observing the movement, requiring heightened presence in order not to anticipate weight changes or fall behind impulses. In performance, I had to stay engaged in this performative present in order to maintain focus throughout the different modes of action and attention needed. This presence was woven into the fabric of the movement and became intrinsic to the correct execution of the piece.

In the gunshot section mentioned earlier, there was a faster and more weighted sense of falling from one movement to the next, to convey the dramatic nature of the moment. The challenges in performing this section lay in the tension between staying in unison with the other dancers while moving at a fast pace, which resulted from complicated weight shifts and impulses. The movement had the tendency to almost overtake the body's ability to execute it, as it fell from moment to moment in a state of controlled abandon. This state required responsiveness to the others, poised between waiting and pre-empting the movement. It was like the moment when a building caves in; there is a build-up of tension before falling into collapse. Although there was a dramatic narrative throughout this section, I was not pulled into the drama of the moment. This was because three bodies danced the piece, which removed it from a singular to a multiple, a personal to a shared,

experience. I wrote, 'connection, history, part of a whole – I don't experience a sense of individuality. This work is not about expressing a "self". In this way, the solo represents my working process with Liz. I am somehow aligning to a shape or form that feels as if it's already in existence, part of a bigger picture.' Moments such as scratching the back of the head or brushing something off the sole of the foot, all carried out in unison, were experienced both as personal expressions and as wider abstracted actions. These moments emphasised details that might normally indicate the subjective expression of an individual dancer.[6]

During performances, as I was the only dancer lit onstage, the gaze of the audience seemed magnified as each movement and expression was amplified. This sense of scrutiny created a stark dimension in the work that was not present in rehearsals due to the shared experience of dancing together. In performance, the audience seemed like the external projection of my internal observing eye. I did not focus my attention on the spectators because I was occupied with sensing the other two dancers (Figure 5.2). My attention was drawn into unfolding the detail of the movement, rather than into the narrative themes that were produced through the dark costuming, lack of soundtrack and poignant subject matter. Roche asked us to exaggerate some of the moments of strain in the gunshot section in order to add to the dramatic quality and at these times, I consciously directed this expression outwards to the audience. There was no need to construct a supplementary performative self, as the performance quality happened as a result of my activity. However, I was required to present composure despite the many levels of emotional turmoil and anxiety that I felt in attempting to connect with the other two in relative darkness. I experienced this as a kind of duality projecting serenity in spite of the underlying tension and unease.

The in-depth analysis required in order to align our movements in this solo made me aware of the differences between the soma as internally sensed from the first-person perspective and the body as perceived from the outside. This was never more evident than when trying to embody each of our idiosyncratic dancing predilections to create a common sense of sensation, timing, imagery and dynamic. Hanna (1995: 341) recognises that there are significant differences between an individual viewed from first-person and third-person perception; this is because 'the sensory access is categorically different as are the resultant observations'. Externally viewed, bodies appear as objectively measurable entities that obey 'universal physical and chemical principles' (Hanna 1995: 341). In contrast, Hanna (1995: 342) explains, 'from

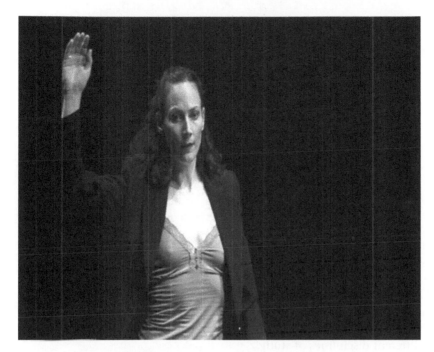

Figure 5.2 Video still of Jennifer Roche in Liz Roche's *Shared Material on Dying* (2008). Videographer Enda O'Looney.

a first-person viewpoint [...] quite different data are observed. The proprioceptive centers communicate and continually feed back a rich display of somatic information which is immediately self-observed as a process that is both unified and ongoing.'[7] The contrast between these viewpoints is stark.

Anna Pakes (2006: 87) writing about the relationship between dance and cognitive/neuroscience, explains that current scientific approaches to the study of consciousness indicate a move towards 'physicalism', whereby 'consciousness must [...] be explicable – if it exists at all – in physical terms'. In dance, this has directed research towards mapping the brain activity of subjects in motion to yield awareness of mirror neurons,[8] for example. Since 2002, Wayne McGregor has been developing research into the area of choreographic cognition, utilising input from cognitive scientists to increase the potential of dancers and choreographers to extend creative options in the dance-making process (Delahunta, Barnard and McGregor 2009). Similarly, research

undertaken in the *Unspoken Knowledges* project (Grove, Stevens and McKechnie 2005) explored the cognitive functioning of choreographers and dancers in the creation of choreography. These research projects have added value to the status of dancers by uncovering the sophistication and complexity of the skills they embody and point to the rich possibilities for interdisciplinary collaboration between dance and cognitive and neurosciences.

However, Pakes (2006: 89) explains that to date many projects exploring 'cognitive and neuro-science of dance' are embedded in scientific enquiry and thus, approach these explorations empirically rather than including philosophical investigations of embodiment. She questions whether physicalist approaches can account for other dimensions of the phenomenological or *lived* experience of the dancer and the many complex layers of experience that surround a dance movement, explaining, 'a description of the physiology and neuro-physiology of a dancer raising her arm will not help us appreciate the complex of kinaesthetic sensations she feels, or other aspects of her phenomenal experience' (Pakes 2006: 95). Gallagher (2005) claims that an interdisciplinary approach is necessary to investigations of embodied cognition, albeit somewhat perilous to attempt to conceptualise across a range of different disciplines of study.

Merleau-Ponty's corporeal phenomenology recognises that 'experience is always necessarily embodied, corporeally constituted, located in and as the subject's incarnation' (Grosz 1994: 94). While acknowledging the subjective nature of this position, Grosz (1994: 95) highlights that this aligns 'experience to the privileged locus of consciousness' and thus, demonstrates how the lived body can be a producer of knowledge. Some choreographers are exploring this terrain through the structure of their choreographies, that is, making the dancer's experience explicit in the work. In January 2014, British choreographer Siobhan Davies presented a work entitled *Table of Contents*, which gave the audience the opportunity to experience the embodied knowledge of the dancer through the performers' (including Davies') articulation of the activities they were engaging in. Dance critic Judith Mackrell (2013) explains how this intimate performance at the Institute for Contemporary Arts, London illustrated to dance experts and non-experts alike the skills that dancers possess.

> Even more revealing is the item in which we're each invited to instruct an individual dancer through the apparently simple task of getting from a prone to standing position. The complexity of

swinging, levering moves involved in this everyday action is a vivid reminder of just how exquisitely complex the art of dancing is.

Jérôme Bel's choreography and subsequent film *Véronique Doisneau* (2004) is another type of exploration which created structures for this dancer's personal narrative to be revealed. It centres on the career path of the Doisneau, a 'subject' (meaning a dancer who can perform both soloist and corps de ballet roles) of the Paris Opera Ballet who is on the brink of retirement. As a lone figure on the vast stage of the Palais Garnier theatre she talks about her dancing preferences, as well as performing extracts of different pieces from her personal repertoire as a member of the company. This insightful study of one individual dancer's experience within a large dance institution reflects the underlying power systems at play. Bel subsequently followed this work with a dance piece entitled *Cédric Andrieux* (2009), with the same premise but focused on the work of Andrieux, a dancer with the Merce Cunningham Dance Company for eight years. In an interview with dance critic, Donald Hutera (2011), Bel explained that his intention was to demystify dance and highlight the specialist knowledge that dancers possess from being so close to the dance work, while acknowledging that dancers are not visible within the discursive arena of a dance piece as it is usually dominated by choreographers and critics.[9]

Casperson (2011), from her collaborations with William Forsythe, has written about the dance-making process in detail, explicating the subtle skills of the dancer's practice within Forsythe's choreography. Her articulate analysis of the creative process of Forsythe's *Decreation* (2003) brings new perspectives to the work through measuring the impact of the process on the dancers and the roles they embody in materialising the piece. An example of dancers writing about dancing processes can be seen in Claid (2006) in which she captures her experience in passages that utilise an autobiographical stream of consciousness text. Externalising her inner voice alongside an academic appraisal of her themes produces a polyvalent text that shows the impact of dance training and professional practice on Claid as a human subject, rather than as the mythologised dancer. Hilton (2012) has also written evocatively about her embodied experience in the article '10 Realisations Made Possible by Acts of Dancing', presenting dancing as a mode of knowledge production that yields ontological insights:

I think that by watching her [Jennifer Monson] I'm empathetically having that experience and that by dancing with her I'm somatically

absorbing that experience. I'm thinking that dancing is deeply incontrovertibly, socially constructed. It fleshes out, manifests, that space between interiority and community [my insertion]. (Hilton 2012: 7)

Davies and Bel have demonstrated how narratives emerging from practice carry a sense of the embodiment of the experience of dancing and that the immediacy presented through the autobiographical mode maintains connection to corporeality. Alys Longley and Katherine Tate (2012) describe practice-led dance writing as 'movement-initiated writing', stating, 'the practices of dancing and writing are imbricated in each other. If the writer has not participated as a dancer or choreographer in the dance work of which they write, they are working in the more general field of documentation, rather than movement-initiated writing' (Longley and Tate 2012: 234). As an example of this, the following passages written from the first-person perspective of each dancer in *SM* reveal what this 'lived' experience might offer to illuminate the underlying complexities of this particular piece. These passages articulate from our three different perspectives what passes through each dancer's consciousness when dancing the same fifteen-second moment (Figure 5.3).

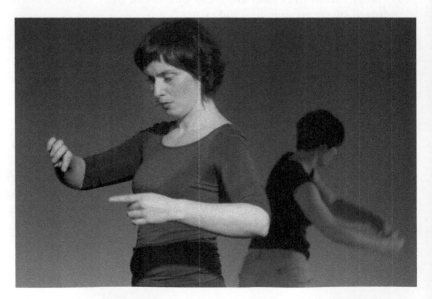

Figure 5.3 Liz Roche and Katherine O'Malley in *12 Minute Dances* (2009) by Liz Roche. Photograph by Maurice Gunning.

Liz Roche: As we are standing waiting to begin the movement I have to visualise the three small sections in succession and confirm to myself that I am clear about the sequencing. The three are versions of each other so I can get confused. At one point I was last in line but recently have been the head of the line so it is my responsibility to get it right. Wait, for a 'slightly longer than comfortable' time. Weight shifts to left foot. I sing the rhythm of the movement to myself as we are doing it. When my elbow dips with my right side ribs there is a sensation that I can identify and gauge as 'correct'. Hold. Release hand. All energy goes to right heel and as I travel slowly backwards, that sensation in my heel travels up the side of my right leg as far as my right ear. I check spacing in relation to my centre mark on the stage and I am standing again on both feet. Take three steps to end. I must remember to relax my feet and breathe, which is peppered with thinking, 'just do the thing – not that big of a deal – be light with it'. I re-check the sequence again in my mind before moving. I decide not to cough or think about the silence. Remember that the next one turns.

Jennifer Roche: My weight drops into the right foot and before I step to the left my right wrist engages, ready to undertake the circular action. I visualise the final position, the place that I have to reach. The first movement feels constructed by numerous corrections from Liz – keep spine lengthened before moving, don't let upper back collapse, keep the flow through the movement – as I transfer weight to the right leg. I tune into Liz ahead of me. I move slowly enough to catch the beginning of her movement. Weight transfers to the outside of the foot as left knee bends. Step forward and right ball of foot drags along floor as knee opens, elbow circles back further than leg. This movement has been adapted and changed many times so the modifications construct the shape in my mind's eye. Starting the movement with the other two and leaving them for a moment, when I arrive at the final shape, I find them again in momentary stillness. I release the hand and a chugging rhythm comes into my mind. Sometimes I sing it under my breath to give a sense of continuity and to slow me down, as I am less sure of the shapes on the path back to the beginning position.

Katherine O'Malley: Suspended, joined, intentionally waiting. Pelvis moves, gently swings right and pours weight into the right foot, arch bridging the floor – it helps me stand. Left hip joint dips, softening and bending the left knee to step forward carried

by the girls ahead of me. We're part of the material, something that stretches, ties and supports us to be the same. Transferring all the weight to the left foot, folding in the right knee influencing the right hand to curl and draw up, they reference each other – right wrist (I think of a rearing horse) – right knee leads, soft on the ball of foot and then stepping right, the wrist, arm drops opening the torso with a swing to enjoy a moment of abandon. As soon as it arrives I know it's over and I follow the girls forwards again with the knuckles of my right hand along a similar landscape. At the end of this the arm curls overhead and I feel us all solidify. I think of a sickle. We wait here, I remember waiting here with Liz in the studio; we didn't know what was going to happen next. Then she lets her hand drop open, fingers drip towards the floor and we dissolve back, stepping back on ourselves, retreating to watch the space. The right hand falls into the space in front of us. Waiting. I feel that my gaze can rest more comfortably on Jenny now and I have a blueprint of the messages from moments before to guide me so I feel ready.

The potential to write or speak about the dancing process represents the possibility for dancers to claim an expert position, a Deleuzean *line of flight*[10] which extends knowledge beyond the territory of the studio and the inherent power dynamics surrounding the choreographic production to establish alternative creative and critical outlets. The absolute immersion in the choreographic environment may produce in certain instances sense of disempowerment and creative disenfranchisement for dancers, yet it is this very absorption and the knowledge it produces that would allow for the revelation of unique insights about the creative process, leading to opportunities to reclaim these knowledge-producing experiences. Embodiment is re-materialised through personal narratives and this can be powerfully conveyed from the point of view of dancers as they bring to light finely tuned descriptions of corporeal sensation. As so few of these insights were available to access through other avenues, I was inspired by the clarity with which my interviewees articulated complex bodily processes such as the relationship to movement as other, the ways that choreographic movement is imprinted on the moving identity and the embodied knowledge gained over years of this type of engagement and reflection. In order to reveal these perceptions, the enquiry must be centred in a dancer's own experience, which may differ significantly from a choreographer's understanding of any given process. Speaking from this identity as mover and thus linking narratives with embodied practice evokes an authority all of

its own. Bojana Cvejić (De Keersmaeker and Cvejić 2012: 8) explains how choreographers and dancers must contribute to the development of theoretical perspectives on dance by explaining their processes and methodological tools to '*amateurs de danse* and scholars' in order for more complex understanding to circulate within the theoretical field of choreography [emphasis in original]. She explains that there is still insufficient self-reflective writing from artists, which is needed in order to 'illuminate choreography as an authorial poetics' (De Keersmaeker and Cvejić 2012: 8).

The accounts from the experience of dancing *SM* above illustrate the series of multi-modal stimuli that become encoded over the course of rehearsals and then recalled in performances of the choreography. In dance, memory is multi-modal – kinaesthetic, visual, auditory, spatial and temporal – employing implicit knowledge, such as the ability to perform certain movements, and explicit knowledge, that is, the understanding of movement phrases and how they fit together (McKechnie and Stevens 2009). When memorising information, encoding happens by creating meaningful connections to already existing knowledge (Schacter 1996). McKechnie and Stevens (2009) explain that the majority of explorations of memory for dance have been carried out with ballet dancers, who draw from a lexicon of established movements. In contrast, there has been little research into contemporary dance, which utilises novel movements (not from a fixed vocabulary) that usually emerge in a dynamic interchange between choreographer and group in the relational setting of the dance studio (McKechnie and Stevens 2009).

In dance, the choreographic piece is built up over time through creative experimentation, rather than dictated as an already completed plan from choreographer to dancer. As a dancer develops new choreographic pathways through discovering and defining movement material, complex coordinations become increasingly familiar and achievable. Instructions about quality, rhythm and timing of different movements further finely tune the choreography, which becomes increasingly delineated through this process. Connaughton[11] described how he forms 'a mental pattern of the piece in [his...] head, an emotional, mental, energetic pattern'. This involves mapping the schema of the choreography in such a way that this can be repeated accurately under the pressures of live performance in front of an audience. This map contains associations that produce particular types of experience, body texture and sensation. In my rehearsal notes, I wrote that I experienced the dance works as webs or matrices, resembling holographic images.

These maps held the information of the pieces, showing the specific alignments and dynamics of each work: 'I contain them and they contain me as we interweave'. Although this schema of the choreography must be outlined in such a way that this can be repeated accurately, it must be flexible enough to allow for variations that could occur in the live performance environment.

The level of attentiveness required in dancing *SM* made me aware of the duality I experienced between my busy internal world and my serene performance identity, bringing to attention the myriad negotiations I engaged in throughout dancing the piece. Roses-Thema (2008: 7) through her interpretation of neuroscientist Antonio Damasio's theories of how embodied experience is mapped in cortical regions, explains that dancers in performance are constantly 'negotiating a multitude of variables making rapid in-the-moment decisions'. She writes that embodied states are mapped as *in the moment* events and are registered as they are happening, altering from moment to moment because 'the internal milieu changes from second to second' (2007: 3). She argues that dancers experience even subsequent performances within the same performance venue as different and thus, their strategies need to be flexible and responsive to the changing environment. Roses-Thema (2008: 4) writes, 'changes, reactions, and relationships are born and dissolve between the dancer, audience, and choreographer (through the choreography) during a live performance'.[12] Writing from her experience of dancing in his work, Rothfield (2008) gives an example of how Dumas purposefully cultivates an approach to embodiment which keeps the dancers attentive to these somatic states. Rothfield (2008: 8) outlines how Dumas seeks to enable the dancer to be a 'body available to movement', so that this body 'can adapt to new physical requirements of emergent movement vocabularies' through the negotiation of an unstable stance. Rothfield explains that this differs considerably from the way that classical dancers must make subtle adaptations when performing familiar steps from highly defined vocabulary of classical ballet. She writes:

> Dumas explicitly rejects the notion of control in his work, preferring to speak of the dancer's management of instability. He intensifies that instability by keeping to a narrow base (legs under hip sockets) rather than the soldier's wide stance with feet firmly planted on the ground. Allied to the elimination of muscular holding patterns and the increase of felt sensation, this body is alive to the micro movements that emerge and cluster around a choreographic moment. (Rothfield 2008: 10)

By oscillating between stability and change, dancers demonstrate an intensified ability to repeatedly incorporate and integrate new motor skills that are imprinted on the central nervous system. In the way that new motor skills impact on existing movement patterns, choreographic engrams alter the dancer's moving identity over time. The many layers of instruction and adoption of specific strategies form a corporeal map that, like a score, forms the choreography. This seems to be the plan that a dancer adheres to in performance, located in body sensation and internalised choreographic instructions. This plan is built through trial and error in rehearsals, throughout the process of anchoring ideas into the body's tissue. As this map flows from a dancer's corporeal relationship to the environment it forms a wider matrix that settles into a specific performance identity. Thus, dancers have moments of stability through which they can organise around a particular performance identity – only to be destabilised again within a new creative process.

I performed this piece in four subsequent settings and the cast changed twice to incorporate a different dancer.[13] This required us to recalibrate our shared moving identity each time. In the rehearsals for a performance at the Purcell Room in London's South Bank Centre, I remember working on the movement that was repeated many times throughout the piece and is outlined in the texts above. I tried a number of times to find the correct placing of the arm and body, the right timing and swooping action and the correct placing of emphasis in the phrase. Although this was a minor moment, I experienced this rehearsal as a kind of breaking through my embedded patterns to find the correct detail. After I accomplished this, it anchored me firmly in the work each time I danced the piece, so that the rest of the piece unfolded with less conscious effort. It was a way of tuning in. I wrote about this moment, 'each time I go to re-embody the trio/solo I am acutely aware of my body having been unhooked from the "grids" that tie us together in the work and that I need to re-find the co-ordinates of our three bodies moving together in space'.

This solo process involved choreographer and dancers moving together in the studio as articulated in the previous chapters through Gardner (2007a) and Rudner and it resembled Melnick's process of configuring through dancing. It also resonated with the structures of Authentic Movement, whereby the mover is authentically present to the movement as it is happening. Working on this piece, I shared a moving identity with the two other dancers. Our established dancing relationships meant that there was a sense of shorthand in the studio exchanges. Less time was taken for explanation and, due to

time pressures, more focus was given to breaking down movements, analysing and clarifying details as well as integrating differences in how we executed the material. For example, if any one of us had difficulty articulating a movement in a particular way, we had to find a common ground between the three of us so that we could be in unison. In spite of the familiarity of this working environment and the long history of working together, the choreography was still new and it took intensive analysis to feel fully integrated. The process of finding a common movement vocabulary that was still fluid and dynamic required me to break through many habitual movement patterns and rhythmical tendencies – to open up new movement terrains and experiential spaces.

6
Corporeal Traces and Moving Identities

> I trace the movement behind Jodi [Melnick]. Trance-like my body mimics and responds. I feel passive, in the receiving mode. Then when I have to feed-back, to show what I have managed to capture, I am sure that I don't have it. But something of the shape remains in my body, something of the understanding and co-ordination. Her movement makes me feel like a part of myself that I like. A fluid and feminine energy directed and clear. So much so, that I wonder am I copying her in life too. Are my mannerisms becoming like hers? When I was little, I used to copy personality traits that I liked in other people, until I would catch myself doing it unconsciously and then stop myself. That felt like a lie, as if there was some more profound self that I should be true to.

In spite of the fragmentation that I experienced in rehearsals, in the performance of *Solo³*, I found a sense of continuity that led me through the three pieces. The entire programme became a complete gestalt so that the separation between each solo was less distinct. The process of destabilising my known and habitual movement which seemed central to integrating the new choreography throughout rehearsals was no longer as pronounced in performance as the three-solo-evening became solidified into a sixty-minute event. The running order of the solos created a particular pathway that I assume would have felt very different if they had been run in another sequence.

I identify this feeling of continuity, whereby I began finding connections and through-lines, as the process of the moving identity. Core

to the notion of the moving identity is the relationship to multiplicity which dancers engender. This idea comes into focus in relation to the incorporation of numerous inscriptions as exemplified in the *Solo³* project.

Multiple dancing selves and multiple configurations of selves have the potential to reform and be redefined temporarily into a stable entity such as a dancing identity, a choreographic work, or in the case of this project, an evening performance. I am drawing from the notion of being multiple and thus composed by numerous selves rather than contained within a singular or 'molar' identity. Deleuze and Guattari (1987: 159) identify the complex networks of social connections, which impose a dominant reality on subjects and enclose them within 'molar' identities in terms of three major social strata, 'the organism, significance, and subjectification'. These strata demand the following, 'you will be organized, you will be an organism, you will articulate your body – otherwise you're just depraved. You will be signifier and signified, interpreter and interpreted – otherwise you're just a deviant. You will be a subject, nailed down as one' (1987: 159).

Deleuze and Guattari encourage shaking off these organising principles in order to experience the disorganised and undifferentiated being-ness that underlies these stratifying concepts (Colebrook 2002: xxi). The resulting state is the Body without Organs (BwO), which supports an exploration of contemporary dancing practices that rupture the paradigm of the choreographer and dancer as singular and separate molar entities. For example, Bel gives an example of being inhabited by multiple selves, in which he names the variety of bodies that he was inhabited by while writing a particular text; bodies with names such as Samuel Beckett, Peggy Phelan, Madam Bovary, Diana Ross and further 'unknown individuals in the megalopolis' in which he lives (Bel 1999: 36; Lepecki 2006). He writes, 'what we call my given body actually consists of billions of bodies. The upshot is that in any interchange, including writing and reading, my body is contaminated by your body' (Bel 1999: 37). Bel's 'refusal to accept the notion of subject as a self-representational, closed entity, limited by its localizable and visible corporeal boundaries' (Lepecki 2006) mirrors Deleuze and Guattari's (1987: 260) proposal that 'a body is not defined by the form that determines it nor as a determinate substance or subject nor by the organs it possesses or the functions it fulfills'. As Deleuze and Guattari (1987: 30) explain, 'the full body without organs is a body populated by multiplicities'.[1]

I experienced the borders of each different process as I uncorporated and traversed between them in rehearsals. I became plural; inhabited by

these multiple differentiated incorporations. Each creative environment required a clear change in attention and bodily attitude. When rehearsing with Jasperse, on the day before the performance, I was aware of the certainty of his movement which had clear points of arrival. It had a pro-active and extroverted quality. Having spent two hours with him in the studio and clarifying the different qualities and bodily positions required for the movement, I had the desire to fully concentrate on this material and its specific detail, to rest in this one place. A rehearsal with Melnick followed this session with Jasperse which interrupted the previous bodily state. In the attempt to change focus to the next piece, I became aware of a heightened definition in my muscularity which lingered as residue from Jasperse's movement. This sensation was too generally located throughout my physicality and insufficiently sensitive to allow me to express the subtlety of Melnick's movement. Her movement required me to be in a dance state through which I could be in flow while expressing nuanced detail in my gestures.

The process of building up the choreographic schema in Melnick's solo, like sediment settling over time, stimulated a particular way of performing. Rather than thinking my way through the movement, as I did at times in Jasperse's piece, I allowed Melnick's embedded choreography to rise up out of my body. I did not feel as if I was making this movement happen, but rather, I entered into the solo by tapping into unconscious memory states through a kind of trance. Rather than consciously leading the solo, this particular process allowed me to be somewhat passive, to be more of an observer than to direct each movement. This receptivity became more apparent when making the transition into rehearsals for Roche's piece which I again experienced as an intrusion. Being carried along by the movement was the residual sensation I brought forward from Melnick's solo and it was not appropriate for the third piece. Although Roche's work required absolute accuracy in order to maintain strict unison, each dancer had to share responsibility for achieving this. Moving from the internal quality of Melnick's work, to incorporating the embodied presences of the two other dancers into my bodily schema in Roche's piece, required me to find common ground quickly and to jettison any lingering preoccupations from the previous two processes.

The transition from Melnick's rehearsal which had settled into a comfortable and fluid state, to Roche's rehearsal, was like being thrust outwards into a somewhat volatile and risky environment which required a rawness that went beyond merely a performance style to engender a contrasting experience of beingness. The sense of risk came

from the way in which the trio exposed any mistakes made by the performers and the heightened concentration needed over the length of the piece. There was also an intrinsic continuity between rehearsals and performance in this piece, because the only way to rehearse this work was to dance it fully together as if in performance. Mistakes, such as timing discrepancies, only became evident in these moments. This third piece evoked inner anxieties and self-consciousness, putting me in a constant state of checking and assessing my execution of the movement. This experience felt more 'real' to me than the other two solos. This is because I was unable to hide behind a performance veneer, where I could mask my mistakes. Quite simply, as a solo performer in the other two pieces, I could deviate from the choreographic script without the audience knowing.

Although this was an extreme example of moving through three solo works in a condensed time period, throughout my previous dancing career, I had felt decentred frequently, as if being constructed and pulled apart through the various creative projects that called me into being differently as a dancer. This felt multiple, in terms of the many different selves that I embodied, and simultaneously empty, as if there was no true essential self as a reference point. From a psychological perspective, Salgado and Hermans (2005) explain that multiplicity is an established paradigm within social constructivism, as it accounts for the human experience of being different selves within different social contexts. Although we may be aware of the multiple personalities that are brought into being through various situations, we usually have a concurrent sense of continuity of selfhood. Social constructivism defines this continuity as an accumulation of behavioural patterns, memories and social contexts into a concept of self that allows self-recognition, rather than being regarded as evidence of a deep, essential self. This connects to Deleuze and Guattari's (1987) notion of fluid selfhood, that is, without a centre.[2] Indeed, in this latter model, which has been adopted 'overwhelmingly' in postmodern philosophy, 'mind and self become socially distributed processes' and thus the inner self is seen to be a myth that is formed through language and social games (Salgado and Hermans 2005: 6–7). Articulating the Deleuzean perspective, Slavoj Žižek (2004: 117) describes this in the following way:

A Self is precisely an entity without any substantial density, without any hard kernel that would guarantee its consistency. The consistency of self is thus purely virtual; it is as if it were an Inside that appears only when viewed from the Outside, on the interface-screen – the

moment we penetrate the interface and endeavor to grasp the Self 'substantially', as it is 'in itself', it disappears like sand between our fingers.

Dancers' willingness to interrupt the quotidian body and engage in choreography shows the ability to throw off conditioned movement, which limits and controls embodied action. Encouraging subjects to shake off the oppressive forces that pin them down to a singular 'localizable' identity Deleuze and Guattari (1987: 160–1) name this process 'de-stratification', which they describe as a revolution of the self. This implies that dancers de-stratify at the beginning of a creative process only to become reconstituted in different ways through the development of a new work. Butcher's creative process seemed to engage with this act of de-stratification most resolutely by asking me to descend into the sources of deep sensations and stimuli from my body and dissolve the signifying identity markers that created a sense of a unified self. 'The dissembling into the unknown, the dispersal of me. What is lost? The trappings of self.'[3]

However, although dancing implies this de-stratification, can dancers truly be regarded to free themselves from signifying forces, as they are endlessly connecting up in other ways with systems of choreographic control? Perhaps, through the variety of different choreographic systems encountered and the constant forming, breaking and reforming of moving identities, the potential for locating and following inner desires and impulses emerges. Through accumulation this process can lead to following 'one's interests', as Bennett[4] describes it, which represents developing a taste for particular kinds of movement explorations that have been honed over a dancing career. She outlines how these choices can accumulate to direct dancers towards a particular area of interest:

> it gets to that stage where it's really enjoyable to be able to pick and chose [...] when I was working with Finn [Walker], I knew she was really strong on improvisation and that was a real pull for me. And I really wanted to learn something more about that. Especially in duet form. I knew she would find a way of getting things out of me that I would not quite know how to access myself.

The process of uncovering and acting on these desires, however, may take time and maturity of approach, therefore it could be said that dancers are initially forced to de-stratify through their practical engagement with choreographic systems.

Although they encourage de-stratification, Deleuze and Guattari (1987: 160–1) warn that the subject has to 'keep enough of the organism for it to reform each dawn' so that even in the act of destabilisation, they can maintain some level of underlying continuity. Equally, Braidotti (2000: 158–60) stresses that the transformative capability of becoming is not limitless but must be contained through 'an ecology of the self', as the materiality of the body presents real physical boundaries. Braidotti's (2000: 158) description of embodiment, which foregrounds the material perspective, is as *enfleshed complexity*. Braidotti (2000: 159) describes a Deleuzean body which consists of intensities and flows that underlie the hierarchy of its biological and symbolic organisation as 'an assemblage of forces or passions that solidify (in space) and consolidate (in time) within the singular configuration known as an "individual"'. She explains that it is 'a field of transformative effects whose availability for changes of intensity depends, first, on its ability to sustain and, second, to encounter the impact of other forces or affects' (2000: 159).

While foregrounding the material limitations of the body, she is not proposing an essential, boundaried body, but rather, she acknowledges the material reality of embodiment alongside its transformative capabilities. Indeed, Braidotti (2000: 160–1) recognises that within the current Western 'bio-political' and 'geo-political' context, bodies are 'abstract technological constructs'. Therefore, the relationship to body as self is highly complex, as it is mediated through the 'psychopharmacological industry, bio-science and the new media' (2000: 160–1). Describing the dancer and choreographer as *forces or passions* that engage in processes of becoming across a range of networks of interaction, as Braidotti's (2000: 159) writing suggests, evokes a fluid process of exchange. It also allows for the dancer's alteration through encounter with the choreographer and how this may result in being inhabited by many different influences simultaneously, rather than being a clear proponent of a specific approach or style. Dancing bodies are neither stable entities that define a molar identity, nor completely fluid, transformable systems but variable, as they negotiate a relationship between stability and change.

Braidotti's mediation of Deleuze and Guattari's endless transformations, through her assertion of the materiality of the body, has implications for contemporary dancers. Although dancers engage in endless transformations, they face body limitations on a daily basis and this is not without material or indeed psychic consequence. For example, Ríonach Ní Néill, an Irish contemporary dancer, who participated in my research workshops, highlighted how unsettling this process can be over time:

It's more that because of how I've worked in recent years, with a few different people. You ask what's my movement identity, I don't have one anymore, all I can do is give on the outside of me what somebody else wants to see, remove the places that I've definitely wanted to go, and gotten rid of them and go somewhere else and it's like 'none of this belongs to me'. When I'm improvising maybe that's what I have to do, to find what me is, but it's like I've had plastic surgery.[5]

However, although my experience of moving between different choreographic processes resonates with aspects of Ní Néill's description, Hilton[6] describes a contrasting sense of self-hood that remains stable through various creative processes in spite of the different approaches required. She explained, 'I guess I always think of it as myself doing these different things. So rather than this transformative experience, it's always me. But it's me doing John's [Jasperse] work or me doing Stephen's [Petronio] choreography.'[7] While Deleuzean concepts of a virtual self, lacking substance, is congruent with the experience of multiplicity and is a compelling idea in relation to dancers' capabilities to be transformed across dance pieces and from one choreographic style to the next, the notion of a dialogical self that is relational and brought into being through interaction with the other has emerged in psychology more recently and seems to account for the dual sense of unity and multiplicity that Hilton describes. Salgado and Herman (2005: 2) explain that the dialogical notion of self addresses the issue of 'unity versus multiplicity' while acknowledging and valuing both of these aspects of human experience. I began this research believing that dancers transform significantly from one choreographic process to the next, questioning whether this is experienced as fragmentary or whether an underlying unity of experience prevails. Hilton's awareness of a sense of self that exists in various creative situations, illuminates that in spite of immersion in multiple processes she does not necessarily lose the reference point of a continuous experience of self.

Though similar to the theme of selfhood within social constructivism, Salgado and Herman (2005: 8) explain that this notion of a dialogical self creates 'two bounded, yet contrasting, poles: a centre and a periphery', a mechanism which allows human beings to define themselves through that contrast. In this way, they explain, 'each human being is constituted as a communicational agency' that emerges from and is defined through dialogue (2005: 8). This concept proposes that the self is 'populated' by various real or potential 'I positions' that are

produced through the self's dialogical properties (2005: 9). Furthermore, as personal meaning is produced in the process of addressing another, the self changes when the person addressed changes (2005: 9). Each 'Other' is experienced as an element of the self and may operate as 'another I' because 'selfhood and otherness are intertwined processes' (2005: 9). Manifestations of these '*I* positions' accumulate over time into a tangible and recognisable identity. To translate this idea into dancing processes, the accumulation of different dancing selves, held together by a reference point that is continuous, gathers substance and becomes perceivable as a moving identity.

Butcher's work represented something 'other' for me. It evoked awarenesses outside of my usual experience, a certain surgical clarity that I do not possess in my outlook. It was attractive because I experienced it as 'not me'. This otherness helped me to define new aspects of myself. For *Solo³* the choreographers drew different aspects out of me, with each solo constructing me in a different way. As the quotation from Bennett[8] earlier in the chapter illustrates, part of the attraction of working with other choreographers is the different elements that they can reveal to her in her dancing.

The dialogical self gives a perspective of multiple selves that are produced through social contexts. However, it offers an alternative to previous definitions, adopted widely by postmodern philosophy, in which the person was understood to dissolve into the social realm in this process. These definitions were problematic because they did not account for the subjective experience of the person. The dialogical self allows for an experience of multiplicity and unity while also indicating how the self is reconstituted through a relationship with the other; 'if we consider the *I* as the centre of the here-and-now experience, the *I* will remain to be the centre of the experience of the person from one moment to the next, even though it occupies a different positioning' (Salgado and Hermans 2005: 10). Thus, multiplicity becomes something like, 'the multiple ways of being-with' (Salgado and Hermans 2005: 11). Visual artist Helen Chadwick (1989: 109) resonates with this notion of how interaction with the 'other' brings person-hood into being when she writes, 'like a bout of the hiccups, interactions keep making me happen'.

The dialogical self is relevant for dancing practices because it accounts for the ways in which a dancer may be in a relational process with each choreographer to be brought into being in different ways through each dance piece, rather than an empty subjectivity traversing between creative events. As outlined earlier, at times throughout my career, the strain

of being available to be reconstituted in different dancing processes produced feelings of emptiness and disconnection from self. These feelings related more acutely to periods of intense work, where there seemed to be insufficient time to process new and challenging experiences. During the *Solo*[3] project my body suffered from being pulled in many different directions, I froze up and parts locked down. I felt somewhat invaded by each of these choreographers but could not resist the experience because they were facilitating my project. It was not any easier because it was a willing act. Afterwards, I needed space to let the experiences unravel and settle. I had broken apart the process of being a dancer and I felt fragmented from it. By naming the traces from each choreographer, I did not know anymore where 'I' resided.

Braidotti's notion of the ecology of self stresses the importance of maintaining balance and sustainability within creative practices as within any ecosystem. Similarly, in her writing on Sigmund Freud's exploration of the physical symptom in psychotherapy, Peggy Phelan (1996) proposes that bodies process experience at a different rate to thinking consciousness. Although this appears to re-enforce the mind/body schism, Phelan's (1996: 91) main point here is that 'psychoanalysis suggests that the body's "truth" does not organize itself narratively or chronologically'. She posits that narratives function to suture mind/body schisms into a chronologically sound history of the self. If the nervous system registers differences of approach in each choreographic encounter, this may engender a minor 'shock' each time a dancer enters the choreographic process anew. Therefore, in order to resist a certain psychic disorientation, which can be the result of encountering different and even conflicting choreographic approaches, dancers may need to adopt a sense of continuity – a continuous sense of process – which stitches together diverse methods and choreographies for a subject-in-process. This need to experience underlying unity invokes the moving identity as a continuum that can carry dancers through potentially fragmentary experiences of disparate or conflicting movement approaches.

The experience of concurrently embodying three different choreographic schemas seemed to destabilise inner structures of identity and self-hood that had previously felt 'solid'. I felt multiple and somewhat dispersed. However, in hindsight, this had a positive impact on my ability to embody complexity and to integrate difference, while leaving me somewhat confused as to my identity and role as a performer.

Each choreographer settled into my moving identity. Melnick is nearer to consciousness – in my movement choices in how I feel as

a dancer. Butcher is the deep dropping down into stillness. Roche is the materiality of the body – its reality and Jasperse is complexity, duality and multiplicity. They reflect me back to myself. I have embedded and integrated their patterns. They inform my choices now.

A sense of carrying these influences prevails to this day. As movement choices emerge I am sometimes surprised by them and see a connection to these earlier influences.

Exploring the moving identity from the perspective of other dancers, I asked a group to write about whether they experienced possessing a moving identity as part of research workshops that I facilitated.[9] One participant wrote:

I have patterns in my movement, so yes, I have a moving identity. The identity has been formed over years of dancing. Very much influenced by my training and then, in more recent years, by my own choreography and impulse to move. This too, is influenced by past choreographers and current teachers in contemporary movement. My movement identity is deliberate because of how I like moving and that I like, perhaps unconsciously, to mimic choreographers' styles.

When approaching my interviewees with the same question, the responses to the notion of a moving identity were resonant, if difficult to describe in words. Bennett said, 'I certainly have a sense of it. I don't know if I can describe what it is [...] I know [choreographer] Carol [Brown] always says that I have a very particular way of moving, but that's also to do with my height and the very nature of my physicality as well'.[10] She described the moving identity being related to issues such as attention to detail and specific types of phrasing, rhythm and coordination. Bennett expressed enjoyment in 'finding the intention in what I'm doing within different movement phrases. That's when I'm not thinking about producing material, but more thinking about the intention or the quality of the movement.'[11] Hilton said that 'energetic connection is definitely one of the characteristics. How you move in and out of outwardly expressing and inwardly containing and collecting. There are all these things that when I think about them to me make a kind of moving identity and intelligence as well.'[12] Rudner expressed how the moving identity is 'not as constructed, not the role I have to play in my life, something more raw, more essential', explaining that in

the space of the moving identity, 'I would say that I am more of myself, whatever that means. I feel more at home [...] I am locating myself essentially as the blood and sweat and bones I am.'[13]

Could the moving identity be described as a kind of style? It certainly represents a stylistic consistency. Multiplicities of disparate dancing experiences are held together through the moving identity of individual dancers, which produces experiences of wholeness out of the fragmentation and diversity of differing choreographic practices. Viewed from a perspective of multiple dancing selves, there may be a sense of fragmentation but equally, viewed from the substance that holds these multiplicities together, unity and continuity of practice are revealed. Consistency comes from 'a holding together of disparate elements', which for dancers may consist of the assemblage of various dancing multiplicities that produce an underlying stylistic identity (Massumi 1992: 7). Expressed as a state of being and tendency towards particular movement choices by the interviewees, the moving identity could be likened to Deleuze and Guattari's (1987) *plane of consistency* as a field of potentiality incorporating the multiplicity of dancing selves. 'The plane of consistency['s ...] number of dimensions continually increases as what happens happens' – therefore it is accumulative (Deleuze and Guattari 1987: 266–7). They argue that even as it absorbs new dimensions, it remains a 'fixed plane' but this does not mean that it is immobile, indeed 'it is the absolute state of movement as well as of rest, from which all relative speeds and slownesses spring'.[14]

Laurence Louppe (2010: 91) writes about style as it relates to individual dancers and choreographers, also exploring how group styles are formed and what kind of values they might signal to the audience. She explains, style is 'the subtext, that is the true text, which murmurs under the choreographic language'. Not reducible to the choreographic vocabulary or individual movements, this radiates outwards from the choreographer's individual way of moving but also incorporates the relations that are formed within a particular group of dancers over time. She describes how Rudolph Laban, in his movement analysis, prioritised the transitional phrases between recognisable movements, and how he claimed that 'these bear the marks of the style and of "sense"' (Louppe 2010: 93). This underlying connecting force between movements is where the stylistic tendencies are revealed; they are the way in which choreographers assemble movements together, and equally, how dancers transition between them.

In order to understand the moving identity of the dancer, it is important to identify the other conditions that may shape embodiment and

how they impact on the way in which bodies move through the world. Hayles (1999: 200) writes that 'incorporating practices perform the bodily content; inscribing practices correct and modulate the performance'. Thus she makes a distinction between the cultural shaping of the body through social discourse (inscription) and embodied action (incorporation). She writes, after Hubert Dreyfus, 'embodiment means that humans have available to them a mode of learning, and hence of intellection, different from that deriving from cogitation alone' (Hayles 1999: 201). For human subjects, there are socio-cultural factors that create consistency in bodily comportment and the performance of everyday activities. The concept of 'habitus', that is, the unconscious bodily enactment of a socially inscribed cultural *modus operandi*, proposes that human subjects become inculcated into societal rules through the control of bodily behaviour. According to Shusterman (1999: 5), who draws from Pierre Bourdieu's usage of the concept, 'the *habitus* acts through its bodily incorporation of *social relationships*' [emphasis in original]. The habitus reflects the range of movement acceptable to the underlying control systems and cultural rules of any given society. This term can be applied to dance as a means of describing the range of defined movement of a choreographic style (or individual piece of choreography) and evokes cultural invocation through bodily habits. Shusterman (2008: 22) describes how 'entire ideologies of domination can [...] be covertly materialized and preserved by encoding them in somatic social norms that, as bodily habits, are typically taken for granted and so escape critical consciousness'.

Although a person may be operating in a variety of situations that are not exactly the same, she/he is able to adapt the rules of socially mediated protocol in order to apply the appropriate behaviour to each specific situation. These rules become integrated and at the same time, flexible, while not necessarily being understood or definable by the subject. When a subject makes this kind of unconscious yet somewhat prescribed choice, the habitus comes into action (Bouveresse 1999). Therefore, on a daily basis the body unconsciously enacts and expresses inscribed cultural belief systems and embedded societal rules. This is one of the layers of society's inscription on the body and it is deeply embedded and unconsciously activated.

The habitus is a useful term for dance because it denotes longevity; cultural inscription happens over time and needs time to take hold. Choreographer Olivia Millard (2013: 10) explored the development of a group-dancing habitus over a period of three years in a research project she instigated, which focused on six individual dancers forming stylistic

consistencies through improvisational practice; she explains, 'the coming of each individual dancer to belong to our group was not a result of explicit direction. The cohesion or "groupness" in the dance came not from choreographic decisions aimed to create cohesion but from practising together over a period of time with [improvisational] scores' [my insertion]. Millard (2013: 7) describes how the group 'adhered to implicit "conventions"', which were not articulated but emerged out of the recurring shared practice. Another way of describing the formation of this group identity could be in terms of a plane of consistency; the group becoming organised into shared movement patterns, while maintaining the multiplicities of individual moving identities and interpretations of the improvisational tasks. Over time, the sedimentation of movement tendencies, through conscious and unconscious absorption, creates a layer or stratum, which is not a solid entity but has a recognisable form nonetheless.[15]

From the perspective of gender, embodied acts anchor the individual's sense of identity in a kind of gendered performance. Albright (1997: 5) examines the ways in which 'culture is embedded in experiences of the body and how the body is implicated in our notions of identity'. She engages with the work of Judith Butler in relation to the enactment of gender roles and how repeated acts or gestures solidify over time to form what appears to be a stable identity. Albright (1997: 8) explains how Butler 'recognises the existential limits of performance' and the ways in which 'repeated acts undermine the stability of the very gender they are said to express'. This instability arises through countless repetitions of these movements that reveal the difference between one enactment and the next. An example of the exploration of this phenomenon is given in choreographer Jérôme Bel's piece *The Last Performance* (1998) through which he displays how repetition reveals difference. In this work, Bel and three other performers each dance the same segment from *Wandlung* (1978) by German choreographer Suzanne Linke. They all wear the same costume, a white dress, and state, 'Ich bin Suzanne Linke' (I am Suzanne Linke) before dancing the movement. According to Lepecki (2006: 61), in a public lecture on this piece, Bel explained that the 'perceptual question of how repetition unleashes series of differences' inspired the creation of this scene. Although this vignette borders on parody, it demonstrates the duality of the dancer in relation to the material she/he is performing. When dancer Claire Haenni embodies this piece, there is a sense of coherence as she fits the physical profile of the role and we identify with her as the young girl. When Bel and dancer Frédéric Seguette dance in the

white dress we see both the choreography and the dancer as somehow separate while coexisting in the moment of performance. It is possible to imagine the choreography as a separate force (or movement pattern) rather than expressive of the *core self* of the dancer. It is this kind of duality – through which gender and identity are performed – that Albright foregrounds in her text.

No body precedes society's inscription upon it. Even in the attempt to explore *natural* ways of moving in dance, Albright (1997: 32) explains that this is in fact a 'very conscious construction – one that, in fact, takes years to embody fully' and the student begins to realise over time that 'it feels quite different from one's everyday experience of corporeality'. For example, Sayers (2011: 87) writes about the dancers in the work of Butcher, identifying the 'quality of their neutrality', which infers that this *neutrality* is somewhat constructed and relates more to a performative approach than the achievement of a neutral state of being. Similarly, dancer Vicky Schick (Roche 2013: 15) explains how Trisha Brown was one of the key choreographers to influence the 'trend of voluptuous slippery movement on this new relaxed and naturally aligned body', which other choreographers and dancers have subsequently emulated. Schick described how this changed the relationship to the body in dance generally, so that 'there were fewer rigid spines and puffed out chests, movements were more nuanced' (Roche 2013: 15). In spite of this bodily comportment emerging as a prevailing aesthetic, she maintains 'there was no coined vocabulary for these complexities', it was more of an attitude towards posture and performance that incorporated an understated quality of restraint and clarity (Roche 2013: 15). Therefore, what we might consider a 'natural' body with neutral presence also engenders the incorporation of a 'body of ideas' (Foster 1992: 482). Although a useful means to explore personal movement tendencies outside of codified techniques (as exemplified through the example of Butcher's work with Summers), the notion of *originary* ways of moving outlined in Chapter 1 present a similar dichotomy (Foster 2005). The dancing body is constructed, and even in supposed neutrality is embedded with values. This can be a somewhat conscious creation as in the example from the workshop participant above, who likes to mimic the styles of different choreographers, but also involves unconscious accumulation of dancing and life experiences over time.

The nuances incorporated in the moving identity can be transferred both consciously and unconsciously between choreographer and dancer. One aspect that supported my ability to move through the different works was the 'live' presence of the three choreographers;

backstage, in the audience or on stage. This allowed me to keep tuned in to the specific textures in each work and to embody their subtle differences. In a recent TED[16] talk, choreographer Wayne McGregor demonstrated how his dancers operated as part of his distributed memory by embodying and recording stages of choreographic process as he moved quickly between his ideas. Similarly, in light of the range of complexity involved in each solo work and the differences between them, the three choreographers were my memory banks as their physical presences cued me to find ways into the particular movement textures needed in each work. Over time it may have become easier to keep the distinctiveness of each piece without this support. On the other hand, I suspect that the more familiar the pieces became, the more challenging it would be to avoid merging these styles and textures into older and more deeply embedded movement patterns and rhythms.

Being pulled out of engagement with each solo process by the next solo, or even by the requirement to manage practical elements of production and research, gave me a clear indication of the depth of engagement I had with each piece. The degree of absorption in configuring the corporeal map, which I discussed in Chapter 5 as a kind of internalised score of instructions, embodied memories and sensations, could be characterised as a type of 'possession'. Through the formation of this corporeal map each solo directed me to inhabit a different embodied self, which permeated my physicality and altered how I projected my moving identity in the world.

So how can we read these instances of possession, colonisation or willing immersion in terms of the autonomy of dancers? Although working environments can differ significantly, from my early years of training, I was conditioned to be compliant in the studio. This can mean being silent and not expressing an opinion or questioning aspects of the creative process. This tendency towards passivity is articulated by a dancer in training who was involved in a research project instigated by Fortin, Vieira and Tremblay (2009: 55), she said, 'it is surprising to see all the sacrifices that a dancer makes without ever complaining. The law of silence, this is what we call it in the milieu.' The choreographer/dancer relationship is already mediated through a range of social protocols, which are equally intimate and formally professional and in which dancers may not always freely speak back. In spite of my close connection with each of these choreographers, this formality prevailed to some degree throughout our working together. I became habituated in these relationships to receive information from them, rather than offering my opinions or inputs creatively.

This project demonstrated how my role involved maintaining a fine balance in the choreographic process between being at the service of the choreographic project and being capable of choosing appropriate strategies, when needed, in order to realise the work. However, in terms of the broader project, I was not creatively autonomous in these solos but dependent on the choreographers to direct the outcomes. Within the culture of contemporary dance the most prominent means of attaining creative autonomy is to become a choreographer, as many dancers do. Within the binary relationship of choreographer as embodied mind of the work and dancer as the body, it seems more and more attractive for dancers to move into creating choreography in order to position themselves in a more empowered role. The sense that only choreographers can be self-representational means that dancers may not want to stay in the role of dancer for very long. In this increasingly diversified sector, funding is often geared towards emerging artists encouraging them to be entrepreneurial and to create work on and for themselves. However, this may be problematic when young dancers have reduced opportunities to work extensively with choreographers to develop their dancing craft and to hone choreographic skills from inside other choreographers' processes. Hilton[17] outlines how this can homogenise the work emerging out of a particular independent dance scene, for example in Melbourne, Australia where she is based. She explains, 'With all this project work, with the younger generation all working with each other [...] it's getting more hermetic here and they go away less and less. They make work on each other and they've all had these particular experiences, one of which is me and it all starts to look the same.' Traversing prematurely into collaborative or choreographic roles means that dancers may not have opportunities to accrue, recognise and hone their dancing influences in order to develop them into an original choreographic signature.

The frame of authorial authority of the choreographer means that being a dancer can be regarded as somewhat juvenile until one matures into a choreographer. However, although the availability of critical analysis of dance-making by dancers is limited, the shift in choreographic practices and the complexity of dancers' career paths has enhanced awareness of dancers as agents within the choreographic process.

Rudner[18] identified the porosity of the boundaries between different creative roles in dance: 'I've always thought that there's a great continuity between dancer, choreographer, improviser, teacher; that it all is one thing. And you have to have experience in all areas. You might hang out more comfortably in one area; people have different preferences.' The

interchangeable quality of these roles is due in some part to the democ-ratisation of dance production and the inclusion of dancers' creative input into choreographic work. Davida (1992) expresses this fluidity of exchange when she describes the emergence of new methods of dance-making in the 1990s:

> Not only are these [New] dance-makers fervently engaged in the search for an individualistic means of expression, but this impera-tive has changed the very nature of their work with the dancers. I have entered numerous rehearsal studios where the choreographer is proposing an improvisational structure to the dancers – extending to them great freedom of interpretation. Their bodies become the site for mediation between creative idea and gestural response. The dancer generates the movement material from which the choreog-rapher chooses and shapes the final performance. An interchange of ideas seems to be replacing the directive setting of material on the dancer [my insertion].

Card (2006) identifies a group of Australian dancers who display a nota-ble sense of creative autonomy and agency as artists. She writes, 'these dancers offer choreographers what they need. They are experts in their field. They exhibit the high level of intelligence associated with being good at what they do, and they have the ability to be where they need to be in the short, fragmented time frames offered by project employ-ment' (Card 2006: 14). These dancers hold a certain value as artists in their own right and possess the versatility and skill to succeed across many different creative contexts. They have become empowered and exercise agency from within a position that is often considered to lack agency by becoming valued for the skills they bring, even if those skills are not specifically defined.

This increased autonomy evokes Braidotti's (2000: 170) explanation of becoming minoritarian as a means of 'undoing power relations in the very structures of one's subject position' so that one does not leave the minority role but, instead, brings its specific qualities and challenges to light. Her interpretation of Deleuze and Guattari's notion of 'becoming minor',[19] which means finding empowerment and agency from within a subject position, could be applied to the often politically invisible dancer (Braidotti 2002: 70). Becoming minoritarian, Braidotti (2002: 84) explains, involves going through a period of identity politics in order to claim a fixed location. Braidotti (2002: 85) defines the type of thinking that leads to repositioning of identity as a break from the recognised

means of understanding subjectivity, presenting this as the potential to journey out of molar identities, which objectify the subject.

Awareness of the predilections that lead dancers to follow certain directions throughout a career and writing from this perspective offers avenues for deepening knowledge of these processes, without destabilising the relationships through which dances are made. Acknowledging dancers' creative contributions makes it more difficult to infantilise or reduce them to their physical attributes such as *her expressive feet* or *his flexible spine*. Positioning dancers as enquirers within the dance-making process, rather than being the subject of research undertaken by external parties, makes it possible to establish points of reference to interrogate dancing practices. This repositioning challenges the power balance and perspective across dance practice, dance studies and the marketplace, so that subtlety and nuance can be added to the knowledge bank of the creation and performance of choreography. Dancers owning the knowledge production emerging from creative practice and establishing critical discourses on dancing where they count – the marketplace and the academy – would go a long way towards a project of becoming minoritarian.

This chapter has outlined the dancer's 'moving identity' as an accumulation of choreographic movement incorporations and training influences, which also includes the life path of a dancer as a gendered, socially and culturally located subject; it is the site where consistencies are apparent and patterns emerge. A dancing body is a crucible, a host to the haunting power of choreographic traces (that remain available to be re-embodied again), a site of potentiality, a lived archive and the dancer's habitual form. Ravn (2009: 273) explains that the dancers in her study 'describe this habit body as more than automatic coordination'; it is 'always more than some localised, incorporated mechanisms coordinating their limbs'. The moving identity is an accumulation of incorporated movement that is assembled through dancing experiences. Previously embodied movement is integrated into the moving present through a process of sedimentation – a settling over time. Beyond merely a habit body, the moving identity displays the stylistic subtext as a movement signature that a dancer forms throughout her/his career path.

In the creative processes for the solos, I was directed by each choreographer to become a body-in-motion. This required me to 'unfix' movement in a variety of ways. In each case, the process was a destabilising experience for me that interrupted my sense of a continuous and solid corporeal self. This process engendered breaking new creative

ground through interrupting habitual and familiar movement. This may have been more acutely experienced because of the intensity of working within the solo form. I was required to reorganise around new choreographic schema, and so the moving identity was the interface where I experienced the *otherness* of the choreographer, that is, where some new element had to be incorporated. With Jasperse, I experienced this through the challenge of revisiting past ways of moving that I had consciously discarded, and with Melnick, in my requirement to suspend conscious analysis of the movement and to *allow the body to make connections*. In Roche's process, this destabilisation occurred through extending my perception beyond the borders of the body image to form a shared moving identity with other dancers, and with Butcher, it required a journey inwards to experience more while doing less.

Dancers metamorphose in the moment of becoming through dancing, in a dialogical encounter with a choreographer as the other, thus producing various dancing selves through embodied complexity. Contemporary dancers embody multiplicity as a fundamental part of their career path and dancers are capable of being *many dancing bodies in one* through incorporating a range of different movement styles. Although the moving identity can appear to be stable, it is also sufficiently flexible to shake off signifying factors that construct the sense of a unitary self, such as body image, gender and the habitus. Yet, from the body image to the habitus and throughout social interactions it is a human necessity to experience stability. In as much as the dancing process might destabilise, it simultaneously reforms new identities. For example, a colleague who danced professionally for many years recently expressed to me how she felt (*re*)assembled by each new choreographic process she encountered as a dancer and these experiences contrasted greatly with her everyday sense of fragmentation.[20]

As discussed earlier, Deleuze and Guattari (1987: 160–1) advise that in the midst of de-stratification the subject has to 'keep enough of the organism for it to reform each dawn'. Concurrently with experiencing de-stratification, how might this projection of a continuous self act as a defence against the destabilising effects of continual change? Hilton and Bennett explained that they project a continuity against which to manage encountering newness. Bennett describes how the process of becoming the dancer is 'a translation process' wherein you must 'mediate between [...] who the choreographer is and what they want stylistically', whereas, as explained earlier, Hilton has a sense of a continuous self that underlies the experience of dancing with each different choreographer. The ecological borders of the self which Braidotti (2000)

identifies, indicate that the potential for de-stratification is not endless and that it has limitations that arise from the material boundaries of the body. This resonates with the notion of the dialogical self that continually produces a series of real or potential 'I positions' in the encounter with the other (Salgado and Hermans 2005). As I am produced differently by each new encounter, I concurrently experience the multiplicity of positions and an underlying unity. For instance, the choreographers and I formed a multiplicity in the creation of the performance together. We worked around each other; through scheduling issues and staging challenges we committed to form the works and to be altered by each other; Jasperse designed the lighting for each piece. The choreographers watched each other's rehearsals, giving feedback and support; there was a shared investment in the outcome as we drew the many disparate elements together.

Whether they are stirred, jolted or eased into different performative instantiations, contemporary dancers move from one choreographic process to the next, to be (re-)formed and (re-)constituted through each new choreographic interaction. As noted earlier, Chadwick (1989: 109) writes, 'interactions keep making me happen' and her description of her embodied self as 'variable, as event within the dynamic of place' resonates with how the dancer is produced anew as a specific dancer through each choreographic environment. Through the development of a choreographic work, assemblages of choreographic schema settle into an experiential identity, producing different sensations and feedback with various emotional and psychological states as temporary landing sites for a specific embodied identity that is fully absorbing and gives a sense of stability for a finite period of time. However, this is temporary and can be interrupted and redirected by the next choreographic process. Through the catalysing encounter with a choreographer, habitual movement patterns are redirected and the break in continuum allows dancers to follow new corporeal configurations through which novel movement possibilities and experiential terrains can be revealed.

7
Further Iterations and Final Reflections

In her article on the remains of performance, Schneider (2001: 102) writes that the memories of body-to-body transmission reside in the flesh. A dancer's materialisation of choreographic work disappears as flesh from bones, at least from public viewing. Dancers are no longer called to embody the work once it enters the archive. As their enfleshedness cannot remain after the event, it is the choreography as a series of codes and ideas that travels forward in space and time. Indeed, Lepecki (2006: 124–5) writes that choreography emerged to counteract the ontological condition of dance's 'curse', by which it is destined to be lost 'in the temporality of modernity'. Lepecki outlines that the characterisation of dance as ephemeral by writers such as Marcia Siegel (1972) presents dancers' labour as ultimately futile. Positioning dance at the vanishing point, disappearing just as it materialises, means that the dance work and a *dancer's work* evaporates in the moment of performance. Thus, in spite of the long years 'of conditioning body and mind for the fleeting moment of dancing', dancers must embrace 'a sacrificial subjectivity' (Lepecki 2006: 125). Lepecki (2006: 125–6) argues that it is this 'melancholic drive' that pushes dance into institutionalising systems in order to preserve the codified techniques of deceased masters and create a reproductive economy.

Although, as Lepecki writes, choreography is reproducible, a dancer's live performance is not. Ballet lends itself to reproduction through video because of its two-dimensional design for the proscenium arch stage and its stop/start quality, wherein signature poses are highlighted so that the audience sees 'a series of mini-pictures punctuating the dancing with recognizable moments' (Albright 1997: 14). In contrast to this, modern dance emerged through an investment in the visceral transaction between performer and audience, which Albright

(1997: 18) attributes to Isadora Duncan forming a powerful kinaesthetic interchange with the audience by refusing the 'visual poses' of dance.

Independent dance risks exclusion from the reproductive economy occupied by canonical dance when it draws from idiosyncratic ways of moving and thus does not reference codified movement signatures or recognisable virtuosity. As I outlined in Chapter 1, Claid (2006: 120) explains how enabled through the feminist movement, the 1970s female performer gained identity and subjectivity by performing her 'real' body and stripping away the 'fetish of the marked female dancer's presence'. However, through neutralising the external projection of expression and virtuosity – the means by which the spectator is engaged – the dancer simultaneously became invisible. The cost of gaining subjectivity, through abandoning the seductive illusion of virtuosity and transcendence of the real female body, was to become 'unmarked'[1] (Claid 2006: 120). Thus, moving outside the codified styles in the modern dance canon reduced the categorisable potential of these now hired, hybrid or eclectic bodies which emerged during the 1990s. Despite the near dissolution of modern dance codified styles in current and emerging professional practice, the preservation of codified signatures can be seen in training institutions that may acknowledge independent approaches, whilst teaching through the more established and traditionally validated dance techniques. Similarly revealing are the social and economic distinctions made for example in New York City between non-funded experimental independent *downtown-based* dance and *uptown*, nationally funded modern dance and ballet companies.

Engaging in bodily practices inevitably evokes the instability of bodies and their relationship to temporality. In a career that is generally short-lived and unpredictable, dancers manage instability and loss as part of the terrain. Arguably, the most challenging aspect of this career is the loss of connection to dancing as they age.

Dancer Isobel Mortimer explained at the Dance UK *Beyond the Body* conference in 2013, that dancers must 'grieve' the loss of the dancing self when their dancing career comes to an end (Dance UK 2013). Although both modern and postmodern dance show many examples of older dancers performing in their 60s and 70s, with Merce Cunningham and Martha Graham extending this to their 90s, youth is still a key demographic feature. Jackie Lansley and Fergus Early (2011: 12), two influential dancers in the British New Dance movement, explain that ageism in dance reflects the prevalent ageism in society: 'Western theatre dance has always been obsessed with sexuality [...] this sexual fantasy world has always demanded that dance be constantly replenished

with a supply of fresh young bodies, threatening and ousting more mature artists.' Rainer explored this issue through her article 'The Aching Body in Dance', where she questioned why the aged dancer performing might not indeed reflect the project of the Judson era, 'who tore down the palace gates of high culture to admit a rabble of alternative visions and options' (Rainer 2014: 106). She proposes that, rather than being compared to younger dancers and found lacking, the older dancer, with ageing body, might be understood as 'a thing unto itself' and represented as such within dance performance (Rainer 2014: 106).

The peripatetic nature of a dancing career is punctuated by the loss of individual dance works as they come to completion and sometimes by the loss of an individual choreographer. Louppe (2008: 24) writes of 'the disarray, the wounds, the grieving and rupture in the continuity of the dancer's work when (as happens only too often) the choreographer is no more'. Taking as an example the French choreographer Dominique Bagouet, whose untimely death from AIDS in 1992 left a company of mourning dancers who subsequently formed Les Carnets Bagouet (The Notebooks of Bagouet) with the purpose of preserving and restaging his choreographies,[2] Louppe (2008: 24) says that Les Carnets Bagouet demonstrated 'how much work (*travail*) survives the civil presence of the choreographer. How much the bodies marked by him were still at work in the space where his regard had held them in a poetic engagement that death could not dissipate.'

In an interview and article on choreographic legacy in the *New York Times*, which questioned what happens to the dances once the choreographer is gone, Merce Cunningham expressed the hope that his dancers would maintain 'a kind of live archive' so that they would keep the work alive through physically 'doing it' (Solway 2007). This article predated Cunningham's death by two years and in 2008, Charmatz created a work drawn from a book by David Vaughan that chronicles fifty years of Cunningham's work in pictures. Charmatz (2009) explained that he hoped to create a 'Meta-Cunningham event' drawn from the reproduction of the many pictures in the book by creating a choreography that mirrored Cunningham's creative approach, which was not concerned with developing organic movement but cutting up phrases and selecting different movements and positions based on chance (Charmatz 2012). Charmatz proposes that something of the real essence of Cunningham's oeuvre might be evoked in the interstices between postures as they appear in the book.[3]

This approach to preservation is an interesting one. Rather than engaging in the economy of reproduction, Charmatz presented a work

compiled from disjointed images of Cunningham's choreographies, while not attempting to reproduce any recognisable passages from his oeuvre, or the choreographic flow of Cunningham's material. The dissembling of the reproductive mechanism, which is at the heart of this work by Charmatz, allows the audience to encounter the potential loss at the heart of every live dance performance, to face fully all that will be left as material trace or artefact after the event and to examine how reconstruction, reproduction or recording does not address this loss. Where Cunningham's work comes to life again, is not through straightforward reproduction, but through re-imagining and thus, re-entering from a different perspective that reveals the gaps between the original performative moment and its re-instantiation in the present, including the sense of loss that permeates this. Timmy De Laet (2012) identifies an emerging trait of re-enactment in contemporary dance, in which contemporary artists such as Martin Nachbar and Vincent Dunoyer dialogue with past choreographies to comment on the many mnemonic dimensions of dance. De Laet (2012: 102) explains that the function of these works is not to preserve the past choreographies as might be achieved through reconstruction but 'to creatively reflect on issues regarding the preservation, transmission and temporality of dance and to go beyond the aim of merely constituting the past as it supposedly has been'. This is the aspect that Charmatz is addressing in Flipbook in ways that a reconstruction of the works could not.

New approaches to ameliorating the loss of live dance, besides traditional archiving tools, such as notation and video recording, have been further facilitated by recent developments in motion capture technology. Most notably, in 2010 the Forsythe Company began steering a four-year project to create online digital scores of leading choreographers, thus developing new possibilities for archiving choreographic 'texts'.[4] With the potential to preserve the remains of dancers' work, research is also being undertaken by Ruth Gibson in collaboration with Sarah Whatley from Coventry University for the AHRC Creative Fellowship entitled 'Capturing Stillness: Visualisations of Dance through Motion Capture'. Whatley (2012: 276) explains, 'the dots, lines and animations that result from the captured data are often identifiable as the individual dancer; the dancer's idiosyncrasies, muscle tone and movement "signature" seem to remain and carry forward into the visualisations'. In addition to this, Whatley outlines that 'Motion Capture can participate in what might be termed the poetics of the moving sensing body' as a means of 'generating visualisations that reconfigure the temporal properties of dance and feeding back to the dancer her sense of

embodiment, place and presence'.[5] This technology has the possibility to capture the moving identities of dancers and to represent some of the individual traits of dancing.

Other ways of understanding the remains of performance are offered by Schneider (2001) through her critique of Phelan's (1993: 146) notion that 'performance's only life is in the present'. Schneider states that live performance does leave a trace, but that this may not be detectable through the conventional archiving process. Schneider (2001: 101) questions whether 'in privileging an understanding of performance as a refusal to remain, do we ignore other ways of knowing, other modes of remembering, that might be situated precisely in the ways in which performance remains, but remains differently', for example, as we might experience in the memory of a performance or in the dancing traces that linger after the event. For example, as we saw in Chapter 6, Ravn (2009: 262) found that the dancers in her study experienced the reappearance of movement traces when moving. Ravn (2009: 274) refers to the circulation of traces when repeating movements in rehearsals not 'as repetition but as a continuous recreation that unfolds aspects and sensations of the movement. The dancers are in that sense investigating aspects of former experiences to be unfolded and reshaped in the present.' In a similar vein, Martin Nachbar (2012: 12), writing from his first-person perspective as a dancer, describes the 'differentiating body' of dancers who discern between the 'past of the remembered movement', and the current moment of its performance. He outlines how past and present movement experiences cohabitate, 'in and through the present bodies [...] when we remember steps in a dance class or whole choreographies while touring a piece' (Nachbar 2012: 11). Indeed, De Laet (2012: 102) outlines the elusive nature of dancing memories that are distributed across bodies and time: 'there is not one single localizable substrate where "the" memory of dance would reside [...] with every transmission dance assumes another guise and [...] its memory can only be maintained through re-actualization and multiplication in various, ever changing forms'.

In light of the possibility for performance to 'remain differently', how might individual dancers' traces register within a singular work or the body of work of a particular choreographer? As I outlined in Chapter 1, the archive favours the artefact and the word as modes of documentation, separating the knower from the source of knowledge (Taylor 2003). In contrast to this, the repertoire involves the presence of people who produce and reproduce knowledge by being involved in the exchange. However, the dancer's imprint could live on without

the physical presence of the dancer, as with the Derridean notion of iterability, which describes the possibility for the mark, be it speech or writing, to continue to 'act' even when the author is no longer physically present (Royle 2003).

In the case of Jasperse's work, as mentioned earlier, the creative process was already distributed among different dancers as the movement material travelled back and forth between Dublin and New York. Jasperse researched and expanded on the choreographic ideas with Cornell and Pourazar, dancers he regularly worked with through his company. From this first solo piece, these ideas moved through multiple iterations, with the first significant transformation from the solo into a group piece, *PURE* (2008) at the American Dance Festival and from there into *Magic, Mystery and other Mundane Events* (2010) and finally into *Truth, Revised Histories, Wishful Thinking and Flat Out Lies* (2011). Additionally, Jasperse showed different extracts of the piece as works in progress throughout those years.[6] I observed the reverberations of the first solo being materialised in different ways, evolving into other dances. Although my solo was the first public performance, I am not sure that it was the first iteration of the work or that the work had a specific beginning. Rather it seemed to accumulate new elements, while losing others, evolving through the different performative events that defined its circumstances each time.

This solo was unusual in that it was made through a group choreographic process, whereas the solo form presumes a relationship to the dancer who is featured. As Claid (2006) writes, the 'surface illusion' of the projected dancer's subjectivity is ambiguous and it is never clear whether we are witnessing the expression of the dancer's interiority or the choreographer's craft. For example, Cornell developed the 'bad magic tricks' mentioned in Chapter 4 and I learned her version from a DVD and added to it in rehearsals with Jasperse and performed it in Dublin. In spite of her contribution, Cornell did not perform in my solo version, nor did I perform in subsequent versions of the piece. The initial solo performance was taken as representative of my personality despite being drawn from a number of different sources. Furthermore, when speaking about the development of a section of the solo in which I perform a single pirouette and then harshly critique my performance, Jasperse (Roche 2009: 112) explained that he had been influenced by my ballet training roots and that he had been interested in asking me to revisit and investigate a physicality that no longer interested me. Jasperse performed this section in the larger group piece *PURE* soon after the Dublin performances, which was reviewed in the following way by Byron Woods (2008): 'Jasperse comes out from offstage left and places

a microphone [...] as a spotlight shines from above, the choreographer attempts a pirouette and then analyzes and critiques his effort, speaking into the mic. After several failed iterations, an offstage voice [...] gives conflicting, simultaneous critical feedback.' It reappears in a *New York Times* review of *Truth, Revised Histories, Wishful Thinking and Flat Out Lies* at the Joyce Theatre, New York: 'Mr. Jasperse appears, in sober black, and begins to try out single pirouettes, offering an auto-critique as he goes' (Sulcas 2010). I am not proposing that Jasperse endlessly repeats elements of his work but, rather, affirming his assertion that he works on an idea across a series of choreographies.[7] This particular section is easy to describe and to follow into other iterations of these ideas. Indeed, there were numerous similar traces carried through into the subsequent pieces. As a humorous vignette it is discrete and self-contained. While not exactly a subtle trace to follow, it gives an indication of the migration of ideas across different works and versions (Figure 7.1).

Although some aspect of my story sparked this idea in Jasperse, it was not necessary for me to perform this section to give it context. From a Derridean perspective, in order for a mark to be meaningful and *iterable* it must be repeatable and able 'to break with its context'; even to assume a new meaning as a circulation in other works (Cooren 2009: 46). Derrida (1977: 185–6) explains that 'the possibility of repeating and thus of identifying the marks is implicit in every code' and this is the aspect which causes it to be 'communicable, transmittable, decipherable, iterable for a third, and hence for every empirically determined receiver in general'. He defines the productive nature of writing, which functions as a kind of machine, explaining that the absence of the writer or the originally intended receiver 'will not, in principle, hinder in its functioning' (Derrida 1977: 180). Viewed through this lens, choreographic material which has been inspired, or even constructed through task-based methodologies, by an individual dancer does not need to travel with the work for the work to produce meaning. It is the dancer that performs the work in the present that stands for meaning. Cooren (2009: 45) explains, whereas the mark can be removed from context and continue to act, it is through the 'sequentiality of conversations' that are made possible in the incarnate presence of the interactants that miscomprehensions can be ameliorated and managed. Similarly, it is the embodiment by a dancer that creates a context for the choreography, as the choreographic 'mark' is given meaning through the specific locality of a particular dancer in performance.

Although Phelan (1993: 146) presents the irreproducible nature of performance – becoming itself through disappearance – she

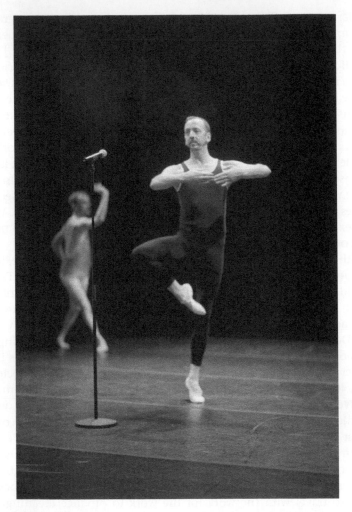

Figure 7.1 John Jasperse in *Truth, Revised Histories, Wishful Thinking and Flat Out Lies*. Photographer Cameron Wittig. Courtesy of the Walker Arts Centre.

counterbalances this by asserting the value of the 'now'. She states that this quality of presence that the performative moment can offer is elided due to the pressures of the 'reproductive economy' on performance practice, explaining, 'only rarely in this culture is the "now" to which performance addresses its deepest questions valued' (Phelan 1993: 146). In spite of the validity of Schneider's (2001) counterpoint to the ephemerality of performance by affirming its possibility to remain

differently, Phelan's assertion of the situational locatedness of performance is at the centre of what dancers can bring to a dancing moment. Butcher (Butcher and Melrose 2005: 198) expressed this fascination with producing the lived experience 'of a moment, or seeing someone experiencing a moment' through her work, instantiated by a dancer in time and space, and Monni (2008: 41) described how dancers' live 'being-in-the-world' can disclose reality. Trisha Brown describes what this live actualisation brings to her choreography, recognising that a dancer's individual moving identities become visible in the interstices between dancer and choreographic instruction as materialised in the moment: 'I don't ask my dancers to go make the phrases for me; but what they're capable of doing, what their excellences are, disparate and arising unpredictably from moment to moment, that's what the audience is going to see' (Brown in Morgenroth 2004: 65).

Arising in the moment of dancing, the individual traits that Brown is describing leave a mark on a choreographer's body of work. When reflecting on the exchanges with the four choreographers, I had overlooked my own colouring and shaping of these interactions. When I spoke to Melnick about a further performance of her solo and not being sure if I had recaptured all of the elements correctly, she assured me that any choice I would have made had relevance because of the time we had shared working together. She acknowledged my influence on the work that emerged and could see this in a way that I could not. I had not registered or valued my influence on her or the other choreographers' decision-making processes. Morris (2001) explores this in terms of the impact of training genealogy and physical attributes of particular dancers on choreographic stylistic choices in Frederick Ashton's ballets. Equally, Hilton identified her continuing influence on the choreographic signature of Petronio and Lucy Guerin even when she no longer danced with these choreographers, saying, 'you change them just as much as they change you [...] I can look back at Stephen [Petronio's] earlier work and see me, not just actually me, but my contribution and with Lucy Guerin the same, I can see my particular influence on that body of work [...] it is the way we mark and scar and shape each other.'

According to Louppe (2008: 24) in the work of artists of the 'grande modernité' who developed strong and lasting creative signatures, the dancer's role was to carve out the choreographer's signature with her/his body.[8] This is acknowledged by Derezinski (2006: 23) in writing about Twyla Tharp's development of a choreographic signature in the postmodern era: 'taking her ideas into the studio, Tharp then collaborated

with her dancers Margaret Jenkins and Sara Rudner in defining an aesthetic, or distinctive visual style'. Rudner elaborates on this exchange, describing a kind of reciprocity of influence evidenced in the work:

> I think that's why I had such a successful relationship with Twyla. We were not at all alike in terms of our personalities, in terms of our training. But there was some resonance, a recognition of something that enabled me to embody something of her physicality, and then *my physicality and how I approached things started coming back into the work* [my emphasis].

The fact that we can witness choreography danced by different dancers separates the choreography from any one dancer's embodiment of it. Lepecki (2006: 63) characterizes this as choreography's 'uncanny force', its ghost-like haunting of dancing bodies. Extending this notion of haunting further, we can reflect on how choreography has the ability to linger, to continue to act after the event. Dancing movements constantly re-circulate, as Nachbar (2012) articulates earlier in this chapter, and it is a discerning dancer who draws from this embodied repertoire to produce the appropriate movement in the present. Philosopher Henri Bergson (2004: 74) writes, 'the past is essentially *that which acts no longer*' as opposed to the present, '*i.e. that which is acting*' [emphasis in original]. By this measure, movements are not necessarily confined to the past once they have been performed. As long as the movements continue to act, they are still present. The following paragraph evokes the way in which dancing traces can remain long after the event and how they may be reactivated years later.

I recently attended a presentation by a colleague who was discussing various types and uses of choreographic scores and one of her examples was taken from a work entitled Deserts d'amour by French choreographer, Dominique Bagouet. I danced in a reconstruction of this piece by Les Carnets Bagouet, performing the piece in the Montpellier Festival 1996 as a coproduction between Les Carnets Bagouet and Dance Theatre of Ireland. When I read the score, all that was on the page were two lines of squiggles, an arrow, pointing left to right, an upside down 'U' and clusters of little circles. Each of the lines had a different order of sequence with the name 'Dominique' beside one line and 'Claire' beside another. As I looked at the page, a whole range of associations came flooding back. This was the notation from the 'deuxiéme Mozart' section of the piece and each

symbol stood for one of three different movement phrases that were danced simultaneously but in different sequence by each dancer. I danced Claire's Chancy's role and it was her name on the page. I was amazed that sixteen years later these little notes could evoke the corporeal memory of this choreography and even more moved by the fact that I had never met Bagouet in the flesh. The traces of this choreographer's work are still reverberating in me and can be re-instantiated without much effort of recall.

Throughout the subsequent five years following the performance of *Solo³*, it was possible to track the influence of Melnick's work. It seemed to haunt my body, seeking an outlet, until I created an adaptation of the solo for a performance in 2012.[9] In this adaptation, I reworked some of the original ideas (with Melnick's permission) and changed the focus of the work to explore traces that remained. In this new solo, *Altered Copy*, I revisited the remembered movement from the original solo, *BB*, to see the resonances it currently held for me. I was interested in exploring what I categorised as Melnick's movement re-circulating through my movement vocabulary as opposed to what I considered to be essentially my way of moving. One year after the performances in Dublin, Melnick presented *BB* at a benefit gala[10] and although the material only referenced aspects of the original solo, it was possible to recognise traces of the original in this new version.[11] Melnick's performance of this solo was markedly different to mine and the nuances that distinguished Melnick's movement style from my own were evident (Figure 7.2). As I progressed in my adaptation, it became clearer how the work we produced was more of an amalgamation than I had realised at that time, how influenced I had been by her moving identity and reciprocally, the particular traits that I had brought to her work.

The circulation of choreographic traces that inhabit the dancing body could be described through Barthes' (1977: 146) notion of the written text as 'a tissue of quotations'. In this case, the body is the 'multi-dimensional space' in which various incorporations from diverse origins 'blend and clash' (Barthes 1977: 146).[12] The ubiquitous lineages of influence in dance are enacted through corporeal exchange as dancers are filled by the choreographic texts of past performances. Barthes is referring to a cultural space of exchange and transaction, where influences may be acting on the individual from a broad range of sources. When transferred to dance, we can observe through the moving identity that subcutaneously embodied traces circulate and influence, resurfacing to shape (often unknowingly) the movement choices dancers make.

Figure 7.2 Jodi Melnick in *Suedehead* 2009. Photograph by Julieta Cervantes.

If in remembering we reconfigure our past, the multitude of movement traces do not represent a solid archive, but a body-in-flux that recreates these traces anew when they are recollected.

Dance movements drift away from specificity over time. As outlined in Chapter 6, during the solo creation period, the physical presences of the choreographers helped to maintain the boundaries of each work so that I could situate myself in each piece. They operated as reference points, anchors and memory banks, helping me to discern and remember the subtle differences between each solo. Due to the fluidity of embodiment, the proliferation of choreographic signatures and the practice of independent dancers becoming choreographers, sources of movement ideas in contemporary dance are often difficult to discern. As Launay (2012: 51) explains:

> Random or intentional vague memories or a proclaimed homage, subversion, or faithful copy, literal quote or disintegrated reference merged into a new work – revivals, reconstructions, adaptations, and reenactments in contemporary dance occur in such myriad shapes that it is impossible to catalogue an exhaustive list of their techniques.

The accessibility of choreographic data that projects such as Motion Bank offer is beginning to provoke questions regarding authorship and the need to establish ways of 'referencing' choreographic quotations.[13] Yet, this has always been a characteristic of contemporary dance which functions through a porosity of practice. From a copyright perspective, dancers do not own the traces of past choreographic processes. These belong to the specific context of the choreography and only in this space can they legitimately be re-enacted. Launay (2012: 49) writes that within the 'closely guarded circuits' of modern dance 'citation was formally forbidden' and this was possible to enforce because of the strong signature of individual choreographers and the monolithic nature of the institutions that they established. Video recordings of modern dances were also not widely available.

In recent years, there has been renewed interest in copyrighting choreographic authorship sparked in some part by claims of plagiarism made against singer Beyoncé Knowles, by Anne Teresa de Keersmaeker, regarding Knowles' music video 'Countdown'.[14] Yeoh (2007 online) writes that the copyright laws regarding choreography centre on the 'fixation [or documentation] of dance acts' in order to determine the identity of the work [my insertion]. However, she adds that creative methodology must also be taken into account because choreography is a collaborative process, whereby 'a choreographer creates on dancers in a studio environment, and her ideas are "moulded" and embodied in the dancers, unlike a composer or dramatist who can be solitary in the act of creation who fixes her ideas directly onto paper' (2007 online). The studio is a social space where choreographers lay bare their processes and practices. As choreographer Agnes de Mille observed, 'the choreographer is glued immobile as a fly in a web and must watch his own pupils and assistants, suborned to steal his ideas and livelihood. Several dancers made paying careers out of doing just this' (de Mille in Yeoh 2007 online).[15]

For copyright to be established, the choreographic work must be definable 'as an original creation, worthy of being "signed" by the author' (Yeoh 2007 online). Yet, if the dancer co-forms the choreographic signature with the choreographer, much of what is manifested in a work might originate so significantly from collaboration with a particular dancer that the dancer's creative identity is entangled in this signature. If the choreographer maintains the authorship role, he or she emerges from the collaboration with ownership of the signature. Certain dancers may have contributed so significantly to the development of a choreographer's work that they can be creatively disenfranchised by the ending of the working relationship.

In contrast to Jasperse's solo, I subsequently performed Roche's *SM* on many occasions following its first iteration. Although the piece has always morphed and changed according to the performance environment and, at times, a change of dancers, the original premise has been the same. A key factor of this work is the personal resonances and shared dancing history of the performers and although other dancers have substituted for the side dancers who are in darkness, each time I have performed in the centre position in the work. My relationship to this work has been deepening over time, as each new performance environment initiates a reworking of aspects of the piece. As the relationship to the other dancers is intimately interdependent, restaging the work involves a recalibration of our moving identities each time.

Joseph Roach (1996: 26) describes performative movements as 'mnemonic reserves'. He refers to the act of remembering events through re-embodying gestures, and thus in re-embodying choreography we revisit our earlier selves. Influenced by the moving identity of the dancer, choreography encodes this material trace. Thus, lived experience is encrypted in movement as choreographic forms are passed on *ad infinitum* into future iterations of a piece or across a body of work as they circulate and subcutaneously influence. Dancer Pat Catterson (2009: 6) writes about her relationship to Rainer's *Trio A* over a number of years, explaining, 'it so changed my sense of myself inside my own dancing and performing that I never wanted to let it escape my body's memory'. She discusses the difference between learning about this piece in theory as a cultural icon, rather than experiencing it at the 'ground level' of embodiment and that the latter experience brings it into the present tense through corporeal engagement; 'its history is embodied in its doing' (Catterson 2009: 11). This relationship with a choreographic work over time, where it helps to shape a moving identity and there is a desire to keep it present, speaks to the potential for choreography to continue to impact on dancers after the performance. Catterson (2009: 9) describes returning to the choreography for a performance in 1999 having performed the work for the first time in 1969: 'its beauty was still there in all the same ways for me. My body has aged. Movements in *Trio A* that were not difficult at all at twenty-three are much more difficult now, and yet I understand it so much more.'

With Butcher, the traces of our research period could be seen in *Episodes of Flight*, choreographed by Butcher for Dance Umbrella 2008 and performed by Elena Giannotti, which followed our last research period by many months. In a review of the work, Sanjoy Roy (2008) writes how Giannotti 'seems to have been beached on terrain to which

she is ill adapted to travel, yet travel she must'. Though we had left the idea at a very early point in its development, it was possible to trace how Butcher and Giannotti had progressed some of these ideas forward towards a completed work. The notion of evolutionary cycles was still present when viewing the work[16] and Roy's (2008) description mirrors the experience of duality in performing micro-movements that triggered huge sensations (see Chapter 3) when he writes,'meanwhile, the audiovisual environment is suggestive both of a vast, indifferent exterior world and of an inner landscape that finds no physical expression'.

In a group-devised choreography, dancers often develop and contribute movement material that they do not perform in the completed work. Butcher describes how care is needed about what is discarded throughout the rehearsal process in light of the investment made by individual dancers in producing choreographic material. She manages this by explaining to her dancers that material that is devised will be directed towards an overall concept. Butcher (Butcher and Melrose 2005: 60) explains, 'that's why [dancers ...] are special people. They have to live with the idea that the process is selective and it is a selection that rests with someone else.'

As performance is the only visible outcome from the intensive work in the studio, the instances of collaboration are hidden from public view. Thus it is difficult to quantify the dancer's labour, which rarely has value within a cultural marketplace that prioritises product over process. Bojana Kunst explains that in the early part of the twentieth century, modern dance co-emerged with an autonomous free body as an alternative to the rationalised working body of the Fordist factory. This positioned dance as opposite to work, as an opportunity to discover the body's natural inner potential rather than the instrumentalisation of the labouring body perhaps leading to a tendency not to recognise a dancer's work as work. However, she acknowledges that dance 'is work in terms of its material rhythms, efforts, in how movement inhabits space and time. It is work in the sense of how bodies distribute themselves in space and time, how they relate to each other and how they spend and expand their energies [...] it is deeply entwined with the power of work, with its virtuosity and failure, dependence and autonomy' (Kunst 2011: 57). This labour is mainly visible throughout the process and often integrated by the time performance is reached. It includes the creative contributions made during the development of the work and the many layers of complex decision-making that lead to the final product. Although many choreographers acknowledge the centrality of dancers in shaping choreography, dancers do not own their

creative contributions to choreography and do not have ownership over the work. By their willingness to relinquish this ownership and become subjects who investigate and instantiate choreographic precepts they embody particular ways of being in the world, which involve learning through encountering the other. Bennett[17] explained:

> the dealing card for me is that I'm going to need something out of this as well. You know what the choreographer's interests are just by being in a working process with them. It really varies between whether the emphasis is on the vocabulary or whether it's improvisation or whether it's performance [...] you can move into different areas that you want to explore or that you need for your own development.

Rather than being doomed to embrace a sacrificial subjectivity, dancers can and do engage with dancing practices in ways that are creative, exploratory and knowledge-producing. How this work might be more fully recognised and furthermore, how the knowledge it produces might find an outlet is a pressing question for the dance field.

Rather than beginning as neutral surfaces that are inscribed upon, contemporary dancers enter the choreographic process with a range of experiences that have formed their moving identities. Thus, a dancer is not a *tabula rasa* but rather, carries the traces of past embodiments and life experiences that implicate her/him beyond the position of neutral choreographic 'instrument' or 'tool'. Although dancers are often required to integrate the choreographer's signature movement, they may be chosen by choreographers for their unique moving identity and its impact on the outcome of the work. Thus a dancer is a kind of artisan who creates a distinct dancing signature through an individual dancing lineage. Artisanal approaches acknowledge the craft of dancers by locating the production of work directly within their instantiated embodiment. However, I propose moving further beyond the model of artisanal relations that shape a dancer through dancing with one choreographer over many years, to identify how autonomous trajectories form dancing identities across multiple choreographic processes.

As outlined in Chapter 2, choreography could be regarded as autopoietic (Varela 1996: 212), emerging out of the individual nature of each process of engagement by specific choreographers and dancers to create distinct choreographic works. Due to the instantiated nature of its materialisation through dancing bodies, choreography encompasses the individualistic qualities of the dancers (culture, race, gender, life

narratives), economy of production of the work (funded, non-funded and to what degree) and the situated location where the work is created and performed (prevalent cultural and aesthetic preferences, socio-economic status of dance and space to create/perform in). However, this assemblage produces more than the sum of these ingredients in the relational process of choreography (Sabisch 2011). How a dancer enters a work could be described in myriad ways: as '"trying on someone else's clothes", seeing how that feels and then exploring how one could make them one's own' (Clarke, Cramer and Müller 2011: 223) or the 'trans-lation' process that Bennett mentions earlier. It could be described as tracing choreographic movement beside the choreographer as Schick remembers from her experience of dancing for Trisha Brown: 'dancing next to her, you could feel her body like a warm engine; her spirit was infectious, and yet, it all was so uncatchable, unknowable'; or internal-ising given tasks, as with Butcher's process in *SF*, to be reproduced in performance through a written score.

Although it is widely acknowledged that individual dancers make an impact on both the development of an individual choreographic work and choreographers' creative signature, the degree to which a dancer's moving identity and creative engagement impacts on the formation of the choreography is not often brought to light. The inclusion of the dancer's embodied experiential perspective in the arena of dance dis-course bridges the gap between an objectified interchangeable dancer who is identifiable only by the markings of the inscription of dance technique on the body, and the current reality of a dancer-in-flux who incorporates and co-creates many different choreographic styles, while living a normal, pedestrian life with all the complexity that implies in the twenty-first century. As Bel[18] highlights, dancers possess specialist knowledge of dance works, with unique insights into their construc-tion and realisation while also knowing intimately the work's embed-ded feeling states, dynamics and structural patterns. Writing from this perspective situates the reader in the 'now' of this incarnate presence, allowing a type of engagement with aspects of dance practice that are normally unavailable to academic research. However, Roses-Thema (2007: 5) writes that it is challenging for dancers to analyse embodiment and represent findings in linear sequence because they speak languages of embodiment that are 'not linear, but simultaneous and synergistic'. This invites the development of frameworks which allow dancers to contribute to the analysis of the dance field through languages that emerge from practice and that translate their lived experience of 'syner-gistic' experiential states to other branches of knowledge. When dancers

become researchers of creative practice, new critical perspectives of the dance-making process and rich new experiential realms are uncovered.

Dancers manage a high level of complexity and multiplicity by engaging in practices that are predicated on breaking new ground and opening new experiential terrains. As Grosz (1994: x) writes, '[historical and cultural] representations and cultural inscriptions quite literally constitute bodies and help to produce them as such' [my insertion]. Different epochs have constructed dancers differently and new media and the information age will no doubt continue to impact greatly on how this role is embodied. As highly agile subjects in a postmodern world, dancers are well positioned to contribute to current explorations of consciousness, subjectivity and human embodiment. But this runs counter to the 'sacrificial subjectivity' that Lepecki (2006) highlights and which is still deeply implicated in dance training and professional practice. Dancers' corporeality is the weak point, the mortal reality that must always be faced. The disappearance from view of creative labour that is rendered visible only in the ephemeral moment of performance and the lack of a means to validate the studio work or assign creative ownership over certain aspects is problematic. As much as we might challenge the status quo, the reality is that the contemporary dance marketplace promotes the signature choreographer and, arguably, pushes younger and less experienced dancers to choreograph as a means of taking ownership of a personal creative identity. As dancers develop opportunities to be considered contributors to culture through engagement in choreographic practices they can further explore strategies for developing creative agency. This requires a move beyond the creative passivity that training systems still often reinforce and which can encourage subservience and obedience, towards models that nurture autonomy and collaborative thinking.

Dancers' moving identities are the composite of past movement experiences that are gathered through various interactions with teachers, choreographers and other dancers. In as much as they represent the repertoire of previously embodied dancing selves, these embodied traces are available to be reproduced in a wholly new way as they are materialised through the incarnate presence of a dancer in a moment in time. The moving identity could be regarded as a creative toolbox, which is the result of the accumulation of choreographic movement incorporations and training influences. This is the marking and scarring that Hilton so poetically describes; the means of tracking where we have been and by whom we have been touched. This amalgamation of influences produces stylistic idiosyncrasies that emerge when dancers

themselves begin to choreograph. However, I am not proposing that this would be a complete accumulation of the entirety of a dancer's movement past. As each dancer is produced anew through the choreographic environment, some elements remain more fully than others. As with the evolutionary process, new elements are adopted while others are discarded or dissipate through lack of use. Therefore, the moving identity is the result of a dancing agency, the composite of choices conscious and unconscious that have been made throughout a dancer's career. It is the site through which dancers establish a self-in-movement and realise the potentialities of a creative dancing signature.

Notes

Preface

1. Kolb is drawing from recent writing by Antonio Negri, Michael Hardt and Maurizio Lazzarato to describe the move from industrial to post-Fordist societies, which represents a shift towards the production of 'immaterial' goods such as services, knowledge and cultural experience and away from mass production of material items for consumption (Kolb 2013: 41).
2. Other contributors include Irish contemporary dancers Katherine O'Malley, Philip Connaughton and Ríonach Ní Néill.
3. Interestingly, both of these works are discussed in Wendy Perron's (2013) publication, *Through the Eyes of a Dancer*, where Perron questions the legitimacy of appropriating choreographic material into other dances and asks whether this constitutes 'stealing'.

1 Dancing Multiplicities

1. For example, there are many obvious differences between the high octane virtuosic athleticism of Belgian choreographer Alan Platel's *VSPRS* (2006) for Ballet C de la B, involving dancers tumbling and contorting in a myriad of forms and configurations and the movement minimalism of Jérôme Bel's piece entitled *Jérôme Bel* (1995). The latter involves the most subtle and basic explorations of the body and relative to Platel's piece, employs very little movement at all. Both of these dance pieces were performed within the context of the International Dance Festival Ireland (IDFI) (renamed the Dublin Dance Festival in 2008), *VSPRS* in 2006 and *Jérôme Bel* in 2002. Although Platel's work is unconventional in approach, with much of the choreography appearing as a chaotic and random expression of the dancers' momentary impulses, its relentless movement easily places it in a dance context. However, Bel's minimalist piece provoked an audience member to sue IDFI on a charge of false advertising because he believed that there was nothing that could be described as *dance* within Bel's performance (Lepecki 2006: 2). I use these two examples because the activity of the dancer as performer is highly contrasting in each work, yet both are classified as belonging to the contemporary dance genre.
2. This is in reference to Jacques Derrida's (1978) essay, *Writing and Difference* in which Derrida critiques the notion of the theological stage that comprises an author-creator who is absent from the stage but represented by the muted interpreters who enact his thoughts through action and words.
3. Throughout this text, I use the term choreographic signature as both the named and profiled choreographer as author that writes across all aspects of the work and the marks of identity and qualities of style that are consistently carried across a choreographer's oeuvre.

4. One of the results of this approach was Contact Improvisation, the technique that Steve Paxton is credited with originating but which does not carry his name, a legacy of the democratic positioning of movement authorship within a strand of dance performance that was fostered through the Judson project.

5. This shift echoes Roland Barthes' (1977) concept of 'the death of the author', which I explore further in Chapter 2. Among other tools, Cunningham used the *I Ching*, or *Book of Changes*, an ancient Chinese system of divination, which involves throwing three coins, the numerical sum of which corresponds to a hexagram. Each hexagram advises on a specific course of action.

6. Although this article was originally published in *Contact Quarterly*, I have only been able to access it online through Davida's personal website. Accessed 14 May 2014. http://denadavida.ca/articles/dancing-the-body-eclectic/.

7. Ideokinesis, which originated with Mabel Todd (1880–1956) and was developed further by Lulu Sweigard (1895–1974) and many subsequent teachers and practitioners, is a method that uses imagery to enhance anatomical alignment. It has infiltrated contemporary dance training as well as creative process.

8. During the period from 1989 to 1996, all programmes supported by the National Endowment for the Arts were significantly reduced and restructured. For a summary of dance funding in the US throughout the twentieth century, see Prevots (1999).

9. Independent Dance has been operating since 1992 and began receiving regular Arts Council funding in 1998. It is currently housed in Siobhan Davies Dance Studios, London. Information from website. Accessed 20 May 2014. http://www.independentdance.co.uk/who/context/timeline/.

10. Some examples are Dancehouse, Melbourne; Mercat des les Flores Barcelona; Centre Nationale de la Danse, Paris; Tanzquartier, Vienna; and Tanzhaus NRW, Düsseldorf.

11. Due to the location of the creative work in Ireland, I give here a brief outline of the dance landscape in Ireland. Following a major redistribution of Arts Council funds for dance in 1989, the majority of dance funding was directed towards new choreographers and fledgling companies leading to a democratic funding environment that is still project-based (McGrath 2013). The establishment of Dance House in Dublin in 2007, managed by the all-Ireland resource organisation, Dance Ireland, provides support for independent dance practice in Ireland. A number of independent dance artists operate out of Dublin and international touring is supported by the government agency, Culture Ireland. The Dublin Dance Festival (previously the International Dance Festival of Ireland) annually programmes international dance work, which also influences the choreographic trends coming out of the country. Increased economic security in Ireland in the period from 1997 to 2007 opened the possibility for travel and exchange, leading to commissions by Irish companies from choreographers such as Rosemary Butcher (UK), Thomas Lehman (Germany), Sara Rudner (US), Steve Paxton (US) and Rui Horta (Portugal). As well as dancing with choreographers, the Arts Council of Ireland incentivises independent dance artists in Ireland to create work independently and/or collaborate with artists from other artistic media

through the availability of one-off, short-term project funding (Anon. 2010). However, due to the limited infrastructure for dance in Ireland, independent dancers do not have the same strong positioning as is in evidence in the UK, through support organisations such as Dance UK and Independent Dance.

12. Tonus describes the underlying activity of the body's tissue even when in rest and is visible through quality of bodily movement. See Hanna (1979).

13. Interview at Dancehouse, Melbourne, 11 July 2008.

14. Extemporary Dance Theatre (1975–91) was formed by six contemporary dancers and toured new works by modern dance choreographers on a small scale. While in the role of artistic director, Claid guided the company towards more experimental works. Dancers who worked with the company include Lloyd Newson, Nigel Charnock and Yolande Snaith, and choreographers whose works were featured include Steve Paxton, Tom Jobe and Karole Armitage. See National Resource Centre for Dance at the University of Surrey. Accessed 2 April 2014. http://www.surrey.ac.uk/library/nrcd/archives/collections/coarchives/extdancetheatre/.

15. Foster presents a structuralist approach to the development of dancing bodies, a position that has been critiqued by Gardner (2007a) who, furthermore, brings to light a vital distinction between the inscription of dance techniques on the dancer in training and the way in which dancers learn through dancing with one choreographer over an extended period of time. In her exploration of modern dance practices, Gardner draws on the views of dancer/choreographer, Sara Rudner, who values 'artisanal' rather than 'distant, formal or industrial' practices (Gardner 2007a: 42). Gardner (2007a) draws attention to the specific modes of production of dance techniques in modern dance, which she explains are often conflated with the hierarchical legacy of technical training in classical ballet, in spite of emerging in opposition to the balletic model.

16. Davida (1992) demonstrates the commitment that practitioners are seen to make to a particular movement approach, to the exclusion of others, through a quote from Francis Sparshot (1988): 'It may well be that some (or even all) performers are personally committed by this self transformation in such a way that – as a matter of integrity or simply as a psychological impossibility – they cannot afford to take seriously any alternative standpoint.'

17. Rudner explains that the practice of working for concentrated periods with one choreographer to develop the dancer has been replaced by the generic dance class – a shift that she terms 'regrettable' (Gardner 2007a: 42).

18. However, it must not be assumed that dance techniques are closed systems. Paradoxically, as techniques are utilised to clarify and codify movement, they are also subjected to change and modification through various (re-) incorporations. For example, the movements and aesthetics of ballet have changed significantly from the beginning of the twentieth century to the current day. Modern dance techniques have also been adapted as they are passed on from teacher to student. Dancers do not *perform* technique, but rather choreography, which even within clearly defined styles is open to adaptation across dance pieces. Dance critic Jean-Marc Adolphe (2002: 301) explains, 'when she was asked at the end of her life about the proliferation of techniques that carried her name, Martha Graham claimed to have never developed a rigidly set technique and to still be at a stage of research'.

19. Claid is referencing Peggy Phelan (1993) here, she explains: 'In a patriarchal economy of desire (inherent to conventional performance contexts) the marked term is the male subject and the unmarked is the female, which the subject then marks as his own' (Claid 2006: 118). Claid (2006: 120) explains how enabled through the feminist movement, the 1970s female performer gained identity and subjectivity by performing her 'real' body and stripping away the 'fetish of the marked female dancer's presence'; the cost of which was invisibility.

20. From a Deleuzean perspective, molar identities are produced through the complex networks of social connections, which impose a dominant reality on subjects and enclose them in relation to the three major social strata, 'the organism, significance, and subjectification' (Tampio 2010).

21. If a shift in power relations occurs when dancers are positioned to articulate creative practice, this is not dissimilar to the reshuffle of power dynamics in the production of a solo programme involving work by other choreographers, which could be seen as a coming of age. Inherent in this structure is how a solo dancer might be revealed as a continuous presence through different choreographers' works and thus elevated to the centre of the event. Examples of solo programmes instigated by other dancers include Maedée Duprès (Jordan 1992: 91) who presented *Dance and Slide* in 1978 at the Association of Dance and Mime Artists festival in the UK and created subsequent projects to become a well-established solo dance artist. Two projects which relate particularly to the project of this book were produced by Stephanie Jordan in 1983 and Milli Bitterli in 2002. Jordan independently commissioned solos from three UK-based choreographers, Michael Clark, Micha Bergese and Mathew Hawkins, performing at the Place in London and subsequently touring to venues around the UK in 1983. As Jordan (1984) was also writing as a dance critic at the time, she illuminated the experience of performing these three works in terms of her physical and production-based preparations for the performances. More recently, Austrian dancer Milli Bitterli created a programme of commissioned solos entitled *In Bester Gesellschaft* (In Best Company) by choreographers Wendy Houstoun, Christine Gaigg, Superamas and Christine de Smedt, which was premiered in Tanzquartier Wien. A description of the programme on Bitterli's (2014) website reads, 'In her dual role as curator and player, Milli Bitterli reverses the usual pattern "choreographer seeks dancer".' British South Asian dancer Aakash Odedra toured a series of solo choreographies internationally that were created by Odedra, Akram Khan, Sidi Larbi Cherkaoui and Russell Maliphant. The purpose of this programme, entitled *Rising*, was to explore 'different processes and aesthetics to create a new personal language', thus Odedra endeavoured to develop his choreographic language through encounter with the multiple perspectives offered by these three choreographers (Odedra 2014).

22. More details on Butcher's biography can be found at the following address. Accessed 25 April 2014. http://www.rosemarybutcher.com.

23. Jasperse has received numerous fellowships, awards and prizes including a Guggenheim Fellowship and a New York Dance and Performance ('Bessie') Award. For his work *Excessories* (1995), he received three prizes from the 1996 Rencontres Internationales, Choréographiques de Bagnolet, France. More information on his biography can be found at

the following link. Accessed 11 May 2014. http://www.cprnyc.org/about/founders/john-jasperse-thin-man-dance-inc/.

24. 'Navigating through Time and Space' review, *New York Times*, 17 November 2011. Accessed 11 May 2014. http://www.nytimes.com/2011/11/18/arts/dance/john-jasperses-canyon-at-brooklyn-academy-of-music-review.html.

25. *Fish and Map* (2003) – commissioned by Rex Levitates, performed in Diversions Festival, Temple Bar, Dublin; *Wanderlust Kentucky* (2004) – commissioned by Maiden Voyage Dance Company, Belfast, performed in the Belfast International Festival at Queens; and *Suedehead* (2008) – commissioned by Rex Levitates, performed in the Irish Museum of Modern Art.

26. She has received two New York Dance and Performance Awards ('Bessies') for sustained achievement in dance (2001 and 2008) From Melnick's biography. Accessed 26 April 2014. https://dance.barnard.edu/profiles/jodi-melnick.

27. Gia Kourlas, 'From the Everyday, the Extraordinary: Jodi Melnick at New York Live Arts', *The New York Times* Dance Review, 9 March 2012.

28. For more information on Melnick see the following source. Accessed 26 April 2014. https://dance.barnard.edu/profiles/jodi-melnick.

29. Artist's statement taken from New York Live Arts website. Accessed 26 April 2014. http://newyorklivearts.org/artist/Jodi-Melnick.

30. In 2007 I left my role as director but continued to perform occasionally with the company. In 2012 the company rebranded as Liz Roche Company (see http://www.lizrochecompany.com).

31. The piece was entitled *One Story as in Falling* (1992) commissioned for The Bagouet Company. Accessed 25 April 2014. http://www.trishabrown company.org/?page=view&nr=504.

32. Roche was a former recipient of the Bonnie Bird UK New Choreography Award for Choreography and Peter Darrell Award (UK). More details on Roche's biography can be found at the following address. Accessed 25 April 2014. http://www.lizrochecompany.com/aboutus/lizroche.asp.

33. Michael Seaver Ballet Tanz International, taken from Liz Roche Company website. Accessed 20 May 2014. http://www.lizrochecompany.com/aboutus/lizroche.asp.

34. Taken from interview with Liz Roche for the documentary *Sky Arts @ Dublin Dance Festival 2012*. Accessed 26 April 2014. https://www.youtube.com/watch?v=hqzRVyfwD0c.

35. Post-performance discussion, Project Arts Centre, Dublin, 25 April 2008.

36. Ibid.

37. Ibid.

38. Interview, Rudner's apartment, New York, 3 January 2006.

39. Ibid.

40. Alongside my relationship to each choreographer there are other significant connections between the choreographers. For example, Roche was mentored by Butcher in the development of *Resuscitate* for the International Dance Festival, Ireland 2003 and performed in Butcher's *Six Frames: Memories of Two Women* in 2005. She danced in *Missed Fit* (2002) and subsequently, in a production entitled *Prone* (2005) by John Jasperse. Melnick and Roche have performed in each other's choreographies, Melnick in Roche's *Secondary Sources* (2011) and Roche in Melnick's *Suedehead* (2008). Jasperse created a

dance piece entitled *Becky, Jodi, and John* (2007) in which he danced along-side Melnick and interviewee Rebecca Hilton.

2 Descending into Stillness: Rosemary Butcher

1. Lepecki (2006) highlights the issues that Bel's works uncover, one of which is the limitations that representation in choreography exposes when there is an attempt to present the performer as a singular identity in the moment of performance. He paraphrases this question as, 'in which ways is Western choreography part of a general economy of mimesis that frames subjectivity and encloses it?' (Lepecki 2006: 46). According to Lepecki (2006: 55), Bel in particular has uncovered a number of questions in relation to the choreographic role, questioning whether we can indeed 'identify an author in its intentional singularity'. Bel has also critiqued the author-function in his work *Jérôme Bel* (1995), a piece to which he gives his name, yet in which he never appears onstage. In this way, the performers, the concept behind the work and its materialisation on stage through many collaborative elements are all contained by his name to become his body of work – *his body*.
2. I explore this issue in more detail in Chapter 7.
3. It should be noted that Butcher names Giannotti as a collaborator in the publicity for many of her works, for example *Time Out London* for Dance Umbrella 2008 reads, 'still radical after all these years, "Episodes of Flight" is a reflection on Butcher's artistic history and influences, in close collaboration with dancer Elena Giannotti, sound designer Cathy Lane and lighting designer Charles Balfour'. Accessed 23 March 2014. http://www.timeout.com/london/dance/dance-umbrella-rosemary-butcher.
4. Numeric scores, for example, where each number represents a specific movement, can be utilised as a stimulus for dancers to create and manipulate phrase material or by merging these, to facilitate unexpected ways for dancers to interact together. Task-based composition wherein dancers must interpret a series of instructions is another means to generate choreographic material, which the choreographer reshapes and integrates into the work.
5. The use of choreographic scores exemplified in the work *Schreibstück* (2002), by German choreographer Thomas Lehman, involves a written score that is interpreted by three choreographers who each work with three dancers. According to Lehman (2002), 'the motivation for "Schreibstück" was to separate conception, planning and structural frames from the further elaborations of the work [...] this process excludes the "metaphysical" communication, the reliance on performers' charisma or personality mythology, existing in between the conceptual process of the choreographer – the author function – and the performers who execute and interpret ideas and material'. By giving his name to the work, yet incorporating many layers of interpretation by others, including the group of dancers who improvised in some sections within a structured temporal and spatial framework, Lehman positions himself as the overarching author while democratising the process of the creation of the work. Although consideration of the author is requested, the three choreographers are free to interpret his instructions as they like.

6. Gardner (2007a: 37) identifies the 'intercorporeal' and 'intersubjective' nature of the relationship between dancers and choreographers. This is explored further in Chapter 4.
7. Anna Pakes adopts the term phronesis from Aristotle, which denotes knowledge accrued from praxis that is not set into rules and principles but variable and responsive to the environment. *'Phronesis* is not concerned so much with general principles, universal laws or causal understanding, but rather with what cannot be generalized. It is a kind of attunement to the *particularities* of situations and experiences, requiring subjective involvement rather than objective detachment; and it has an irreducible personal dimension in its dependence upon, and the fact that it folds back into, subjective and intersubjective experience' (Pakes 2009: 18–19).
8. Drawn from the theories of biologists Francisco Varela and Humberto Maturana *autopoiesis* is a concept that describes the cellular process of emergence, whereby a cell defines a boundary, or membrane, which bootstraps the constituents of the membrane. This is a self-organising principle, so that from an arts perspective, those involved in the work can be considered as both producers and products, rather than creating (machine-like) a product, object or outcome outside of this system (Carlson 2008: 7). When adopted as an approach to the choreographic process, it proposes an organic unfolding of work that emerges from the particular circumstances and constituents of the work. This concept resonates with certain choreographic practices as a way of working creatively with circumstances as they arise, while also offering the possibility to regard the specificity of the performer's embodiment as key in shaping the choreographic work. From a theatrical perspective, the 'autopoietic feedback loop' is a framework for utilising the interconnectedness of audience and performer in shaping performances (Fischer-Lichte 2008). Some dance artists have used this approach as a means of directing and describing choreographic processes. Indeed, Lehman facilitated a workshop in 2008 at Independent Dance in London on *autopoiesis* as a method of creation.
9. Taken from rehearsal video documentation, June 2005.
10. Ibid.

3 Veils within Veils: John Jasperse

1. In Morgenroth (2004) the piece is referred to as Misfit, but the correct name was Missed Fit. See National Archive of Ireland, Irish Modern Dance Theatre Papers. Accessed 26 April 2014. http://www2.ul.ie/pdf/225635256.pdf.
2. Authentic Movement is a movement therapy which has infiltrated dance practices as both a mode of performance and a means to enhance performance skills. It encourages the participant to move freely in the moment supported by the presence of a witness. Janet Adler (Pallaro 1999) describes the witness in Authentic Movement as situated on the periphery of the movement space, bringing awareness, attentiveness and presence to the mover's experience.
3. Post-performance discussion, Project Arts Centre, Dublin, 25 April 2008.

4. Here Lepecki draws from Mark Franko's (2002) publication, *The Work of Dance: Labor, Movement and Identity in the 1930s*.
5. Post-performance discussion, Project Arts Centre, Dublin, 25 April 2008.
6. Ibid.
7. Ibid.
8. To give balance to this viewpoint, in contrast, Gallagher and Zahavi (2008: 161) outline that at the other end of the spectrum, the 'radical bottom up' account situates the sense of agency in pre-reflective neural processes that control motor activity. They explain, 'one version of such an account proposes that efference signals (the signals the brain sends to the muscles to make them move) or certain forward motor control mechanisms (i.e. processes that keep our actions on track as they develop, and prior to getting any sensory feedback about them) generate a phenomenal experience of agency' (2008: 161).
9. This is drawn from Graham and Stephens' (1994: 102) exploration of psychopathology from a philosophical perspective and from which they explain that my sense of agency regarding my action is predicated upon 'whether I take myself to have beliefs and desires of the sort that rationalize its occurrence in me'.
10. Interview at Dancehouse, Melbourne, 11 July 2008.
11. Founded by Pendleton and Wolken in 1971, Pilobilus presents sculptural work that creates optical illusions through movement, costumes and sets (Brown, Mindlin and Woodford 1997).
12. Post-performance discussion, Project Arts Centre, Dublin, 25 April 2008.
13. I describe in Chapter 7 how Jasperse used key elements from this solo in his development of *PURE* (2008) for the American Dance Festival and into subsequent works.
14. Chapter 7 outlines the subsequent development of the ideas in this solo into group pieces.

4 The Shape Remains: Jodi Melnick

1. Post-performance discussion, Project Arts Centre, Dublin, 25 April 2008.
2. Taken from rehearsal video documentation, January 2006.
3. Non-dance (or *non-danse*) emerged as a term in the 1990s in France in relation to the work of choreographers such as Bel and Charmatz because their work challenged virtuosity as a performative goal and used stillness, nudity and other performance practices to question the underlying precepts of dance performance (Noisette 2011). The term concept or conceptual dance is also utilised to describe this kind of work. However, the artists whose work these terms describe have not adopted this nomenclature and, in many cases, contest these terms.
4. Not just commenting on Lepecki's viewpoint here, I am acknowledging the tensions that exist across contemporary dance between more conceptually structured choreography and work that is 'dance' based.
5. This is in reference to Derrida's 'theological stage' as mentioned in Chapter 1.
6. Interview at Dancehouse, Melbourne, 11 July 2008.

7. By situating the origins of choreography in the *Orchesographie* (1589), the foremost dance manual of that period by Thoinot Arbeau, Lepecki illustrates that choreography was not always associated with movement but existed independently as a *written* command to move bodies. While we can see resonances from these early origins in the choreographic practices of today, as we have explored in previous chapters, there are myriad approaches to working choreographically.

8. The notion of a dialogical self which is produced by encountering difference through the other resonates here. I explore this idea more fully in Chapter 6 in relation to Salgado and Hermans' (2005: 9) outline of the dialogical self.

9. Interview at Myriad Dance Studios, Wexford, 15 October 2008.

10. Phone interview 7 November 2008.

11. Interview at Dancehouse, Melbourne, 11 July 2008.

12. The habitus is explored in Chapter 6 in relation to the moving identity.

13. Indeed, Fernando and Alfonso De Toro (1995: iv) write of the similarities of purpose and operation of modernism and colonialism, stating that 'their perennial thrust is systemically outward, their justification endemically exclusionary and esoteric'. Thus we might draw parallels with post-colonial residue, which includes the inability to verbalise the post-colonial experience through the tongue of the coloniser, a conflicted relationship between self and place and a crisis of self-image (Ashcroft, Griffiths and Tiffin 1989).

14. This is drawn from my memory of her presentation and corroborated by her further writing on the subject (see Albright 2013).

15. Lepecki (2006: 10) outlines how choreography enacts a system of control that has resonance with Louis Althusser's theory of the *interpellated* subject, who is called to obedience by dominant state forces in the name of the 'Absolute Subject'. This interpellation is made effective because free subjects enact their compliance wholly by themselves. As Lepecki (2006: 9) recognises, 'this sounds a lot like the fundamental mechanism choreography sets in place for its representational and reproductive success'. For further elaboration on Althusser's theory, see Althusser (1994).

16. This is outlined briefly in Chapter 1, when I explain how Rudner regrets the substitution of a dance class for working intensively with a choreographer over a long period of time. Also see Gardner (2007a: 42).

17. Interview at Rudner's apartment, New York, 3 January 2006.

18. Rudner explained to me that Tharp was pregnant at the time she is discussing here.

19. Dumas was born in Brisbane, Australia in 1946 and danced in Europe with companies such as the Royal Ballet, Culberg Ballet, London Festival Ballet and Strider as well as with Trisha Brown and Twyla Tharp in the US. He formed Dance Exchange in Sydney in 1976. He is currently based in Australia. Accessed 21 September 2014. http://trove.nla.gov.au/people/523548?c=people.

20. Having participated in Dumas' rehearsal process very briefly in 2007 and in 2010, the impression I had was of an atelier or workshop where time is given to exploring numerous possibilities in order to create fully integrated choreographic movements. These were short rehearsal sessions which Dumas invited me to attend and in which I was primarily an observer.

21. Rudner created the first version of this work in 1975.

22. Michael Seaver, 'An Invite to a Dancing Life – Interview with Sara Rudner', *Irish Times*, 13 August 2007.
23. Ibid.
24. Ibid.
25. See Gardner (2007a) on capitalist modes of production in Chapter 2.
26. Card (2006) describes how for the Australian production *In the Dark* (2005), which was choreographed by Wendy Houstoun, Julie-Anne Long, Michael Whaites, Narelle Benjamin and Brian Carbee, Houstoun, as the internationally renowned choreographer, was foregrounded in the publicity for the piece in spite of the prominence of the other artists involved. She describes all the artists taking to the stage to receive the award for 'Outstanding Achievement in Choreography' at the Australian Dance Awards 2005 as a symbolic act.

5 From Singular to Multiple: Liz Roche

1. Post-performance discussion, Project Arts Centre, Dublin, 25 April 2008.
2. Ibid.
3. Phone interview, 7 November 2008.
4. Ibid.
5. The soma, a word of Greek origin, means 'the living body in its wholeness' and thus somatic practices engage with the first-person perception of embodiment (Hanna 1979).
6. Anne Teresa de Keersmaeker used this device to great effect in *Rosas Danst Rosas* (1983) whereby subjectivity was not assigned solely to a single person but embedded in the movement language so that her dancers traverse the line between displaying real and performed subjectivities. De Keersmaeker choreographed moments of performed gestures, which would normally indicate personal and individual agency. In this way, each dancer's seductive performance presence was exaggerated through actions such as brushing her hair away from her face with her hand, gazing directly out at the audience and adjusting her costume. Thus they embodied a split between private subjectivity and performativity, remaining obedient to the choreography while signalling their potential to break with the choreographic score. Burt (2004) references Judith Butler's notion of the instability of gender performance in order to analyse the dancer's performance of subjectivity, with repetition being a key factor in how this site of ambiguity is displayed. He writes, 'De Keersmaeker's [choreography] is marked by an increasing recognition of the fragmentary and conflictual nature of embodied subjectivity', illustrated through the ambiguous 'play between reality and artifice' (Burt 2004: 41). De Keersmaeker's choreography walks the boundary of the burgeoning subject-hood of the dancer, bringing it to the foreground, while simultaneously subsuming it within the overall choreographic schema. Thus she overturned the spectatorial power dynamic and presented the possibility for the dancer's self-awareness to be foregrounded in performance. Albright (1997: 15) describes this potential in another way: 'the physical presence of the dancer – the aliveness of her body – radically challenges the implicit power dynamic of any gaze, for there is always the very real possibility that she

will look back! Even if the dancer doesn't literally return the gaze of the spectator, her ability to present her own experience can radically change the spectatorial dynamic of the performance.'

7. Cynthia Ann Roses-Thema (2007: 3) placed dancers as *rhetors* of their performance experiences within her doctoral research, arguing that dance performances are generally analysed from the perspective of the viewer and not the position of the one who performs the dance. She identified that the dancer's experience is rarely included in dance studies and that when it is the account is very far removed temporally and spatially from the performance moment. Although in current practice, dancers are understood to contribute significantly to the development of choreographic works, Roses-Thema argues that, because of the positioning of analysis outside the work, dancers are generally considered to be following a tightly choreographed script rather than making choices in the performance moment. She interviewed a group of dancers directly after their performances in order to map their complex engagement with materialising the choreography and to uncover their experience of responding to the changeable performance environment.

8. Through initial brain imaging activities in primates, which were then extended to humans, neuroscientists discovered that mirror neurons are activated both when a subject performs an action and when she/he witnesses the same action performed by someone else. Studies of mirror neurons involving expert dancers have been undertaken by Calvo-Merino et al. (2005), showing that more activity was recorded in the dancers' mirror neuron systems when they observed movements that they had previously been trained to perform. This is key in understanding how dancers learn movement and can continually modify it through observation. Rudner (interview, Rudner's apartment, New York, 3 January 2006) described how these functioned when she danced with Tharp: 'I could read the dancing from being external to the dancing. And this was shocking to me, that this could be a dancer's technique. That you don't physically experience it, but you could read the dance. It was so ingrained in me that I could read it like a language. But I don't know if I could have done that if I hadn't first felt it in my own body.'

9. There are many autobiographical texts by dancers who have divulged their inner worlds. For example, Toni Bentley (1982) wrote about her experiences as a member of the corps de ballet of New York City Ballet in a revealing and insightful book. Gelsey Kirkland (1986) also wrote an exposing account of her training and professional life as a ballet dancer. Through externalising the dancer's inner world, these authors have cast light on the dance profession in a broader sense but have not interrogated or commentated on the practices of dancing and how the work is produced. Thus as Roses-Thema (2007: 1) explains, 'the dancer's voice has been locked away in the literature of self narratives'.

10. A Deleuzean concept, the operation of a line of flight is 'the movement by which "one" leaves the territory' (Deleuze and Guattari 1987: 508). It emerges out of the very conditions that produce a territorialisation, a term Deleuze and Guattari use to define the 'connection of forces to produce distinct wholes' (Colebrook 2002: xxii). Colebrook (2002: xxiv) describes the line of flight as a kind of mutation of the connective force that draws

together a territory, but the movement that creates the mutation (which may have negative outcomes, for example, the mutation of the dividing of cells to produce a cancer) can also be used to *reterritorialise* a situation.

11. Interview at Myriad Dance Studios, Wexford, 15 October 2008.
12. In Roses-Thema's research she captured moments from the performance experience of dancers immediately after they performed. By asking the dancers to explain what they perceived in these particular moments, she began to build a sense of the instructions that they adhere to. For example, dancer 'Scott', who took part in her study, explained, 'I set my move up. I just exhale as I take my plié (bend of the knee) and preparation in fourth position just before the turn, and I just go calmly into it without thinking I'm going to have to push this one [...] I say calm, calm, calm, and turn. That's what I say in my head' (Roses-Thema 2007: 78).
13. Cliodhna Hoey performed instead of O'Malley in the Purcell Room at the South Bank Centre, London and instead of Roche in Holyoke, Massachusetts.

6 Corporeal Traces and Moving Identities

1. Brian Massumi (1987) defines Deleuze's use of multiplicity as a break from the representational analysis of the world by Western metaphysics, that reduced discrete entities into components to be ordered in relation to the One and the many, or multiple. Multiplicity requires a rethinking of how disparate components have been categorised as inferior copies in relation to a perfect idea, rather than singularities in their own right, and has implications for how difference including with regards to 'race, class, gender, language, state, society, person, and party' can be represented more fully (Tampio 2010).
2. Deleuze (1988: 14) writes, 'multiplicity remains completely indifferent to the traditional problems of the multiple and the one, and above all to the problem of a subject who would think through this multiplicity, give it conditions, account for its origins, and so on'.
3. Journal entry.
4. Phone interview, 7 November 2008.
5. Interview at Project Arts Centre Dublin, 10 August 2005.
6. Interview at Dancehouse, Melbourne, 11 July 2008.
7. Ibid.
8. Phone interview, 7 November 2008.
9. Rex Levitates Dance Company Research Series, Dublin, 9 August 2005.
10. Phone interview, 7 November 2008.
11. Ibid.
12. Interview at Dancehouse, Melbourne, 11 July 2008.
13. Interview at Rudner's apartment, New York, 3 January 2006.
14. The plane of consistency is interchangeable with the term 'plane of immanence'. Immanence (staying within) presents a non-dualistic counterpoint to the philosophical position of transcendence (moving beyond). 'Absolute immanence is in itself; it is not in something, *to* something; it does not depend on an object or belong to a subject' (Deleuze 2001: 26).
15. In Chapter 3, I describe this idea from the perspective of the working process with Rosemary Butcher by explaining how without moving or

demonstrating choreography, she formed the movement habitus for the performance *Six Frames: Memories of Two Women*. This piece was improvised in performance, yet had a clearly defined range of movement.

16. https://www.ted.com/talks/wayne_mcgregor_a_choreographer_s_creative_process_in_real_time. Accessed 9 September 2014.
17. Interview at Dancehouse, Melbourne, 11 July 2008.
18. Interview at Rudner's apartment, New York, 3 January 2006.
19. Minorities are not counted as such in relation to 'the smallness of their numbers but rather by becoming a line of fluctuation' produced by a gap separating them from the majority (Deleuze and Guattari 1987: 469). Equally, in Deleuze and Guattari, majority relates to an alignment with the kinds of subjectivities that are considered to be normal, socially defined or 'stratified' and dominant.
20. Personal correspondence, 3 April 2014.

7 Further Iterations and Final Reflections

1. See Chapter 1, where I discuss how the dancer operating outside of a canonical movement language becomes unmarked and the reference to Peggy Phelan's writing on the subject.
2. I performed in the restaged *Deserts d'amour* in the Montpellier Festival in 1996, in a co-production between Les Carnets Bagouet and Dance Theatre of Ireland.
3. Charmatz (2014) has created a Dancing Museum (Musée de la Danse) in the Centre Chorégraphique National de Rennes et de Bretagne where he is director and through which he interrogates modes of reconfiguring dance events past and present by combining 'the living with the reflexive – art and archive, creation and transmission'.
4. For more information, see http://motionbank.org/en.
5. Sarah Whatley, taken from the abstract for her presentation at the Dance and Somatic Practices Conference at the University of Coventry, 2013. Accessed 28 November 2014. http://c-dare.co.uk/wp-content/uploads/2013/07/Abstracts-in-chronological-order-final.htm.
6. I saw these works in progress in New York in 2009 and 2010 during showcases in the Association of Performing Arts Presenters conference in New York.
7. See Chapter 4.
8. See Chapter 3.
9. Mapping Spectral Traces International Conference V at the University of Galway.
10. Fire Island Dance Festival 15.
11. I played an extract of Melnick dancing this and copied her movement from my computer laptop which was positioned in front of me on stage, reflecting how we worked much of the time in developing the original work. I included that element to show the exchange we had within the studio and also how different her movement style could appear in relation to my own.
12. See Chapter 3.
13. See http://motionbank.org/en.

14. De Keersmaeker responded to this situation with the following statement: 'People asked me if I'm angry or honored. Neither, on the one hand, I am glad that Rosas danst Rosas can perhaps reach a mass audience which such a dance performance could never achieve, despite its popularity in the dance world since 1980s. And, Beyoncé is not the worst copycat, she sings and dances very well, and she has a good taste! On the other hand, there are protocols and consequences to such actions, and I can't imagine she and her team are not aware of it. To conclude, this event didn't make me angry, on the contrary, it made me think a few things. Like, why does it take popular culture thirty years to recognize an experimental work of dance? And, what does it say about the work of Rosas danst Rosas? In the 1980s, this was seen as a statement of girl power, based on assuming a feminine stance on sexual expression. I was often asked then if it was feminist. Now that I see Beyoncé dancing it, I find it pleasant but I don't see any edge to it. It's seductive in an entertaining consumerist way.' Anne Teresa De Keersmaeker, 10 October 2011. Accessed 30 March 2014. http://theperformanceclub.org/2011/10/anne-teresa-de-keersmaeker-responds-to-beyonce-video/.
15. Agnes De Mille, *And Promenade Home* (Boston: Little, Brown and Company, 1956).
16. Rosemary Butcher's *Episodes of Flight* is available for view at the following link. Accessed 26 February 2014. http://vimeo.com/50230553.
17. Phone interview, 7 November 2008.
18. See Chapter 2.

Select Bibliography

Adolphe, Jean-Marc. 2002. 'P.A.R.T.S How to "School" in the 21st Century'. In *Rosas/Anna Teresa De Keersmaeker*, ed. Guy Gypens, Sara Jansen and Theo Van Rompay. Tournai: La Renaissance du Livre, 301–2.

Albright, Ann Cooper. 1997. *Choreographing Difference: The Body and Identity in Contemporary Dance*. Middletown, CT: Wesleyan University Press.

Albright, Ann Cooper. 2013. *Engaging Bodies: The Politics and Poetics of Corporeality*. Middletown, CT: Wesleyan University Press.

Althusser, Louis. 1994. 'Ideology and Ideological State Apparatuses'. In *Mapping Ideology*, ed. Slavoj Žižek. New York: Verso, 100–40.

Anon. 2010. 'An Integrated Dance Strategy 2010 to 2012', ed. Arts Council. Dublin: The Arts Council of Ireland.

Ashcroft, Bill, Gareth Griffiths and Helen Tiffin, eds. 1989. *The Empire Writes Back: Theory and Practice in Post-Colonial Literatures*. London and New York: Routledge.

Bales, Melanie. 2008. 'Training as the Medium Through Which'. In *The Body Eclectic: Evolving Practices in Dance Training*, ed. Melanie Bales and Rebecca Nettl-Fiol. Urbana and Chicago: University of Illinois Press, 28–42.

Bales, Melanie and Rebecca Nettl-Fiol, eds. 2008. *The Body Eclectic: Evolving Practices in Dance Training*. Urbana and Chicago: University of Illinois Press.

Banes, Sally. 1987. *Terpsichore in Sneakers: Post-Modern Dance*. Middletown, CT: Wesleyan University Press.

Banes, Sally. 1993. *Democracy's Body: Judson Dance Theatre, 1962–1964*. Durham, NC and London: Duke University Press.

Barbour, Karen. 2011. *Dancing across the Page: Narrative and Embodied Ways of Knowing*. Bristol: Intellect.

Barthes, Roland. 1977. *Image – Music – Text*, trans. Stephen Heath. London: Fontana.

Batson, Glenna. 2008. 'Teaching Alignment'. In *The Body Eclectic: Evolving Practices in Dance Training*, ed. Melanie Bales and Rebecca Nettl-Fiol. Urbana and Chicago: University of Illinois Press, 134–52.

Bel, Jérôme. 1999. 'I Am the (W)hole between Their Two Apartments'. *Ballet International/ Tanz Actuell* Yearbook, 36–7.

Bentley, Toni. 1982. *Winter Season: A Dancer's Journal*. New York: Random House.

Bergson, Henri. 2004. *Matter and Memory*, trans. Nancy Margaret Paul and W. Scott Palmer. New York: Dover Publications.

Bitterli, Milli. 2014. 'In Best Company' ('In bester Gesellschaft'). Accessed 18 March 2014. http://www.artificialhorizon.at/produktionen-2/in-bester-gesellschaft/?lang=en.

Bouveresse, Jacques. 1999. 'Rules, Disposition and the Habitus'. In *Bourdieu: A Critical Reader*, ed. Richard Shusterman. Oxford and Malden, MA: Blackwell Publishers, 45–63.

Boynton, Andrew. 2013. 'Jodi Melnick: Like Water Made Human'. *The New Yorker*. Accessed 3 April 2014. http://www.newyorker.com/online/blogs/culture/2013/01/review-of-jodi-melnicks-solo-redeluxe-version.html.

Braidotti, Rosi. 2000. 'Teratologies'. In *Deleuze and Feminist Theory*, ed. Ian Buchanan and Claire Colebrook. Edinburgh: Edinburgh University Press, 156–72.

Braidotti, Rosi. 2002. *Metamorphoses: Towards a Materialist Theory of Becoming*. Cambridge and Malden, MA: Polity Press.

Bramley, Ian. 2005. 'Foreword'. In *Rosemary Butcher: Choreography, Collisions and Collaborations*, ed. Rosemary Butcher and Susan Melrose. Middlesex: Middlesex University Press.

Brown, Carol. 2014. 'Falling Together'. In *Speculative Strategies in Interdisciplinary Arts Practice*, ed. Jane Calow, Daniel Hinchcliffe and Laura Mansfield. N.p.: Underwing Press.

Brown, Jean Morrison, Naomi Mindlin and Charles Humphrey Woodford. 1997. *The Vision of Modern Dance: In the Words of its Creators*, 2nd edn. Pennington, NJ: Princeton Book Co.

Burt, Ramsay. 2004. 'Genealogy and Dance History'. In *Of the Presence of the Body: Essays on Dance and Performance Theory*, ed. André Lepecki. Middletown, CT: Wesleyan University Press, 29–44.

Butcher, Rosemary. 2005. 'Afterword: Backward Glances, 1971–2000'. In *Rosemary Butcher: Choreography, Collisions and Collaborations*, ed. Rosemary Butcher and Susan Melrose. Middlesex: Middlesex University Press.

Butcher, Rosemary and Susan Melrose, eds. 2005. *Rosemary Butcher: Choreography, Collisions and Collaborations*. Middlesex: Middlesex University Press.

Butterworth, Jo. 2004. 'Teaching Choreography in Higher Education: A Process Continuum Model'. *Research in Dance Education* 5(1): 45–67.

Calvo-Merino, B., D. E. Glaser, J. Grèzes, R. E. Passingham and P. Haggard. 2005. 'Action Observation and Acquired Motor Skills: An fMRI Study with Expert Dancers'. *Cerebral Cortex* 15(8): 1243–9.

Card, Amanda. 2006. *Body for Hire? The State of Dance in Australia*. Strawberry Hills, NSW: Currency House Inc.

Carlson, Marvin. 2008. 'Introduction: Perspectives on Performance: Germany and America'. In Erika Fischer-Lichte, *The Transformative Power of Performance: A New Aesthetics*. New York and London: Routledge, 1–10.

Carter, Alexandra, ed. 1998. *The Routledge Dance Studies Reader*. London and New York: Routledge.

Casperson, Dana. 2011. 'Decreation: Fragmentation and Continuity'. In *William Forsythe and the Practice of Choreography*, ed. Steven Spier. Abingdon and New York: Routledge, 93–100.

Catterson, Pat. 2009. 'A Dancer Writes: I Promised Myself I Would Never Let It Leave My Body's Memory'. *Dance Research Journal* 41(2): 3–11.

Chadwick, Helen. 1989. *Enfleshings*. London: Secker & Warburg.

Charmatz, Boris. 2009. '50 ans de dance' ('50 years of dance'). Flip Book/Roman Photo. Accessed 29 March 2014. http://www.borischarmatz.org/en/savoir/piece/50-ans-de-danse-50-years-dance-flip-book-roman-photo.

Charmatz, Boris. 2012. 'The Tanks: Boris Charmatz'. Accessed 5 May 2014. https://http://www.youtube.com/watch?v=7ab5w5iIfAI.

Charmatz, Boris. 2014. 'Musée de la Danse'. Accessed 29 March 2014. http://www.borischarmatz.org/en/node/288.

Claid, Emilyn. 2002. 'Playing Seduction in Dance Theatre Performance'. *Discourses in Dance* 1(1): 29–46.

Claid, Emilyn. 2006. *Yes? No! Maybe ... Seductive Ambiguity in Dance*. London and New York: Routledge.

Clarke, Gill, Franz Anton Cramer and Gisela Müller. 2011. 'Minding Motion'. In *Dance Techniques: 2010 Tanzplan Germany*, ed. Ingo Diehl and Friederike Lampert. Leipzig: Henschel Verlag, 196–229.

Coates, Emily. 2010. 'Beyond the Visible: The Legacies of Merce Cunningham and Pina Bausch'. *A Journal of Performance and Art* 32(2): 1–7.

Colebrook, Claire. 2002. *Understanding Deleuze*. Crows Nest, NSW: Allen & Unwin.

Cooren, François. 2009. 'The Haunting Question of Textual Agency: Derrida and Garfinkel on Iterability and Eventfulness'. *Research on Language and Social Interaction* 42(1): 42–67.

Corey, Gerald. 1995. *Theory and Practice of Group Counselling*, 4th edn. Pacific Grove, CA: Brooks/Cole Publishing Company.

Dale, Alexander, Janyce Hyatt and Jeff Hollerman. 2007. 'The Neuroscience of Dance and the Dance of Neuroscience: Defining a Path of Enquiry'. *Journal of Aesthetic Education* 41(3): 89–110.

Dance UK. 2013. 'Dancers' Career Development on Career Transition and Identity'. Accessed 17 February 2014. http://www.danceuktv.com/dancers-career-development-career-transition-and-identity.

Davida, Dena. 1992. 'Dancing the Body Eclectic'. *Contact Quarterly: A Vehicle for Moving Ideas* (Summer). Accessed 24 April 2014. http://denadavida.ca/articles/dancing-the-body-eclectic/.

Dawkins, Richard. 2004. *The Ancestor's Tale: A Pilgrimage to the Dawn of Evolution*. New York: Houghton Mifflin Company.

De Keersmaeker, Anna Teresa and Bojana Cvejić. 2012. *A Choreographer's Score: Fase, Rosas danst Rosas, Elena's Aria, Bartók*. Brussels: Mercatofonds & Rosas.

De Laet, Timmy. 2012. 'Dancing Metamemories'. *Performance Research* 17(3): 102–8.

De Spain, Kent. 2007. 'Resisting Theory: The Dancing Body and American Scholarship'. In *Society of Dance Scholars: Re-Thinking Practice and Theory*, compiled by Ann Cooper Albright, Dena Davida and Sarah Davies Cordova. Paris: Centre National de la Danse, 59–64.

De Toro, Fernando and Alfonso De Toro, eds. 1995. *Borders and Margins: Post-Colonialism and Post-Modernism*. Madrid: Iberoamericana.

Delahunta, Scott, Phil Barnard and Wayne McGregor. 2009. 'Augmenting Choreography: Insights and Inspiration from Science'. In *Contemporary Choreography: A Critical Reader*, ed. Jo Butterworth and Liesbeth Wildschut. Abingdon and New York: Routledge, 431–48.

Deleuze, Gilles. 1988. *Foucault*, trans. Sean Hand. London and New York: Athlone Press.

Deleuze, Gilles. 2001. *Pure Immanence: Essays on a Life*, trans. Anne Boyman. New York: Urzone.

Deleuze, Gilles. 2003. *Francis Bacon: The Logic of Sensation*, trans. Daniel W. Smith. Minneapolis: University of Minnesota Press.

Deleuze, Gilles and Félix Guattari. 1987. *A Thousand Plateaus: Capitalism and Schizophrenia*, trans. Brian Massumi, 10th edn. Minneapolis and London: University of Minnesota Press.

Dempster, Elisabeth. 1995. 'Women Writing the Body: Let's Watch a Little How She Dances'. In *Bodies of the Text: Dance as Theory, Literature as Dance*, ed. Ellen W. Goellner and Jacqueline Shea Murphy. New Brunswick, NJ: Rutgers University Press, 21–38.

Derezinski, Amelia. 2006. *Twyla Tharp*. New York: Rosen Publishing Group.

Derrida, Jacques. 1977. 'Signature, Event, Context'. *Glyph* 1: 172–97.

Derrida, Jacques. 1978. *Writing and Difference*. Chicago: Universty of Chicago Press.

Dittman, Veronica. 2008. 'A New York Dancer'. In *The Body Eclectic: Evolving Practices in Dance Training*, ed. Melanie Bales and Rebecca Nettl-Fiol. Urbana and Chicago: University of Illinois Press, 22–7.

Dolphijn, Rick and Iris Van der Tuin. 2011. *New Materialisms: Interviews and Cartographies*. Ann Arbor: Open Humanities Press.

EDN. 2013. 'European Dancehouse Network'. Accessed 15 December 2013. http://www.ednetwork.eu.

Farjeon, Annabel. 1998. 'Choreographers: Dancing for de Valois and Ashton'. In *The Routledge Dance Studies Reader*, ed. Alexandra Carter. London and New York: Routledge, 23–8.

Fischer-Lichte, Erika. 2008. *The Transformative Power of Perfomance: A New Aesthetics*.New York and London: Routledge.

Forsythe, William. 2011. 'Choreographic Objects'. In *William Forsythe and the Practice of Choreography*, ed. Steven Spier. New York: Routledge, 90–2.

Fortin, Sylvie, Adriane Vieira and Martyne Tremblay. 2009. 'The Experience of Discourses in Dance and Somatics'. *Journal of Dance and Somatic Practices* 1(1): 47–64.

Foster, Susan Leigh. 1986. *Reading Dancing: Bodies and Subjects in Contemporary American Dance*. Berkeley and London: University of California Press.

Foster, Susan Leigh. 1992. 'Dancing Bodies'. In *Incorporations*, ed. Jonathan Crary and Sanford Kwinter. New York: Zone 6, 480–95.

Foster, Susan Leigh. 2005. 'Rosemary Butcher's SCAN'. In *Rosemary Butcher: Choreography, Collisions and Collaborations*, ed. Rosemary Butcher and Susan Melrose. Middlesex: Middlesex University Press, 108–25.

Foster, Susan Leigh. 2009. 'Dancing Bodies: An Addendum'. *Theater* 40(1): 25–9.

Foucault, Michel. 1977. 'Nietzsche, Genealogy and History'. In *Language, Counter-Memory, Practice: Selected Essays and Interviews by Michel Foucault*, ed. Donald Bouchard. Oxford: Blackwell, 139–64.

Franko, Mark. 2002. *The Work of Dance: Labor, Movement and Identity in the 1930s*. Middletown, CT: Wesleyan University Press.

Gallagher, Shaun. 1995. 'Body Schema and Intentionality'. In *The Body and the Self*, ed. José Luis Bermúdez, A. J. Marcel and Naomi Eilan. Cambridge, MA: MIT Press, 225–44.

Gallagher, Shaun. 2005. *How the Body Shapes the Mind*. Oxford and New York: Oxford University Press.

Gallagher, Shaun and Dan Zahavi. 2008. *The Phenomenological Mind*. Abingdon and New York: Routledge.

Garafola, Lynn. 1989. *Diaghilev's Ballet Russes*. New York and Oxford: Oxford University Press.

Gardner, Sally. 2007a. 'Dancer, Choreographer and Modern Dance Scholarship'. *Dance Research* 25(1): 35–53.

Gardner, Sally. 2007b. 'Tom Rawe and Jenny Way: An Art of Fine Dancing, an Interview with Sally Gardner'. *Writings on Dance* (Summer 2007/08): 36–48.

Gardner, Sally. 2008. 'Notes on Choreography'. *Performance Research: A Journal of the Performing Arts* 13(1): 55–60.

Gardner, Sally. 2011. 'From Training to Artisanal Practice: Rethinking Choreographic Relationships in Modern Dance'. *Theatre, Dance and Performance Training* 2(2): 151–65.

Goldhahn, Eila. 2009. 'Is *Authentic* a Meaningful Name for the Practice of Authentic Movement?' *American Journal of Dance Therapy* 31(1): 53–63.

Graham, George and G. Lynn Stephens. 1994. 'Mind and Mine'. In *Philosophical Psychopathology*, ed. George Graham and G. Lynn Stephens. Cambridge, MA and London: MIT Press, 91–110.

Grosz, Elizabeth. 1994. *Volatile Bodies*. Bloomington: Indiana University Press.

Grove, Robin, Catherine Stevens and Shirley McKechnie. 2005. *Thinking in Four Dimensions: Creativity and Cognition in Contemporary Dance*. Carlton: Melbourne University Press.

Hanna, Thomas. 1979. *The Body of Life*. Rochester, VT: Healing Arts Press.

Hanna, Thomas. 1988. *Somatics*. New York: Addison-Wesley.

Hanna, Thomas. 1995. 'What is Somatics?' In *Bone, Breath and Gesture: Practices of Embodiment*, ed. Don Hanlon Johnson. Berkeley, CA: North Atlantic Books, 341–52.

Hayles, N. Katherine. 1999. *How We Became Post-Human: Virtual Bodies in Cybernetics, Literature and Informatics*. London and Chicago: University of Chicago Press.

Hilton, Rebecca. 2012. '10 Realisations Made Possible by Acts of Dancing'. *Writings on Dance* 25 (Winter), 2–7.

Hilton, Rebecca and Brian Smyth. 1998. 'A Dancing Consciouness'. In *The Routledge Dance Studies Reader*, ed. Alexandra Carter. New York and London: Routledge, 72–80.

Huschka, Sabine. 2011. 'Daniel Roberts: Cunningham Technique'. In *Dance Techniques 2010: Tanzplan Germany*, ed. Ingo Diehl and Friederike Lampert. Leipzig: Henschel Verlag, 166–95.

Hutera, Donald. 2011. 'Story of a Dancer: Jérôme Bel and Cédric Andrieux'. *Dance Umbrella 2011*. Accessed 13 January 2014. http://www.run-riot.com/articles/blogs/story-dancer-donald-hutera-interviews-jérôme-bel-cédric-andrieux.

Johnson, Don Hanlon, ed. 1995. *Bone, Breath and Gesture: Practices of Embodiment* Berkeley, CA: North Atlantic Books.

Jordan, Stephanie. 1984. 'On Stage and Page'. *Dance Theatre Journal* 2(3), 33–4.

Jordan, Stephanie. 1992. *Striding Out: Aspects of Contemporary and New Dance in Britain*. London: Dance Books.

Juhan, Deane. 1987. *Job's Body: A Handbook for Bodywork*. New York: Station Hill Press.

Kirkland, Gelsey. 1986. *Dancing on my Grave*. New York: Berkley Books.

Kolb, Alexandra. 2013. 'Current Trends in Contemporary Choreography: A Political Critique'. *Dance Research Journal* 45(3): 29–52.

Kourlas, Gia. 2013. 'Downtown Diva'. *Dance Magazine* (New York), 87(2), 26–31.

Kunst, Bojana. 2011. 'Dance and Work: The Aesthetic and Political Potential of Dance'. In *Emerging Bodies: The Performance of Worldmaking in Dance and*

Choreography, ed. Gabrielle Klein and Sandra Noeth. Bielefeld: Transcript Verlag, 47–60.

Lansley, Jacky and Fergus Early, eds. 2011. *The Wise Body: Conversations with Experienced Dancers*. Bristol: Intellect.

Launay, Isabelle. 2012. 'Citational Poetics in Dance: ... of a faun (fragments) by the Albrecht Knust Quartet, before and after 2000'. *Dance Research Journal* 44(02): 49–69.

Lavender, Larry. 2009. 'Facilitating the Choreographic Process'. In *Contemporary Choreography: A Critical Reader*, ed. Jo Butterworth and Liesbeth Wildschut. New York: Routledge, 71–89.

Lehman, Thomas. 2002. '"Schreibstück" by Thomas Lehman (2002)'. Accessed 19 March 2014. http://www.thomaslehmen.de/schreibstueck-159.html.

Lepecki, André. 2001. 'Undoing the Fanstasy of the (Dancing) Subject: "Still-Acts" in Jérôme Bel's *The Last Performance*'. In *The Salt of the Earth: On Dance Politics and Reality*, ed. Steven De Belder and Koen Tachelet. Brussels: Vlaams Theater Instituut.

Lepecki, André. 2006. *Exhausting Dance: Performance and the Politics of Movement*. New York and London: Routledge.

Longley, Alys and Katherine Tate. 2012. 'Writing the Somatic in the Insomnia Poems Project'. *Journal of Dance and Somatic Practices* 3(1–2), 229–42.

Louppe, Laurence. 1996. 'Hybrid Bodies'. *Writings on Dance* 15: 63–7.

Louppe, Laurence. 2008. 'Memory and Identity'. *Writings on Dance* 24 (Summer 2007/2008): 21–9.

Louppe, Laurence. 2010. *The Poetics of Contemporary Dance*, trans. Sally Gardner. London: Dance Books.

Mackrell, Judith. 2013. 'Siobhan Davies Dance: Table of Contents Review'. *The Guardian*. Accessed 24 September 2014. http://www.theguardian.com/stage/2014/jan/12/siobhan-davies-dance-table-of-contents-review.

Manning, Erin. 2009. *Relationscapes: Movement, Art, Philosophy*. Cambridge, MA and London: MIT Press.

Massumi, Brian. 1987. 'Translator's Foreword: Pleasures of Philosophy'. In Gilles Deleuze and Félix Guattari, *A Thousand Plateaus: Capitalism and Schizophrenia*, trans. Brian Massumi, 10th edn. Minneapolis and London: University of Minnesota Press.

Massumi, Brian. 1992. *A User's Guide to Capitalism and Schizophrenia: Deviations from Deleuze and Guattari*. Cambridge, MA and London: MIT Press.

Mauss, Marcel. 1992. 'Techniques of the Body'. In *Incorporations*, ed. Jonathan Crary and Sanford Kwinter. New York: Zone, 455–77.

McFee, Graham. 2011. *The Philosophical Aesthetics of Dance*. London: Dance Books.

McGrath, Aoife. 2013. *Dance Theatre in Ireland: Revolutionary Moves*. Basingstoke: Palgrave Macmillan.

McKechnie, Shirley and Catherine J. Stevens. 2009. 'Visible Thought: Choreographic Cognition in Creating, Performing and Watching Contemporary Dance'. In *Contemporary Choreography: A Critical Reader*, ed. Jo Butterworth and Liesbeth Wildschut. London and New York: Routledge, 38–51.

Melrose, Susan. 2003. 'The Eventful Articulation of Singularities – or, "Chasing Angels"'. Accessed 4 February 2014. http://www.sfmelrose.u-net.com/chasingangels/.

Melrose, Susan. 2005. 'Hidden Voices (2004) and The Return (2005): "Always Innovate"'. In *Rosemary Butcher: Choreography, Collisions and Collaborations*, ed. Rosemary Butcher and Susan Melrose. Middlesex: Middlesex University Press, 170–90.

Menger, Pierre-Michel. 1999. 'Artistic Labor Markets and Careers'. *Annual Review of Sociology* 25: 541–74.

Merleau-Ponty. Maurice. 2002. *Phenomenology of Perception*. London: Routledge.

Millard, Olivia. 2013. 'Dancing Habitus: The Formation of a Group (Dance)'. *Brolga: An Australian Journal about Dance* 38 (September): 23–9.

Monni, Kirsi. 2008. 'About the Sense and Meaning in Dance'. In *Framemakers: Choreography as an Aesthetics of Change*, ed. Michael Klein and Steven Valk. Limerick: Daghdha Dance Company, 37–44.

Montfils, Marie H., Erik J. Plautz and Jeffrey A. Kleim. 2005. 'In Search of the Motor Engram: Motor Map Plasticity as a Mechanism for Encoding Motor Experience'. *The Neuroscientist* 11(5): 471–83.

Morgenroth, Joyce. 2004. *Speaking of Dance: Twelve Contemporary Choreographers on Their Craft*. Abingdon and New York: Routledge.

Morris, Geraldine. 2001. 'Dance Partnerships: Ashton and his Dancers'. *Dance Research* 19(1): 11–59.

Morris, Geraldine. 2003. 'Problems with Ballet: Steps, Style and Training'. *Research in Dance Education* 4(1): 17–30.

Mulrooney, Deirdre. 2006. *Irish Moves: An Illustrated History of Dance and Physical Theatre in Ireland*. Dublin: Liffey Press.

Nachbar, Martin. 2012. 'A Dancer Writes: Training Remembering'. *Dance Research Journal* 44(2): 3–12.

Noisette, Philippe. 2011. *Talk about Contemporary Dance*, ed. Élisabeth Couturier. Paris: Flammarion.

Odedra, Aakash. 2014. 'Rising'. Accessed 14 January 2014. http://www.aakashodedra.com.

Pakes, Anna. 2006. 'Dance's Mind-Body Problem'. *Dance Research* 24(2): 87–104.

Pakes, Anna. 2009. 'Knowing through Dance-Making: Choreography, Practical Knowledge and Practice-as-Research'. In *Contemporary Choreography: A Critical Reader*, ed. Jo Butterworth and Liesbeth Wildschut. London and New York: Routledge, 10–22.

Pallaro, Patrizia, ed. 1999. *Authentic Movement: Essays by Mary Starks Whitehouse, Janet Adler and Joan Chodorow*. London and Philadelphia: Jessica Kingsley Publishers.

Parviainen, Jaana. 1998. *Bodies Moving and Moved: A Phenomenological Analysis of the Dancing Subject and the Cognitive and Ethical Values of Dance Art*. Tampere: Tampere University Press.

Parviainen, Jaana. 2003. 'Dance Techne: Kinetic Body Logos and Thinking in Movement'. *The Nordic Society of Aesthetics Journal* 15 (27–28): 159–75.

Pasquinelli, Elena. 2006. 'Varela and Embodiment'. *The Journal of Aesthetic Education* 40(1): 33–5.

Perron, Wendy. 2013. *Through the Eyes of a Dancer*. Middletown, CT: Wesleyan University Press.

Phelan, Peggy. 1993. *Unmarked: The Politics of Performance*. London and New York: Routledge.

Phelan, Peggy. 1996. 'Dance and the History of Hysteria'. In *Corporealities: Dancing Knowledge, Culture and Power*, ed. Susan Leigh Foster. London and New York: Routledge, 92–108.

Ploebst, Helmut. 2001. *No Wind No Word: New Choreography in the Society of the Spectacle*. Munich: Kieser.

Prevots, Naima. 1999. 'Funding for Dance'. *Dance Magazine* 73(12), 100–3.

Rainer, Yvonne. 2014. 'The Aching Body in Dance'. *PAJ: A Journal of Performance and Art* 36(1), 3–6.

Ravn, Susanne. 2009. *Sensing Movement, Living Spaces: An Investigation of Movement Based on the Lived Experiences of 13 Professional Dancers*. Saarbrücken: Verlag Dr Müller.

Reynolds, Dee. 2007. *Rhythmic Subjects: Uses of Energy in the Dances of Mary Wigman, Martha Graham and Merce Cunningham*. London: Dance Books.

Roach, Joseph. 1996. *Cities of the Dead: Circum-Atlantic Performance*. New York: Columbia University Press.

Roche, Jennifer. 2009. 'Moving Identities: Multiplicity, Embodiment and the Contemporary Dancer'. PhD dissertation, Roehampton University.

Roche, Jennifer. 2011. 'Embodying Multiplicity: The Independent Contemporary Dancer's Moving Identity'. *Research in Dance Education* 12(2): 105–18.

Roche, Jennifer. 2013. 'Artists in Conversation: Jenny Roche (IRL) and Vicky Schick (USA)'. *Dance Notes*: Dance Research Forum Ireland.

Roses-Thema, Cynthia Ann. 2007. 'Reclaiming the Dancer: Embodied Perception in a Dance Performance'. PhD dissertation, Arizona State University.

Roses-Thema, Cynthia Ann. 2008. *Rhetorical Moves: Reclaiming the Dancer as Rhetor in a Dance Performance*. Saarbrucken: Verlag Dr Mueller.

Rothfield, Philipa. 2008. 'Feeling Feelings: The Work of Russell Dumas through Whitehead's Process and Reality'. *Inflexions* 2. Accessed 22 January 2014. http://www.inflexions.org/n2_rothfieldhtml.html.

Roy, Sanjoy. 2008. 'Rosemary Butcher: Riverside Studios London'. *The Guardian*. Accessed 24 September 2014. http://www.theguardian.com/stage/2008/nov/06/dance.

Royle, Nicolas. 2003. *Jacques Derrida*. London and New York: Routledge.

Ruhsam, Martina. 2012. 'A Bear, John Cage, and the Dance State'. *Corpus*. Accessed 27 March 2014. http://www.corpusweb.net/a-bear-john-cage-and-the-dance-state-2.html.

Sabisch, Petra. 2011. *Choreographing Relations: Practical Philosophy and Contemporary Choreography*. Munich: Epodium.

Salgado, Joao and Hubert J. M. Hermans. 2005. 'The Return of Subjectivity: From a Multiplicity of Selves to a Dialogical Self'. *E-Journal of Applied Psychology: Clinical Section*.

Sayers, Lesley-Anne. 2011. 'Rosemary Butcher'. In *Fifty Contemporary Choreographers*, ed. Martha Bremser and Lorna Sanders, 2nd edn. Abingdon and New York: Routledge.

Schacter, Daniel L. 1996. *Searching for Memory: The Brain, the Mind and the Past*. New York: Basic Books.

Schilder, Paul. 1950. *The Image and Appearance of the Human Body*. London: Routledge.

Schneider, Rebecca. 2001. 'Archives: Performance Remains'. *Performance Remains* 6(2): 100–8.

Schneider, Rebecca. 2005. 'Solo Solo Solo'. In *After Criticism: New Responses to Art and Performance*, ed. Gavin Butt. Malden, MA and Oxford: Blackwell Publishing, 23–47.

Sheets-Johnstone, Maxine. 1999. *The Primacy of Movement*. Philadelphia: John Benjamins.

Shusterman, Richard, ed. 1999. *Bourdieu: A Critical Reader*. Oxford: Blackwell Publishers.

Shusterman, Richard. 2006. 'Thinking through the Body, Educating for the Humanities: A Plea for Somaesthetics'. *The Journal of Aesthetic Education* 40(1): 1–21.

Shusterman, Richard. 2008. *Body Consciousness: A Philosophy of Mindfulness and Somaesthetics*. New York: Cambridge University Press.

Siegel, Marcia B. 1972. *At the Vanishing Point: A Critic Looks at Dance*. New York: Saturday Review Press.

Siegel, Marcia. 1981. *Shapes of Change*. New York: Avon Books.

Sloterdijk, Peter. 2006. 'Mobilization of the Planet from the Spirit of Self-Intensification'. *TDR: The Drama Review* 50(4): 36–43.

Smart, Barry. 2002. *Michel Foucault*, 2nd edn. New York and London: Routledge.

Smith, Sidonie and Julia Watson. 2001. *Reading Autobiography: A Guide for Interpreting Life Narratives*. Minneapolis: University of Minnesota Press.

Solway, Diane. 2007. 'When the Choreographer is Out of the Picture'. *The New York Times*. Accessed 24 September 2014. http://www.nytimes.com/2007/01/07/arts/dance/07solw.html?pagewanted=all&_r=0.

Sparshot, Francis. 1988. *Off the Ground: First Steps to a Philosophical Consideration of the Dance*. Princeton: Princeton University Press.

Sulcas, Rosalyn. 2010. 'Hamming It Up, With Pink Light, Flashes of Murakami and Flowered Bikinis'. *The New York Times*. Accessed 24 September 2014. http://www.nytimes.com/2010/06/19/arts/dance/19jasperse.html?_r=2&.

Tampio, Nicholas. 2010. 'Multiplicity'. In *Encyclopedia of Political Thought*, ed. Mark Bevir. Thousand Oaks, CA: Sage Publications.

Taylor, Diana. 2003. *The Archive and the Repertoire: Performing Cultural Memory in the Americas*. Durham, NC and London: Duke University Press.

Theodores, Diana. 1996. *First We Take Manhattan: Four American Women and the New York School of Dance Criticism*. Abingdon and New York: Routledge.

Theodores, Diana. 2003. *Dancing on the Edge of Europe: Irish Choreographers in Conversation*. Cork: Institute for Choreography and Dance.

Varela, Francisco. 1992. 'The Reenchantment of the Concrete'. In *Incorporations*, ed. Jonathan Crary and Sanford Kwinter. New York: Zone 6, 320–39.

Varela, Francisco. 1996. 'The Emergent Self'. In *The Third Culture*, ed. John Brockman. New York: Touchstone, 209–22.

Weiss, Gail. 1999. *Body Images: Embodiment as Intercorporeality*. New York and London: Routledge.

Whatley, Sarah. 2012. 'The Poetics of Motion Capture and Visualisation Techniques: The Differences between Watching Real and Virtual Dancing Bodies'. In *Kinesthetic Empathy in Creative and Cultural Practices*, ed. Dee Reynolds and Matthew Reason. Bristol: Intellect, 263–80.

Whatley, Sarah. 2013. 'Motion Capture and the Dancer: Visuality, Temporality and the Dancing Image'. In *Dance and Somatic Practices Conference Handbook*, University of Coventry.

Woods, Byron. 2008. 'Pure, but not simple: In a world premiere, John Jasperse debunks the dance ideal'. Accessed 19 February 2014. http://www.indyweek. com/gyrobase/Content?oid=oid%3A259863.

Yamashita, Akiko. 2011. 'Presenter Interview: The Programs and Missions of Tanzhaus NRW at the Forefront of German Dance'. The Performing Arts Network, Japan, The Japan Foundation. Accessed 24 September 2014. http:// www.performingarts.jp/E/pre_interview/1111/pre_interview1111e.pdf.

Yeoh, Francis. 2007. 'The Value of Documenting Dance'. *Ballet – Dance Magazine*. Accessed 28 November 2014. http://www.ballet-dance.com/200706/articles/ Yeoh200706.html.

Žižek, Slavoj. 2004. *Organs with Bodies: On Deleuze and Consequences*. New York and London: Routledge.

Index

Note: entries in **bold** refer to figures.

Albright, A. Cooper 5, 11, 48, 71–2,
 111–12, 119–20, 146–7
archiving performance 2–3, 116,
 119–23, 150
Authentic Movement 46, 97, 144
authorship 18, 26–30, 114, 131, 139
autopoietic process 33–4, 134

Bagouet, D. 22, 121, 128–9
Bales, M. 8, 12–13
Banes, S. 4–5, 64
Barthes, R. 28–9, 129, 139
Bausch, P. 12–13
Bel, J. 26–8, 65, 91–2, 100, 111–12,
 135, 138, 143
Bennett, C. 70, 83–5, 103, 106, 108,
 117, 134–5
body eclectic 9, 12
body image 14, 82–5, 117
Braidotti, R. 17, 104, 107, 115, 117–18
bricolage 12
Brown, C. 31, 69, 71, 108
Brown, T. 21–2, 67–8, 112, 127,
 135, 142
Burt, R. 2, 16, 56, 147
Business of the Bloom (BB) 60–78, 129
Butcher, R. vii, 14, 19–20, 23, 25–42,
 48–9, 103, 106, 108, 112, 127,
 132–5, 141–4, 149–51
Butterworth, J. 29

Card, A. 29–30, 76, 115, 147
Casperson, D. 52, 91
Catterson, P. 132
Chadwick, H. 106, 118
Charmatz, B. 1, 30, 121–2, 145, 150
choreographer
 as artist 3, 4
 freelance 3, 7–8, 21
 signatures 2, 4, 11, 13, 15, 18,
 26–8, 114, 127–8, 130–1, 134–8

choreographic traces 18, 30, 74–5,
 85, 99–118, 122–5, 128–32,
 134, 136
choreography *see processes*
Claid, E. 5–6, 10–12, 15, 36, 55, 77,
 91–2, 120, 124, 140–1
codification
 of style 6, 9–10, 15, 22, 120
 of technique 12–13, 44, 46, 65,
 71, 86, 112, 119, 140
Connaughton, P. 70, 95
creative agency 27, 31, 36, 50–2,
 57–9, 70–2, 115, 136 *see also*
 structure
Cunningham, M. 4–6, 13–14, 28,
 120–2, 139

dance
 modernity in 65–6, 72, 119
 post-modern 4, 9, 12, 19–20, 30,
 56, 64–5, 102, 106, 120, 127, 136
dance state 64, 77, 101
Dance UK 7, 120, 140
dancer
 compliant 66, 72, 113, 146
 construction of 11, 14–17, 24, 41,
 55, 71, 102, 106, 111–12, 117, 136
 feminism 5, 17–18, 55, 120,
 141, 151
 freelance 7–9
 gender 6, 15, 120, 141
 hired body 9, 13
 hybrid body 9, 15, 120
 identity 54, 59, 69–70, 103, 106–8,
 111–12, 118, 120, 136
 instrument or canvas 1–3, 134
 labour 18, 28, 71, 76, 119, 133, 136
 passivity 3, 23, 58, 66, 68, 72, 99,
 101, 113, 136
 signature movement 15, 17, 116,
 119–20, 122, 137

dancing body 5, 11–13, 15–17, 24, 112, 116, 129
dancing process 43–4, 60–1, 79–80, 93–4
dancing self 16, 71, 120 *see also* de-stratification; moving identity
Davida, D. 5, 9, 29, 115, 139–40
Deleuze, G. 17, 29, 35–6, 65, 94, 100–5, 109, 115, 117, 150
Deleuzean
line of flight 94, 148
self 17, 102, 104–5, 149
Derrida, J. 1, 29, 125, 138, 145
de-stratification 103–4
dialogical self 105–6, 118, 146
Dittman, V. 6–7
duality 42, 88, 96, 108, 111–112, 133 *see also* multiplicity
Dublin Dance Festival (DDF) 19, 24, 38, 40–1
Duncan, Isadora 4, 11, 48, 119–20

embodied self 42, 102–3, 112–13, 118
embodiment 1–5, 14–18, 41–2, 57, 68–9, 73, 82–3, 90–8, 109–14, 134–6, 144, 147 *see also* incorporation; inscription
employment practices 6–9, 120–1
European Dancehouse network (EDN) 7–8

flux state 16–17, 77, 130, 135
Forsythe, W. 47, 52–4, 91, 122
Foster, S. 5, 9–11, 13–15, 84, 112, 140
fragmentation 57, 99, 109, 117 *see also* moving identity
Fulkerson, M. 6

Gallagher, S. 50–1, 84, 90, 145
Garafola, L. 3–4
Gardner, S. 4, 23, 26, 41, 48, 51–2, 66–8, 71–2, 140, 144, 156
Giannotti, E. 25–7, 54, 132–3, 143
Graham, M. 4, 6, 11, 14–15, 120, 140
Grosz, E. 14, 17, 90, 136

habitus 69, 71, 110–11, 117, 146, 150 *see also* moving identity
Hanna, T. 86, 88–9, 147 *see also* somatic
Hayles, N. K. 16, 69, 110
Hilton, R. vii, 10, 53, 57, 67–8, 70, 91–2, 105, 108, 114, 117, 127, 136, 143

ideokinesis 6, 139
improvisation 13, 25, 27, 43, 45–6, 49–50, 58–9, 63–5, 72–4, 85, 103, 105, 110–11, 115, 139, 143, 150
incorporation 100–1, 110, 112, 116, 129, 136, 140
Independent Dance 139–40, 144
inscription 13, 100, 110–12, 136, 140
Irish Modern Dance Theatre 20, 75

Jasperse, J. vii, 19–20, 22, 43–59, 62, 70, 101, 105, 108, 117–18, 124–6, 132, 141–2, 144–5
Jordan, S. 6, 141
Judson movement 4–6, 13–14, 19, 48, 76, 121, 139
Juhan, D. 82, 85–6

Keersmaeker, A. T. de 131, 147–8, 151
kinaesthetics 48, 53, 65, 69, 80, 90, 95, 120

Laban, R. 4, 109
Le Roy, X. 26–8, 65
Lepecki, A. 1, 47, 65–8, 72, 100, 111, 119, 128, 136, 138, 143, 146
Louppe, L. 9–11, 13, 15, 23, 26, 28, 30, 54, 109, 121, 127

McFee, G. 27–8
McGregor, W. 83–5, 89, 113
Massumi, B. 17, 109, 149
Mauss, M. 14
Melnick, J. vii, 19, 21–2, 55, 58, 60–78, 97, 99, 101, 107, 117, 127, 129, 130, 142–3, 145–7, 150
Melrose, S. 20, 25–7, 35, 53
Merleau-Ponty, M. 17, 90
Millard, O. 110–11

Missed Fit 20, 45, 48, 142, 144
molar identity 17, 100, 104, 116, 141
Monni, K. 37–8, 127
Morris, G. 11, 71, 127
movement and motor mapping 14, 37, 84–6, 97, 145
movement patterns 14–15, 18, 53, 77, 85–7, 97–8, 111, 113, 118
movement vocabulary 6, 10, 14, 25–6, 30, 34, 38, 98, 129
moving identity 16, 18, 24, 58, 69, 85–6, 94, 97–118, 127, 132, 134–7 *see also* multiplicity
multiplicity 15–17, 100–2, 105–6, 108–9, 117–18, 136, 149 *see also* unity

New Dance 5, 15, 19

O'Malley, K. 79, 81–2, 92, 93–4

Pakes, A. 31, 89–90, 144
Paxton, S. 4, 139–40
Petronio, S. 10, 57, 105, 127
Phelan, P. 100, 107, 123, 125–7, 141
processes
 choreographic 29, 38, 53, 56, 62–3, 65–6, 75–6, 113–14, 134
 collaborative 25–6, 30–5, 39–42, 48–9, 54–5, 63–4, 68–9, 73–4, 76–8, 101, 124, 131
 connected to 36, 39–42, 44, 49, 57–8, 61–9, 77, 88, 92, 95, 99–100, 108–9, 117, 148
 creative vii–ix, 4–5, 24, 26–8, 31–2, 36, 59, 68–9, 77–8, 91, 93–4
 disconnected from 12, 36, 52, 56–7, 87, 107

Rainer, Y. 48, 121
Ravn, S. 85, 116, 123
Release Technique 6, 49
Rex Levitates Dance Company 19, 21, **32**, 142, 149
Roche, L. vii, 22, 31–2, 34, 55, 58, 79–98, 101, 108, 117, 132, 142, 147–9
Roses-Thema, A. 68, 96, 135, 148–9
Rothfield, P. 74, 96

Roy, S. 132–3
Rudner, S. vii, 21, 23, 61, 73, 75–7, 97, 108, 114, 128, 139–40, 142, 146–50

Sabisch, P. 53, 135
Salgardo, J. 102, 105–6, 146
Sayers 19–20, 112
schema
 body 84–5, 87, 101
 choreographic 24, 30, 36, 84, 95–6, 101, 107–8, 117–18, 147
Schick, V. 21, 67–8, 112, 135
Schilder, P. 82–4
Schneider, R. 76, 123
Shared Material on Dying (SM) 79–98
Sheets-Johnstone, M. 63–4
Shusterman, R. 85–6, 110
Siegel, M. 2, 119
Six Frames: Memories of Two Women (SF) 25–38
Solo³ 18, 22–4, 38, 107, 129
Solo for Jenny: Dance of (an undisclosed number of) Veils (DOV) 43–59
somatic practice
 Alexander Technique 6, 86
 Feldenkrais method 86
somatics 10, 17, 31, 37, 68–9, 79, 85–6, 88–9, 91–2, 96, 110, 147, 150
structure 36–7, 41, 67, 91

Taylor, D. 2–3, 6, 123
Taylor, P. 4, 6
Tharp, T. 23, 51–2, 73, 127–8, 146
Theodores, D. 6, 22
training
 ballet 6, 11–12, 14, 46, 49, 66–7, 71–2, 84, 87, 95–6, 119, 124, 127, 138, 140, 148
 dance 4, 12, 14–15, 35, 38, 48, 70–1, 73, 91, 136, 139

unity 105–7, 109, 118

Varela, F. 36–7, 134, 144

Weiss, G. 82–3

X6 5–6, 12

Printed and bound by CPI Group (UK) Ltd, Croydon, CR0 4YY